FLOW BLUE
A Closer Look

Jeffrey B. Snyder

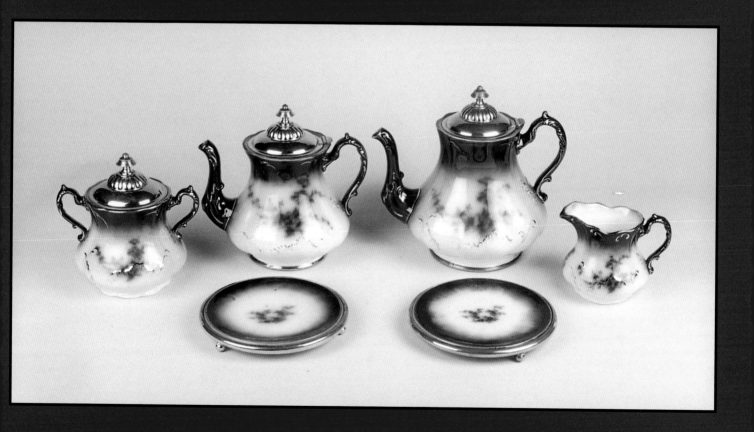

Schiffer Publishing Ltd

4880 Lower Valley Road, Atglen, PA 19310 USA

To Arnold and Dorothy.

Designed by "Sue"
Type set in Americana XBd BT/Zapf Humanist BT

ISBN: 0-7643-1118-2
Printed in China
1 2 3 4

Published by Schiffer Publishing Ltd.
4880 Lower Valley Road
Atglen, PA 19310
Phone: (610) 593-1777; Fax: (610) 593-2002
E-mail: Schifferbk@aol.com
Please visit our web site catalog at www.schifferbooks.com
We are always looking for people to write books on new and related subjects. If you have an idea for a book, please contact us at the above address.

This book may be purchased from the publisher.
Include $3.95 for shipping.
Please try your bookstore first.
You may write for a free catalog.

In Europe, Schiffer books are distributed by:
Bushwood Books
6 Marksbury Ave.
Kew Gardens
Surrey TW9 4JF
England
Phone: 44 (0)208 392-8585
Fax: 44 (0)208 392-9876
E-mail: Bushwd@aol.com
Free postage in the UK. Europe: air mail at cost.
Try your bookstore first.

Contents

Introduction ... 4
The Confounding Popularity of Flow Blue 8
Flow Blue Wares: A Comparison of the Early
 and the Late/the British and the American Through
Four Popular Patterns .. 17

 Early Victorian Wares in the Cashmere and Chapoo Patterns 17
 Late Victorian Wares in the La Belle and Touraine Patterns 48

Flow Blue Ceramics, Additional Forms / Additional Patterns 111

 Tea and Chocolate Sets ... 111
 Syrup Pitchers ... 142
 Children's Wares .. 155
 Patterns Through Pieces—Butter Pats & Egg Cups 159
 Varied Wares, Additional Patterns 167

Bibliography ... 186
Index ... 187
Index of Patterns .. 188

Acknowledgments

 No book is ever completed by an author alone. I want to take this opportunity to thank all of the generous individuals who opened their homes to me, allowed me access to their collections, and generously shared their knowledge and research with me. They truly made this book possible. Special thanks to Tom and Kathy Clarke, Don Iverson, Arnold A. and Dorothy E. Kowalsky, Jim and Shelley Lewis, Warren and Connie Macy, James and Christine Stucko, and Jerry and Margaret Taylor. This book would not exist without you.

 If you are new to Flow Blue collecting and would like to meet knowledgeable, friendly people who share your passion, you should contact the Flow Blue International Collectors' Club, Inc. through the web site: http://www.flowblue.org/ and join the club.

 Finally, I want to thank the readers. Without all of you these books would not be produced. Thank you for reading, writing, and calling. While I am not always able to answer all of my mail, I always appreciate your input. If you have identifications for any of the unidentified patterns presented in this book, please contact me through the publisher with illustrations of the pattern and the identifying mark.

Introduction

In the nineteenth century, England produced ceramic wares in great abundance for the American market. As the century progressed, many British potters, particularly in the Staffordshire district, found this ever-expanding market essential to their livelihoods. Potters were quite keen on producing wares that would be popular with their overseas customers. In fact, so important was the American export trade to many British pottery firms that they produced patterns specifically for that market, patterns never offered to consumers within the United Kingdom's own borders. As a result, the average British citizen knows very little about the Flow Blue made for export and has handled even less.

Early in the nineteenth century, following the War of 1812, England's potters produced ceramics decorated with scenes of British military defeats and American and French heroes of both the Revolution and the 1812 disputes to garner favor with their former colonial customers. In time, transfer printed patterns with soft blue halos on durable, if inexpensive, whiteware ceramic bodies were found to be quite popular in America. Once this happy discovery was made, Flow Blue ceramics were produced in large quantities by numerous potters. While British critics hissed over what they felt to be low quality abominations, sales in the 1840s were strong enough that Flow Blue would be part of the British export trade for decades to come.

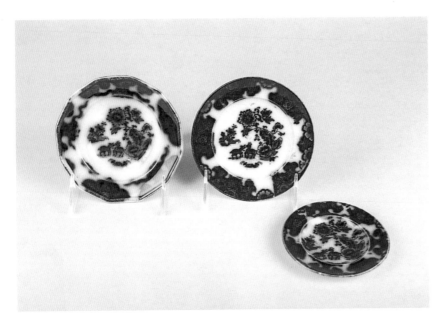

The average British citizen knows very little about the Flow Blue made for export and has handled even less. The Flow Blue CASHMERE pattern, by Ridgway & Morley (Shelton, Hanley, Staffordshire, c. 1842-1845), decorates this berry bowl, toddy plate, and cup plate. The berry bowl and toddy plate measure 5" in diameter while the cup plate measures 4" in diameter. *Courtesy of Tom and Kathy Clarke.* $250-350

While British critics hissed over what they felt to be low quality abominations, sales in the 1840s were strong enough that Flow Blue would be part of the British export trade for decades to come. TOURAINE cake plates by the Henry Alcock & Company (Ltd.) (Cobridge, Staffordshire, c. 1861-1910) and the Stanley Pottery Company Ltd. (Longton, Staffordshire, 1928-1931). Left, ribbon handle cake plate by Henry Alcock & Co.: 9 1/2" in diameter. Right, embossed tab handle cake plate by Stanley Pottery Co.: 10" in diameter. *Courtesy of James and Christine Stucko.* $275+.

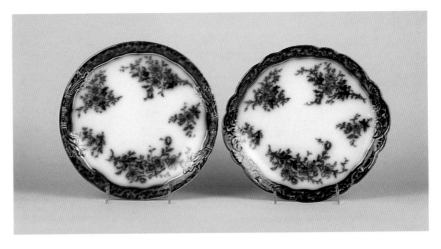

Background

If you have my previous volumes on Flow Blue, at this point you will want to skip ahead to the chapter entitled The Confounding Popularity of Flow Blue. If this is your first book on the subject, welcome and read on! What exactly is Flow Blue? Flow Blue ceramics are decorated with flowing blue transfer printed or hand painted patterns. Put succinctly, "flow blue," or "flown blue" is a decorative technique employing a chemical process that encourages a blue decoration to run during the glaze firing. This process results in a decoration with a distinctive blurred design, or a halo effect around the design. To achieve this effect, "flow powder" (consisting of a formula containing ammonium chlorine or lime) was added to the glost (glazing) oven during the glaze firing.

The extent to which a pattern would flow during the glaze firing was uncertain to the potters using this process. The results may range from a very clear printed image to a heavily flown, indecipherable image composed of amorphous blue shapes. As Herbert Minton stated in an 1848 letter, "...as respect all FB (Flown Blue) patterns, we cannot, after taking all the pains in our power, guarantee that all the pieces of the service should be exactly of the same tint and color or degree of flow. The process is an uncertain one." (Kowalsky 1999, 11)

The body upon which the Flow Blue decoration was applied was a strong white earthenware generally described as "whiteware." In its bisque state (the clay body is fired hard but unglazed), the body is white or pale gray and may be coated with a clear glaze. There are various names attached to whiteware that developed over time, as Robert Copeland explains, "In 1813, [Charles James] Mason's Ironstone was promoted; this began as a genuine stone ware, or vitreous earthenware which was very tough and hard-wearing, pale grey in color.

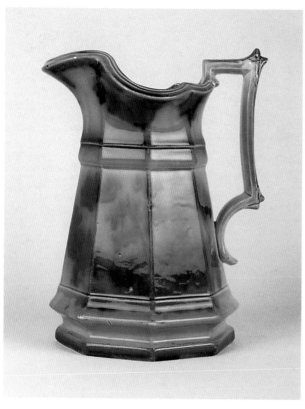

"Flow Blue" is a decorative technique employing a chemical process that encourages a blue decoration to run during the glaze firing. CHAPOO eight panel pitcher, Gothic shape, by John Wedg Wood. John Wedg Wood registered his Chapoo pattern in 1847. The pitcher measures 9 1/2" high to the lip. *Courtesy of James and Christine Stucko.* $1250-1400

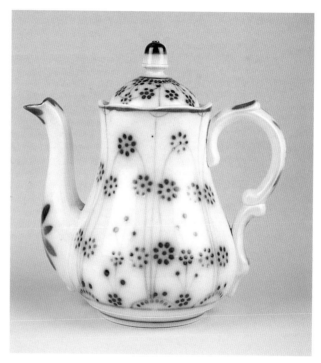

In time, European potters would join the British in the production and export of Flow Blue wares. Unidentified brush stroke pattern teapot by Utzschneider/Sarreguemines, Loraine, France. 8 1/4" high. *Courtesy of Warren and Connie Macy.* $400-500

Utzschneider/Sarreguemines, Loraine, France, c. 1790-1982, printed manufacturer's mark in use from c. 1864-1895. *Courtesy of Warren and Connie Macy.*

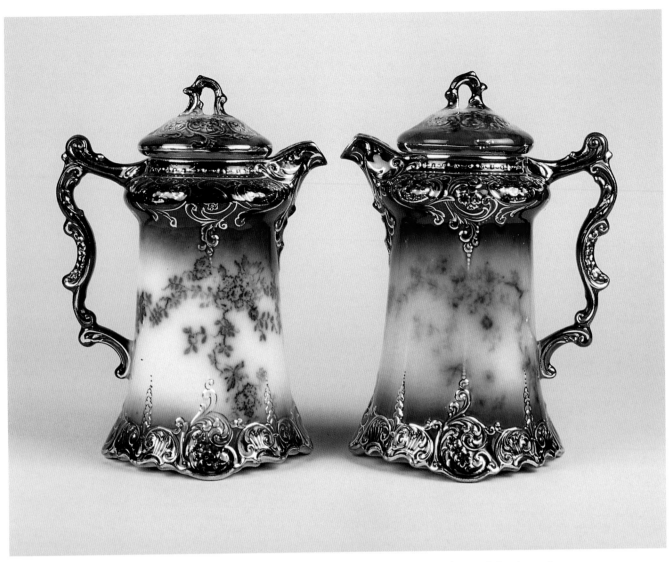

The Americans would follow suit around 1870 with production geared toward the domestic market. LA BELLE chocolate pots by the Wheeling Pottery Company, Wheeling West Virginia, , 1879-1903(10). 9 1/2" high to finial. *Courtesy of Warren and Connie Macy.* $1200-1500 each

Later, the quality deteriorated, and, although the name Ironstone was retained, the body was changed to white earthenware. By the middle of the nineteenth century many manufacturers were naming their medium (to poor) quality earthenwares, 'Ironstone'. 'Stone China', however, made by Spode, Copeland, Davenport, Wedgwood, Hicks and Meigh, and a few others remained a pale grey, good quality, vitreous product. But the terms 'Stone China', 'Opaque China', 'Semi-Porcelain', and similar euphemisms, have clouded the ceramic skies and misled many folk; they were all medium to low quality earthenware, very rarely vitreous, and certainly not china." You will find the term Ironstone and some of the other appellations on the back of Flow Blue wares among the manufacturers' marks. (Copeland 1999, 10)

From the late 1830s through the early years of the twentieth century, the majority of Flow Blue was produced for the American market. In time, European potters would join the British in the production and export of Flow Blue wares. The Americans would follow suit around 1870 with production geared toward the domestic market. Today, Flow Blue has been organized into three general periods of production: The Early Victo-

rian period, from circa 1835 to 1860; the Middle Victorian period, from the 1860s through the 1870s; and the Late Victorian period from the 1880s through the early 1900s. The term "Victorian" is used loosely, bearing in mind that the formidable English Queen Victoria did not take the throne until 1837 and ended her reign in 1901.

Most of the flown decorations were transfer prints. Transfer printing was an early mass produced decoration that allowed sets of dishes to bear the same pattern for the first time. The transfer printing technique was developed first by the Irish engineer John Brooks in the mid-1700s and refined by Sadler and Green of Liverpool, England, in 1756. The process allowed a potter to quickly duplicate a pattern, transferring it from an engraved and pigment-coated copper plate to a ceramic vessel via a specially treated paper. The printed paper was rubbed onto the surface of unfired pottery to transfer the design. The tissue was then removed and the piece was fired.

Pattern designs and themes change recognizably through each period. For printed patterns, the following general guidelines apply: in the Early Victorian period, Oriental patterns and romanticized scenic patterns were common. Familiar Oriental

scenes include the Amoy, Chapoo, Pelew, and Scinde patterns. Through the Middle Victorian period, floral patterns grew in popularity while motifs inspired by Japanese designs were introduced to the Western public. Fusions of the two occurred, combining Japanese designs with flowers, medallions, and ornate borders. Furnival's Shanghae and Hughes' Shapoo patterns are strong examples of Middle Victorian decoration. By the Late Victorian period, Japanese, Arts and Crafts and Art Nouveau designs proliferated. These were simpler, more naturalistic patterns with greater use of white space. These Late Victorian patterns are the most commonly found today. Popular patterns from this period include Conway, La Belle (American), Melbourne, Normandy, Osbourne, Touraine, and Waldorf. (Snyder 1997, 27)

Manufacturers' Marks

Transfer-printed patterns frequently included printed manufacturers' marks. These marks were usually placed on the bases of ceramic wares. Manufacturers' marks contained a firm's name, initials, symbol and location — or some combination of these. Manufacturers' marks are one of the best and easiest guides to identifying Flow Blue.

A Doulton & Co. (Ltd.) manufacturer's mark including the company's factory location in Burslem (part of England's Staffordshire potting district). The company was in business under this name from c. 1882-1955 and this mark was in use from 1891-1902. Identification for the marks found throughout this book came from Arnold & Dorothy Kowalksy's *Encyclopedia of Marks. Courtesy of Jerry and Margaret Taylor.*

However, at times histories of potteries are unavailable to help in the identification of certain marks. Some potteries used marks which have never been identified because of the short life span and limited production of the company. Additionally, many small firms saw no reason to use marks as their company name had no "name recognition value" while some large firms failed to mark certain ware types they would rather not be identified with for one reason or another.

Still, when marks are present, often the pattern name is supplied along with the mark. Be aware, however, that a few firms printed the *name* of the ceramic body or of that body's *shape* rather than the name of the *pattern* on their marks. This may cause some confusion.

This Henry Alcock & Co. mark includes the name of the pattern, "Manhattan." This mark was in use from c. 1891-1910. *Courtesy of Warren and Connie Macy.*

With England's Copyright Act of 1842, diamond-shaped registration marks were added to the backs of pottery as proof that a pattern had been registered and was not to be copied by others. Registration mark design changed slightly over time and this change will help date your patterns, even if you do not know the code used in the marks. From 1842 to 1867 a letter code designating the year of registry was located at the top of the diamond below the Roman numeral IV (a code for ceramics) and a letter in the left-hand section indicated the month. From 1868 to 1883, the year code letter was in the right hand section and the letter code for the month was at the base. In 1884, these registration marks were replaced entirely with simple registration numbers indicating the year the pattern was registered in a numeric sequence beginning with 1 in 1884. (For more information on dating and registration marks, *see* Snyder, *Flow Blue* and *Historic Flow Blue*.) (Snyder 1997, 22-23)

The Confounding Popularity of Flow Blue

There is a certain style of design known as 'Flow Blue', which has nondescript patterns, flowers, geometric designs, and occasionally landscapes, and which has nothing whatever or beauty or interest to recommend it, but which was sent over here in quantities, and of which there is still much to be found.

Of all discouragements which a china collector has to meet, the very worst is flowing blue, next comes the inevitable willow pattern, which every English potter made at one time or another, and which is as plentiful as blades of grass. It varies in colour from the fine old blue, to a tint so reddish as to be almost purple, and is shown in every degree of clearness. It is worth next to nothing, but owners of it hold it at the very highest market price.

— N. Hudson Moore, *The Old China Book,* 1903

For reasons unknown to me, after about 1840 the flood of Flow Blue patterns seems to have been prodigious, judging from the popularity of that class among collectors in the United States in the 1990s. Most Flow Blue patterns must have been cheap, or at least not expensive, low in both price and quality. Could its popularity have started when inferior ware was dumped on the American market in large quantities, and this might have led to a demand for more? Certainly America was used as a dumping ground for pottery that was either not up to standard or had gone out of fashion.

—Robert Copeland, "The Marketing of Blue and White Wares," 1998

The tremendous popularity of Flow Blue wares has remained something of a mystery for many. From its inception, ceramics decorated in flowing blue have been reviled by British critics who simply cannot understand how the ware could possibly have become so popular with their American cousins. As this has been a source of puzzlement and consternation for over one hundred and fifty years now, it seems well worth exploring. Why did Flow Blue wares sell well in the United States? What attracted consumers to these wares originally and what keeps collectors ever on the look out for the next piece today? Is it truly possible that Americans had so much cheap stuff dumped on them that they developed a taste for the second rate? Delving into the records of historians and archaeologists may provide some answers.

Ceramic History

A brief history of transfer printed wares, their production, decoration, and their distribution will set the stage for our examination of the mysterious popularity of Flow Blue ceramics.

Cobalt blue decorated porcelains had been arriving in Britain since the late seventeenth century among the teas the Dutch and British East India Companies were importing from China and Japan. The sparkling white porcelain with its hand painted cobalt blue decoration was quite popular in England, as it was throughout Western Europe. So popular and influential were these wares that the English populace developed a taste for white wares with blue decoration that was to be long lasting, whether the decoration was on porcelain or not. (Holdaway 1998, 41)

By the late 1700s, British manufacturers were supplying matching replacement pieces for owners of Chinese import porcelains who had either broken wares or whose families had gotten larger and required additional pieces. While the less well-to-do, the working middle class, were also in need of these replacement pieces, they were not able, nor willing, to afford true porcelains. Earthenwares with white bodies and blue decorations were produced to meet their demands. The British pottery industry was on the road to creating the blue and white decorated whitewares that were to become so popular.

By the 1780s, the East India Trading Company, the importer of oriental blue and white, was curtailing its operations. This company's fall was due, in part, to the monopolistic trade practices of local British merchants and to the introduction of blue and white transferwares from the Staffordshire potteries. The Spode potting family had established themselves early on as producers of blue transfer print decorated earthenwares. Josiah Spode (and his son of the same name) were soon recognized for earthenwares decorated with beautiful transfer printed patterns showing great artistic detail. Other potteries followed suit, including Rogers, Riley, Clews, Don Pottery, Minton, Davenport, Ridgway, Turner, and Wedgwood. Wares destined for a more well-to-do clientele featured well printed and finely detailed decorations. Wares destined for customers of lesser means featured transfer prints of a lower quality, with lesser detail and overall artistry.

In the 1790s, while England was engaged in war with France, the landed gentry were doing quite well for themselves. They purchased these new blue transfer printed patterns on whitewares from the busy British pottery firms for their everyday tablewares and toiletries, while reserving porcelains for their tea services. It is interesting to note (and will be more so later) that while England was at war with France during this period, less expensive French porcelains were still finding their way into the hands of British consumers. These porcelain wares were popular enough to damage the English porcelain industry, despite restrictive tariffs and war.

Early transfer printed patterns were chinoiseries emulating the decorations on the popular Chinese porcelains. Around

1790, Spode had adapted a popular Chinese design to create the enduring Willow pattern. Many other British potteries were quick to place their transfer printed spin on Chinese designs on the market as well.

Also found on early transfer printed patterns were landscapes and floral displays. Some patterns, such as Asiatic Pheasants, were produced by many potteries and were considered common property.

As the market for blue and white transfer printed wares increased, an interesting situation developed. Some of the better retailers demanded, and received, exclusive patterns that would be traded by themselves alone, within the area they served. This put a great deal of pressure on potters to come up with a wide variety of patterns for their wares. In turn, ceramics

were overproduced during the first half of the nineteenth century, leading to serious competition and price reductions. For firms that were not bankrupted by this situation, quality was reduced to keep prices within a competitive range.

It is hypothesized that with the lowering of standards, a combination of less well produced transfer printed designs, a lower quality cobalt color, and possibly too heavy a coating of glaze lead to the birth of Flow Blue. These traits together would create the blurring effect familiar to Flow Blue. Found to be popular in the American market, the flow was then accentuated by the development and use of a mixture called "flow powder," designed to induce the flowing of the cobalt. In the rush to meet the demands of the pottery market place, Flow Blue was born.

A combination of less well produced transfer printed designs, a lower quality cobalt color, and possibly too heavy a coating of glaze lead to the birth of Flow Blue. This early polychrome decoration shows evidence of a natural flow in the design, a flowing effect not enhanced by the addition of "flow powder." The vase is in the Charles James Mason style (Mason's ware) and is marked "New Stone" on the base. This impressive vase dates from c. 1820 and measures 22" high x 8" in diameter at the mouth. *Courtesy of Tom and Kathy Clarke.* $2000+

When it came to transfer printed earthenwares, British potters found the North American export market to be vital to their continued success in the trade. American customers purchased between forty and fifty percent of the wares exported annually from England's Staffordshire potteries from the end of the War of 1812 up to the American Civil War! It's little wonder many British pottery firms worked so hard to produce wares for the American market. (Copeland 1998, 16-17; Copeland 1999, 10)

The Staffordshire potteries were, in fact, well positioned to take advantage of the American demand for British goods. From the 1820s, raw cotton was the major American export to England. The cotton laden American ships arrived at the Port of Liverpool as it was closest to the Lancashire textile industry. As it so happened, the Staffordshire potting district was also close to the Liverpool port—closer than other English pottery centers in fact—and was able to easily and economically take advantage of those empty American ships.

While the Staffordshire potteries were well placed to sell in the American market, they were not without competition. Continental firms and the growing American china trade (American clipper ships were bringing Chinese wares directly to American shores) vied for the attention of American consumers. Following the Revolutionary War, China began supplying porcelain directly to American merchants. French china was also available to American consumers. Beginning in around 1810, French china became widely available on the East Coast and was firmly established by the 1830s. While French china had long been favored among American diplomats, it came to be the china of choice for many East Coast consumers around the 1830s and 1840s. While the British potteries made fine china of their own, the American consumer admired the French style and preferred the porcelains of France for formal occasions. (Ewins 1997, 10, 26)

It would not be until after the American Centennial Exhibition of 1876 that American potteries would begin to compete at all with their English counterparts and not until near the dawning of the twentieth century that American wares would be accepted in large quantities by the buying public or the merchants that sold to them. American firms had difficulty competing with the lower labor and production costs, and consequently the lower final ware prices, of the long established English firms. Nor could they easily sway consumers from the prejudice that England produced better pottery. After several hundred years of colonial rule where English ceramics had the upper hand and American potters were relegated to providing simple, utilitarian earthenwares, American potteries had their work cut out for them.

Despite the competition, Staffordshire potters producing their transfer printed whitewares were selling crockery in abundance to American consumers. During the early years of the nineteenth century American trade, Staffordshire potters sold their wares to importers. As time wore on, some British potters arrived upon American shores to peddle their wares.

However, most potters either sold directly to retailers with buying agents in England or employed agents themselves. The well settled East Coast market purchased pottery of good quality while the expanding inland markets were unable to purchase anything above inexpensive pottery for many years. As the nation grew, this trend would repeat it self time and again. Established areas purchased better quality wares while the developing regions pushing back the frontier spent what they had on more basic needs and functional wares. Among the popular wares, particularly of the 1840s and 1850s, from Staffordshire were the Flow Blue ceramics. With their many forms—there was Flow Blue for use in every room of the house if you wanted it—durable earthenware bodies in a variety of styles, numerous patterns, and affordable prices, Flow Blue would continue to sell to some portion of the American market on into the early years of the twentieth century.

It would not be until after the American Centennial Exhibition of 1876 that American potteries would begin to compete at all with their English counterparts. An impressive LA BELLE Admiral Dewey jardiniere and stand by the Wheeling Pottery Company of Wheeling, West Virginia. This piece was offered in the company's 1906 catalog for $75. 36" high together from the stand base to the top of the jardiniere handle. *Courtesy of Tom and Kathy Clarke.* $14,000+

In Defense of the Common

Why would Flow Blue have possibly attracted the attentions of consumers in the United States when they were so blatantly disparaged as "common" by consumers and critics on the other side of the Atlantic?

Returning to England's shores, from whence Flow Blue first emerged, may provide clues to solving this puzzle. Taking a look at why post-1835 blue and white transfer printed wares continued to sell in England will help illustrate why Flow Blue remained popular in America.

After 1835, those people rising in wealth and position put aside transfer printed earthenwares in favor of bone china. The demand for blue printed wares dropped, precipitating a lowering of both price and quality in the wares to reach new customers with less buying power for whom bone china was out of reach. The copper plates upon which the designs were first etched were kept in use longer than previously and were sold to lesser firms when they were worn.

Less expensive and time consuming methods were developed to engrave the patterns on the copperplates. Stippling (which created fine shadows and depth) over large areas of the pattern was replaced with either line engraving or acid etching techniques. Line engraving itself was made bolder and thicker with an increase in the line spacing. While all of this created patterns that were less varied and more pale, these steps reduced wear on the copperplates, lowered inking time, and provided the potteries with savings on engravers' salaries. Still, engravers with a fine artist's touch were sought.

By the 1840s, transfer printed designs were changing, reflecting changes both in artistic influences and market realities. Patterns covering the entire surface of an object were being left behind in favor of patterns that left larger areas open and free of decoration. As larger surface areas were left white, central patterns were diminished in size. It was not considered necessary for the central image to cover the entire plate well and extend to the border any more. This proved to be an economical move as smaller designs could be used on a wider variety of shapes, reducing the need for artisans to prepare individual copperplates for the various shapes and sizes.

By way of patterns themselves, in the 1840s scenic views were still popular. By the 1850s, naturalistic floral displays and plants captured the public interest while the 1860s saw a preference for small roundels—scattered flower sprays—in the centers of wares or centers altogether devoid of decoration. When central decoration was absent, broad bands of border stringing were used instead. At times, some geometric shape was placed in an otherwise empty center.

Border styles were changing as well. Prior to the 1830s, the vast majority of borders were adaptations of the motifs featured on Chinese porcelains. Also popular had been borders featuring tightly grouped floral motifs. These floral arrangements were at times embellished with medallions featuring miniatures scenes or fruit. During the 1830s, floral borders loosened up a bit, taking on a Rococo styling at times. The inner border was used as a frame for the inner pattern as well.

In the 1840s, borders featured large plants or flowers commingling with Rococo scrolls. These ornate borders tended to overflow the rims and extend downward toward the center of the dish. Geometric borders were also popular, along with wide bands of either floral or geometric designs, alternating with sizable cartouches within which several different patterns might be found. Such stylistic variations may also be seen in Flow Blue pieces. (Pulver 1998, 48-51)

For many, blue transfer printed wares after 1835 were most attractive. They made a good appearance on the table and were sturdy enough to withstand years of regular service. Predominantly useful, these common, practical wares were used not only at the table and in the kitchen, but throughout the house. The variety of designs and forms enabled these wares to be decorative as well as functional.

Blue and white transfer printed wares included dinnerwares, tea services, kitchenwares and dessert services, footbaths, toiletries, desk accessories, vases, and garden seats. In England, blue and white transfer printed wares served the needs of the middle class British families and did it with respectable style.

Of the toiletries, shaving mugs were all the rage in the second half of the nineteenth century. Many Flow Blue shaving mugs may be found today to attest to the popularity of such mugs in America. As American collectors know, Flow Blue was produced in the same wide variety of attractive yet eminently practical wares. So, while critics dismissed Flow Blue as common, Flow Blue wares capably provided for the needs of an average middle class American family. (Otto 1998, 46-47)

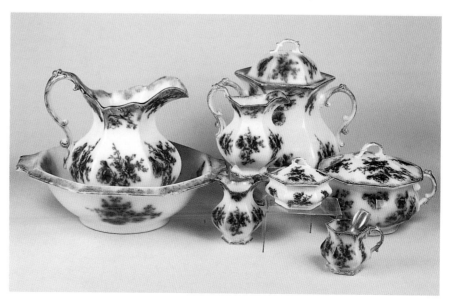

DOREEN toilet set by W. H. Grindley & Co. Pitcher and basin, small pitcher, toothbrush holder, covered soap dish, chamber pot, shaving mug, master slop jar. Slop jar: 15" high. Pitcher: 10 1/4" to lip. *Courtesy of Jerry and Margaret Taylor.* $3200-3500 set

American **Market**
American **Expansion**
American **Taste**

How did Flow Blue last long enough for European and American potters to produce wares of their own during the last quarter of the nineteenth century?

The Social Order

The developing, mobile American society held the keys to both Flow Blue's initial popularity and its continued growth over the decades. Prior to the 1830s, Continental Europe was Britain's largest ceramics export market. By the mid-1830s, the situation had changed and America had taken over the role. With the rapid expansion of the United States, the market continued to grow throughout the nineteenth century. By the mid-nineteenth century, the American population would exceed that of Great Britain. However, it was far from being a stable market. Product demands would fluctuate as economic depressions or war swept the nation. The ceramic needs of the growing nation would also change over time as the economy switched from that of the largely agrarian, rural society preferred by Thomas Jefferson of the early nineteenth century to the mostly urban communities of the later years of the Victorian age.

The establishment of more all-pervasive transportation systems effected England's ceramic trade with America as well. In the early years of the nineteenth century, the waterways provided most of the access to American markets. These markets were located mainly along the eastern seaboard and would extend into the Great Lakes region. As the century progressed, railways and canal systems allowed British ceramics to reach further inland. As transport improved, towns and cities developed within the nation's interior. These established hubs of commerce all demanded their share of British pottery as well. Dealers in British ceramics from the developing cities of the expanding western market in the United States began either coming east themselves to place orders or sent them east to be filled by mid-century. In fact, the bulk of British ceramics manufacturer John Wedg Wood's business with the United States could be seen to move west with the expanding nation.

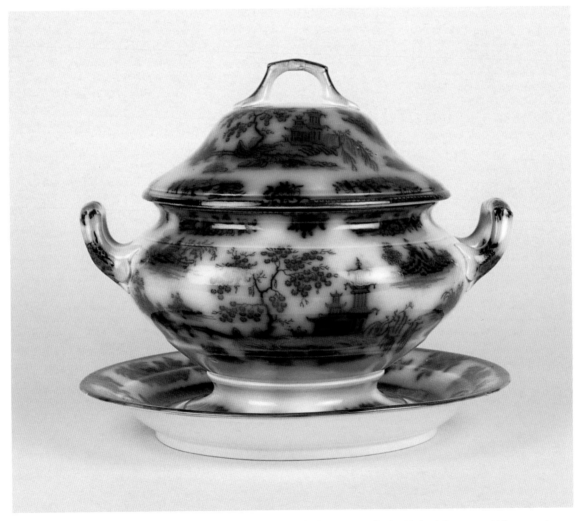

The bulk of British ceramics manufacturer John Wedg Wood's business with the United States could be seen to move west with the expanding nation. CHAPOO chowder style soup tureen with undertray by John Wedg Wood, dating from the late 1840s. Undertray: 13 1/4" in diameter. Tureen: 10 1/4" high x 12 3/4" handle to handle. *Courtesy of James and Christine Stucko.* $6000-7000

The Industrial Revolution altered the American lifestyle. Over the century, much of the labor force left the farms and rural life in which both men and women worked at home together; a society which did not have a great deal of social or class stratification. As the century progressed, ever larger portions of the population moved to cities and industrial centers. There labor was distinctly divided; at first the men left home for work and the married women stayed home to tend to the household and the children. As the urban landscape developed, people were increasingly differentiated by class. In the urban situation, householders felt a much greater need to display their wealth to their peers to establish and maintain their place in the newly stratified social order. A middle class with money to spend developed, a middle class intent on climbing the social and economic ladder to wealth. Part of that climb depended on broadcasting your success, and hence your business savvy, to your peers and your betters in social situations. (Ewins 1997, 5, 18, 38, 56; Klein 1991, 79)

As this shift in lifestyle and thinking became more pervasive in American society, households of most levels began investing greater proportions of their resources in consumer goods. Spending on domestic goods increased rapidly, particularly as job opportunities developed for women, vastly increasing the purchasing power of the family. As women in the urban landscape were considered to be in charge of the home front (whether they worked outside the home or not), a greater percentage of the domestic wares purchased reflected feminine interests.

As the urban social landscape became more stratified and complex, virtually every facet of Victorian life became more complicated as well. Meal time was not excluded. Entire manuals were written on proper etiquette at the dining table, whether the meal was a family affair or a vast formal dinner thrown to impress friends and those you wished to have as friends and business partners. Tableware became much more elaborate in form and decoration as society moved away from the rural and toward the urban. This was reflected in the decorative styles, the amount of decoration employed, the relative cost of vessels used, and in the use of contrasting dinnerware sets within a single household. During the nineteenth century, meals came to be seen as times for women to affirm the family's moral values through civilized, ritualized dining. Among the middle and upper classes in America's growing cities and towns, meals came to symbolize social order itself.

More complex and diverse ceramic forms in an array of decorations were first purchased by nineteenth century women of the upper economic and social class, followed in time by the middle and lower classes as the century progressed. Also, these changes occurred first within the urban households which had the most ready access to a vast array of goods and a more stratified social organization, and would only later begin to effect the more rural families. Rural communities had less disposable income, a less formal society that was far more likely to judge a family by their abilities to run a farm competently than by the wealth they displayed, and less direct access to whatever wares were currently the rage among their cousins in the big city.

During the first half of the nineteenth century, teawares and tablewares were purchased separately. According to archaeologist George Miller, archaeological evidence suggests that families purchased teawares that were significantly more expensive than their tablewares. These teawares were sold in sets while tablewares were sold by their individual pieces or vessel forms. As transfer printed wares lowered in price, the availability of matched tableware sets increased; however, truly large table settings would not become common until the end of the nineteenth century. (Klein 1991, 79-81)

The Wares Themselves and The Demand For Them

In the 1830s, as the American population grew and cities began to become more established, there was a distinct increase in the quantities of printed and painted wares (including less expensive varieties of chinawares), leaving Staffordshire for America's shores. Affordability was key to Staffordshire's success in the American market. As we have seen, with American's preference for French china, elite Staffordshire potters had little success selling their expensive, refined wares in the United States. This disinclination to purchase fine Staffordshire porcelains in styles attractive to the English eye could certainly have lead to the distinct impression amongst Staffordshire's potters that Americans had poor taste ... and were penurious as well!

By the 1840s, the disparity in wealth between the established and accessible East Coast and the expanding and rugged interior of the nation was obvious to foreign travelers and merchants alike. However, the shift from a rural agrarian work force to a centralized urban industrialized labor pool was well under way. A variety of styles and decorative motifs made inroads in the American market. (Ewins 1997, 18, 23, 38, 43)

In the 1840s, the desired Staffordshire wares were no longer merely plain and useful. In the 1840s, Flow Blue wares were sent out in very large quantities and a variety of forms to the United States. Middle class urban American consumers of the mid-nineteenth century, now filled with ideas of the virtues of formal dining, found Flow Blue wares had a style and decoration adequate to meet the requirements for fine dining set out by etiquette books of the day. Reasonably priced and suitable in decoration, Flow Blue was popular with those who wished to make a good impression without facing bankruptcy. Not only that, but the ironstone wares upon which Flow Blue appeared were durable enough to survive the rigors of daily use when not called into duty for those formal dinners. This author would venture to guess that some of the more basic table and tea wares in Flow Blue saw double duty, serving meals on both formal and familial occasions in at least some middle class homes. Kitchenwares, among other useful items decorated in Flow Blue, no doubt also came into regular and repeated service. What Staffordshire porcelain had been making its way into the American market up to this point suffered a distinct drop in sales in favor of Staffordshire's durable earthenwares.

In the 1850s, Staffordshire potters found they must consider "American taste" to sell their wares successfully, a taste considered to be distinctly different from their own. Speaking of Joseph Clementson's wares in the Great Exhibition of 1851 in London, the *Staffordshire Advertiser* came to grips with the issue of American taste, "The taste of our transatlantic friends leads them to select patterns which would not meet with general approval in this Country." The *Advertiser* had hopes for Americans though, "It has been Mr. Clementson's aim to culti-

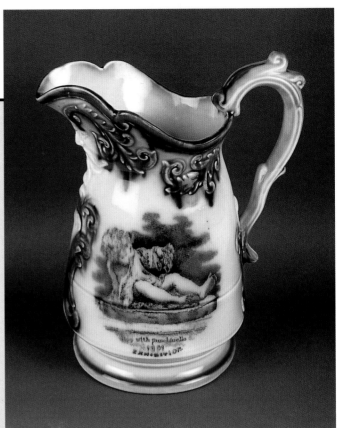

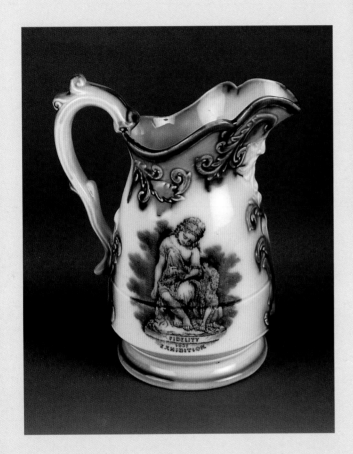

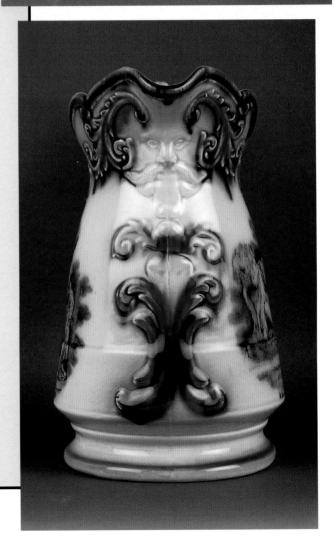

A pitcher from the London Exposition of 1851 with a face at spout. No manufacturer's mark was applied to this piece and its maker remains a mystery. 8" high. *Courtesy of James and Christine Stucko.* $850-950

vate and improve taste among his customers, by generally furnishing a better class of design without directly running counter to their notions, and in many instances he has succeeded admirably." However, Staffordshire's potters found out that crossing the line, ignoring American sensibilities in favor of British style, was likely to lead to unsalable wares—a costly mistake. (Ewins 1997, 44-45)

Of course, taste can be such a fickle thing as it is effected by so many divergent influences. For instance, early in the nineteenth century, the wife of Virginia planter and politician Richard Bland Lee was having problems with some of her Staffordshire pottery. The well-to-do and prominent Lees endeavored to maintain a stylish Philadelphia look to their plantation home. Mrs. Lee had chosen perfectly adequate and popular Staffordshire green feather edged dinnerwares and serving pieces for her family's table. However, in time Mrs. Lee was forced to replace these wares with something of a different decoration. It seems the household slaves considered the green edged wares to be unsuitable for the prestigious plantation home and broke them on a regular basis. In the 1970s, when the Lee plantation house was renovated to serve as a museum, a set of green feather edged plates was found hidden in the attic, each plate cracked right down the middle. No Staffordshire potter would ever have considered the sensibilities of American slaves when determining which wares to market in America.

By the mid-nineteenth century, Americans were finding they had a distinct preference for the white graniteware Staffordshire was offering. Still, Flow Blue would continue to find a place in the American market among different consumer groups on into the early twentieth century.

Staffordshire potters of the mid-nineteenth century had to face the realization they were not to be competitive in high end ceramic wares in the American market. Staffordshire potters turned more completely to the production of less expensive and eminently durable wares.

In the 1870s, Staffordshire potters were aggravated with a decline in orders from their American customers. Sales were down and they blamed the losses on additional competition coming from the upstart American potters. It appears American firms were beginning to make inroads among American customers for the inexpensive undecorated wares that had sold so well for the Staffordshire potters. As a result, Staffordshire potteries attempted to convince their American clientele that plain wares were passé and decorated wares had now returned to fashion. American firms were producing very little decorated ware and the ploy apparently worked. Exports from Staffordshire to America rose in the 1880s.

As the 1870s passed into the 1880s, American inland regions became ever more accessible with improved transportation systems. Established cities along the East Coast and into the interior were now recognized commercial hubs. This translated into an American market with a much more sophisticated "taste." More Americans were becoming increasingly affluent, and consequently were seeking higher end ce-

ramics from the Staffordshire potters. Ornamental wares in majolica and parian ware were in demand, ranging from vases and jardinieres to figurines. Also, the Franco-Prussian war and the collapse of the French Second Empire in 1870 was making the desired French china more difficult to procure. While Americans still preferred both Continental and Chinese porcelains, Staffordshire china was making some advances. (Ewins 1997, 33, 34)

In the later years of the nineteenth century, the heavy graniteware being sold was produced with lighter bodies and more ornamental wares. Flow Blue wares with heavier bodies from years past were also replaced with the preferred thinner bodied wares. Preferences developed for Flow Blue with a much less prominent flowing effect as well. According to the archaeologists, during this period for the first time Americans were amassing large, complete table services. Once again, the more economical, yet adequate Flow Blue would be in favor with some middle or working class families intent on keeping up with social trends but unable to spring for more expensive complete settings. (Kowalsky 1999, 11; Klein 1991, 81)

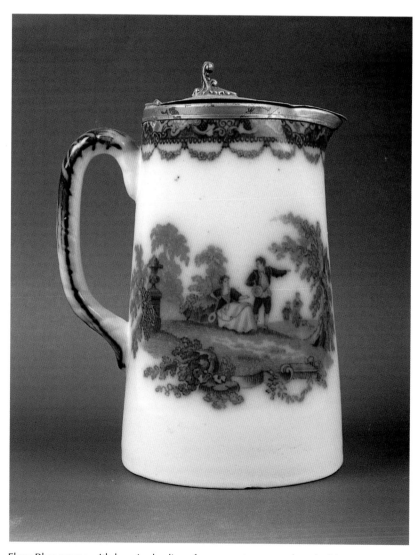

Flow Blue wares with heavier bodies of years past were replaced with preferred thinner bodied wares. Preferences developed for Flow Blue with a much less prominent flowing effect as well. WATTEAU syrup pitcher by Doulton & Co., produced during the Late Victorian period. 5 3/4" high. *Courtesy of Jerry and Margaret Taylor.* $350-400

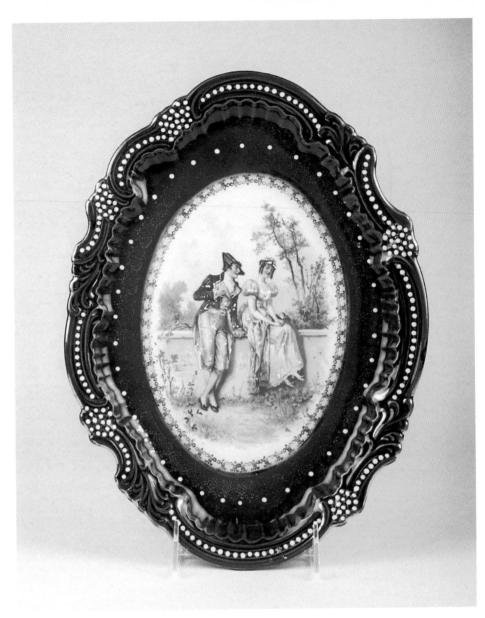

LA BELLE portrait plaque by the Wheeling Pottery Company, Wheeling, West Virginia. 10 3/4" in length. *Courtesy of Warren and Connie Macy.* $300-350

As the nineteenth century passed into the twentieth, new styles gained ascendancy in America and American pottery firms also found their place in the market. Several American firms, including the Wheeling Pottery Company of Wheeling, West Virginia, began producing Flow Blue in abundance. As department stores such as Sears & Roebuck, Montgomery Wards, and others developed, along with home delivery services, American potters, and their British counterparts, gained ever better access to more of the American market. However, with changing fashions and mounting economic pressures, Flow Blue was left behind in the early twentieth century for other wares.

In the end, Flow Blue reliably met the needs of the expanding American middle class for tablewares of an adequate style to serve on formal occasions without embarrassing the host. Over time, as growing numbers of people rose into the working middle class and aspired for wares with a touch of style, Flow Blue was there. While the decoration may not have kept up with British standards for design or current artistic trend, it stayed current enough to serve the needs of those Americans who purchased it.

No doubt part of the reason for the long life of Flow Blue in America was tied with the fact that the nation was expanding and developing throughout the nineteenth century. As new communities in the interior grew into well connected, stable commercial hubs, economical Flow Blue would find new markets among the newest members of the middle class by moving westward. This most certainly kept Flow Blue in circulation longer than it might have been had the ware been introduced into a single, stable, developed market.

Today collectors are attracted to this popular Victorian era dinnerware and kitchenware. It is available in abundance, attesting to its one time popularity. Having lasted so long in the American marketplace, Flow Blue has a wide range of decorative styles and body shapes. Further, prices today range from the tens to the thousands of dollars, depending on the wares being sought. Really, for collectors today, Flow Blue has something for everyone ... a state of affairs not all that different from when the wares were put to use the first time around.

Flow Blue Wares: A Comparison of the Early and the Late/the British and the American Through Four Popular Patterns

What follows is a closer look at four very popular patterns in Flow Blue. Wares adorned with the Cashmere and Chapoo patterns date from the early Victorian period, from circa 1835 to 1860, while the La Belle and Touraine patterns were produced during the Late Victorian period, from the 1880s through the early 1900s. The wares decorated in Cashmere, Chapoo and Touraine patterns were produced by English potters; the La Belle ceramics were produced by an American firm. Photographs have been provided for a wide range of the wares in each pattern and it is interesting the note the differences in design between the early and late Victorian wares. While not every piece produced is provided here, the reader will quickly get a feel for the diverse wares used during the Victorian age.

The photographs are organized as follows: each pattern has its own subheading followed immediately by a listing of the pottery firms whose wares are represented in that section. Each firm's manufacturer's marks will also be displayed in this brief introduction. The marks are identified by the pottery firm, the firm's location, the years that firm was in business and the years during which that mark was in use. The order does not change. Registry dates are given last when they are present with the mark.

As for the wares themselves, tablewares are presented first. Plates and platters (along with other flatware forms) initially provide the reader the best possible view of the pattern. These are followed by the hollow form tablewares, tea sets, and serving pieces. Following the tablewares are dessert sets, tea, coffee, and chocolate services, punch sets, wash sets, and additional wares found around the house or in the garden.

Early Victorian Wares in the Cashmere and Chapoo Patterns

Cashmere

Most of the items displayed here decorated in the Cashmere pattern were produced by the pottery firm Ridgway & Morley of Shelton and Hanley in England's Staffordshire potting district from c. 1842-1845. On the rare occasions that a Cashmere piece represented is from another pottery, it is noted in the captions.

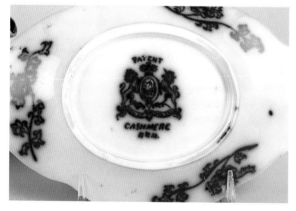

Ridgway & Morley, Shelton, Hanley, Staffordshire, c. 1842-1845, printed manufacturer's mark in use from c. 1842-1845, and Cashmere pattern name. *Courtesy of Tom and Kathy Clarke.*

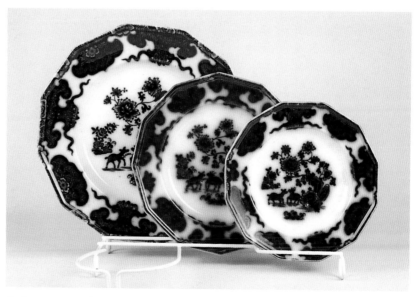

CASHMERE paneled plates. 10 1/2", 8 1/4", 7 1/8" in diameter. *Courtesy of Don Iverson.* $200-275+ (value increases with size)

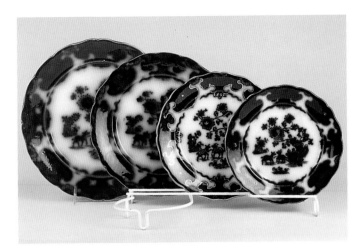

CASHMERE plates with scalloped edges. 10 1/2" in diameter, 9" in diameter, 7 3/4" in diameter, 7" in diameter. *Courtesy of Tom and Kathy Clarke.* $200-275 (value increases with size)

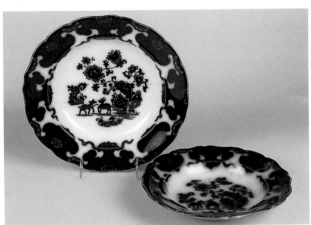

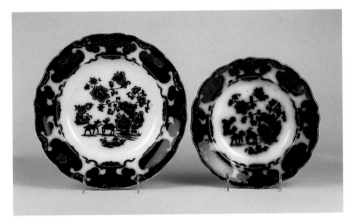

CASHMERE soup bowls. 10 1/2" & 9" in diameter. *Courtesy of Tom and Kathy Clarke.* $250+ each

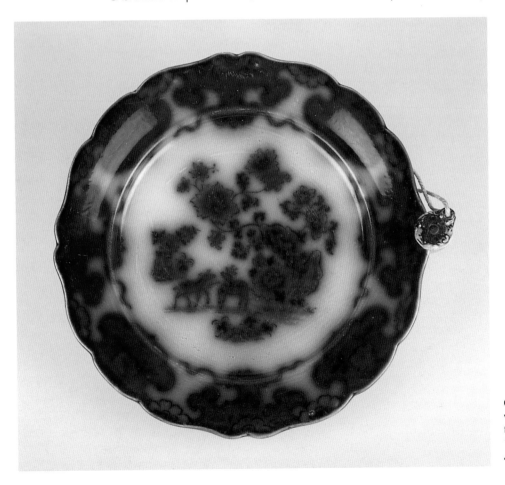

CASHMERE hot water plate, complete with *an original* ceramic cover (cork lined to keep it covering the water spout). 10 3/8" in diameter. *Courtesy of Tom and Kathy Clarke.* $3000+

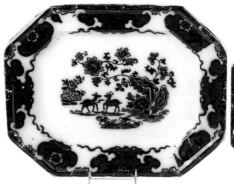

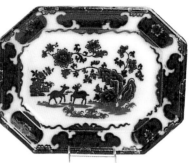

CASHMERE paneled platters. 17 1/2"
in length & 15" in length. *Courtesy
of Don Iverson.* $1500+

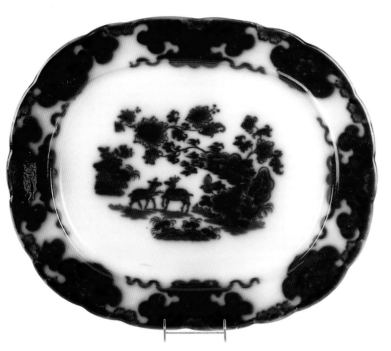

CASHMERE platter. 22 1/2" in length.
Courtesy of Don Iverson. $3500+

CASHMERE eight sided platter. 15" in length.
Courtesy of James and Christine Stucko. $650-750

CASHMERE platter. 21" in length. *Courtesy
of Tom and Kathy Clarke.* $2500+

CASHMERE platter. 19 1/4"
in length. *Courtesy of Tom
and Kathy Clarke.* $2000+

CASHMERE platter with
drain. Platter, 17" in length.
Drainer, 12 1/2" in length.
*Courtesy of Tom and Kathy
Clarke.* Platter: $1700+.
Drainer: $2000+

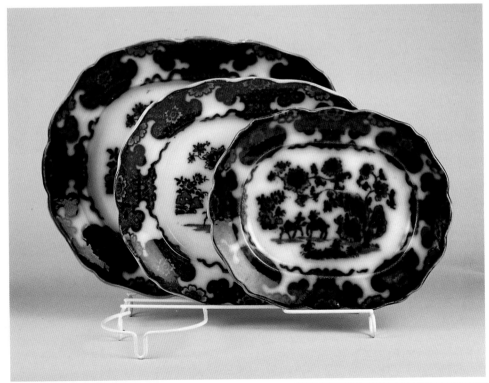

CASHMERE platters in
three sizes. 15", 12 3/4" &
10 3/4" in length. *Courtesy
of Tom and Kathy Clarke.*
$1100-1500 (value
increases with size)

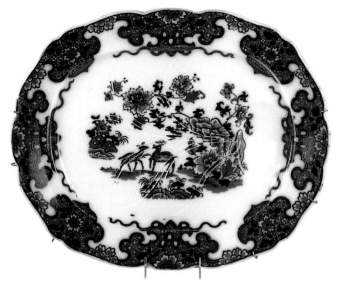

William Ridgway & Co., Shelton, Hanley, Staffordshire, c. 1830-1854, impressed manufacturers mark in use from c. 1830-1854. *Courtesy of Tom and Kathy Clarke.*

CASHMERE well and tree platter by William Ridgway & Co. 21 1/4" in length. *Courtesy of Tom and Kathy Clarke.* $5000+

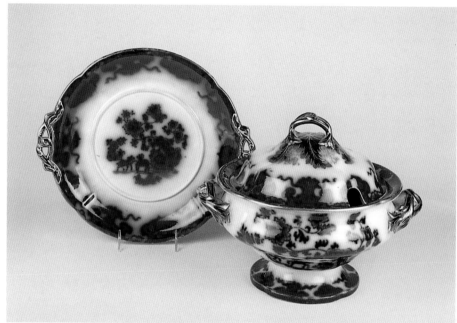

CASHMERE soup tureen with undertray. Tureen: 10 1/8" high x 11" in diameter. Undertray: 14 1/8" in diameter to handles. *Courtesy of Tom and Kathy Clarke.* $8000+

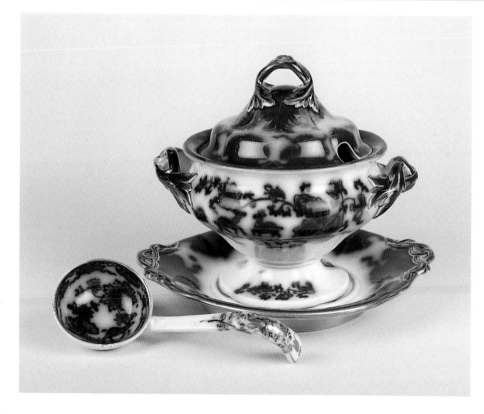

CASHMERE sauce tureen. Tureen: 6 1/4" high. Undertray: 8 3/8" in diameter. Ladle (rare): 6 1/2" in length. *Courtesy of Tom and Kathy Clarke.* Tureen: $1500+. Undertray: $400+. Rare ladle: $2500+

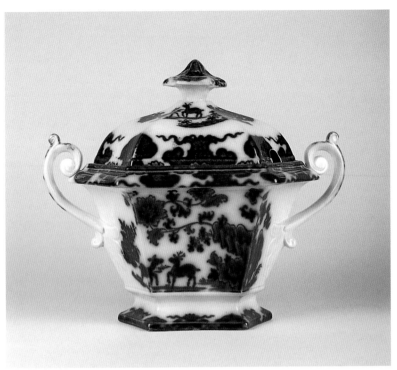

CASHMERE soup tureen, broad shouldered. 15 1/2" in length, 12" high to finial. *Courtesy of James and Christine Stucko.* $5000-5500

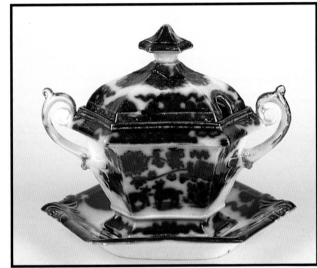

CASHMERE broad shouldered sauce tureen with undertray. Undertray: 8 1/2" in length. Sauce tureen: 6 1/2" to finial. *Courtesy of James and Christine Stucko.* $1900+

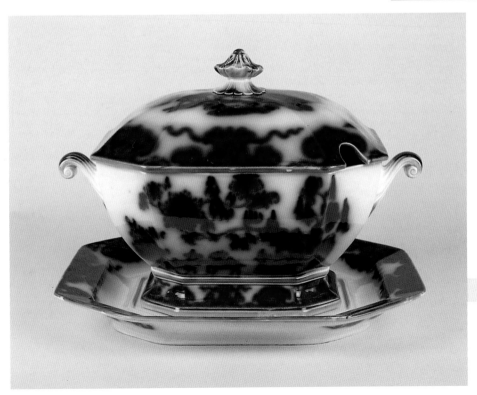

CASHMERE soup tureen with undertray. Undertray: 14 3/8" in length. Tureen: 10" high x 14 1/2" handle to handle. *Courtesy of Don Iverson.* $7500+

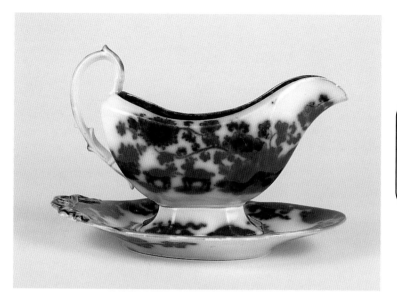

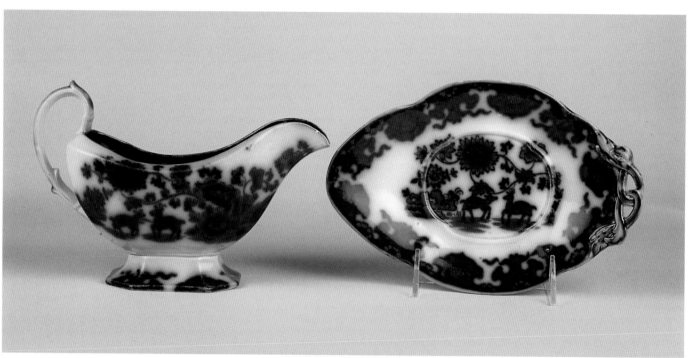

Left and below:
CASHMERE gravy boat and undertray. Gravy boat: 3 3/4" high to spout, 8 1/4" in length handle to spout. Undertray: 8 1/2" high. *Courtesy of Tom and Kathy Clarke.* Gravy boat: $1500+. Undertray: $500+

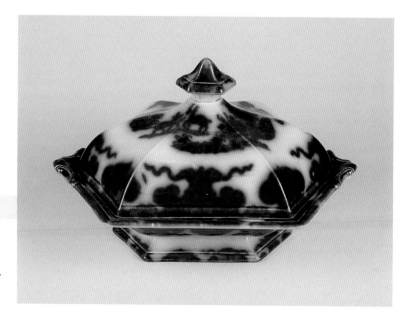

CASHMERE covered vegetable, six sided. 7 3/8" high x 12 1/8" in length. *Courtesy of Tom and Kathy Clarke.* $2000+

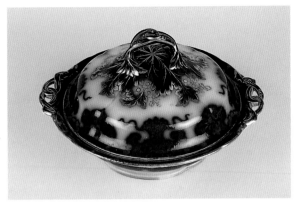

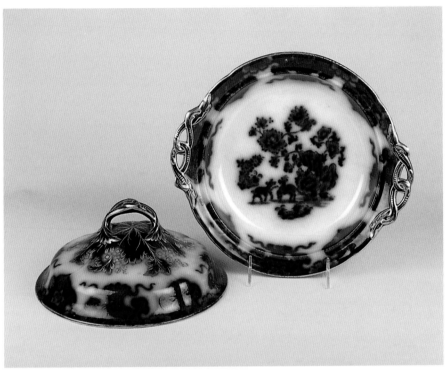

Left and below:
CASHMERE round covered vegetable. 6 1/2"
high x 11 3/8" in length. *Courtesy of Tom and
Kathy Clarke.* $2500+

Below:
CASHMERE open vegetable bowls. 11",
9 3/4", 8 1/2", 6 1/2" in diameter.
Courtesy of Tom and Kathy Clarke.
$750-1100+ (value increases with size)

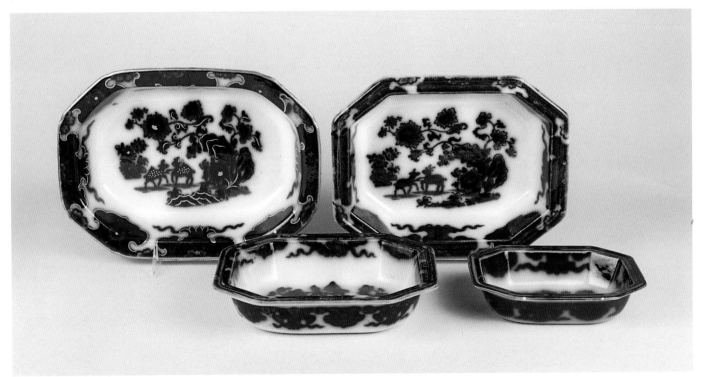

CASHMERE covered butter dish. 4 1/8" high x 8" wide. *Courtesy of Tom and Kathy Clarke.* $2000+

CASHMERE relish dish by Minton. 8 1/2" in length. *Courtesy of Tom and Kathy Clarke.* $800+

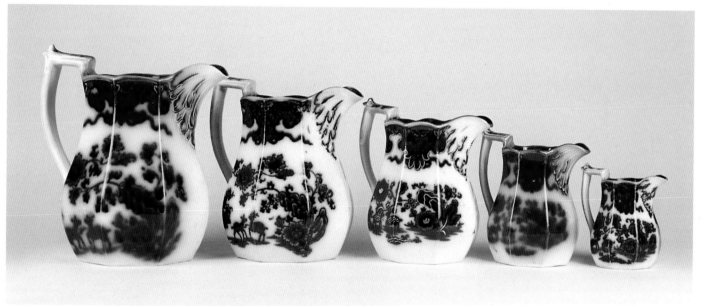

CASHMERE pitchers. 8 1/2", 7 1/2", 6 1/4", 5 1/4", 4" high. *Courtesy of Tom and Kathy Clarke.* Left to right: $2500+, $2000+, 1700+, 1300+, 1000+

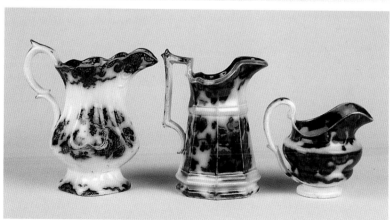

Three CASHMERE small pitchers in different forms. 5 1/4", 5 1/4", 3" high. *Courtesy of Tom and Kathy Clarke.* Left to right: $1000+, $1000+, 1300+

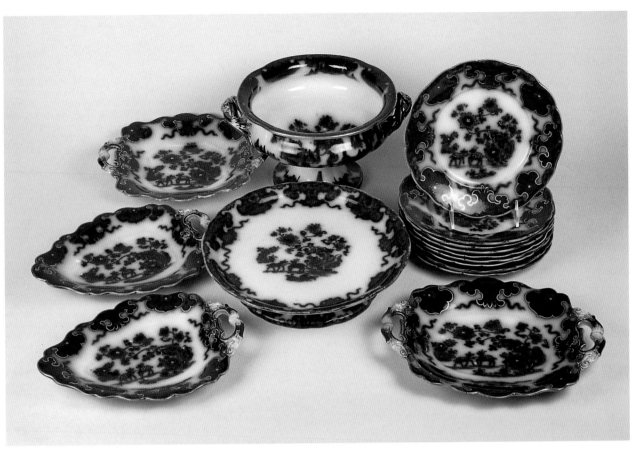

CASHMERE dessert service. Plates: 9" in diameter. Tazza: 11" x 8". Reticulated cake plate: 11 3/4" x 9 1/4".
Reticulated cake plate: 11" x 10". Pedestaled compote: 6 1/4" high x 9 5/8" in diameter. Pedestaled cake plate:
11 7/8" in diameter. *Courtesy of Tom and Kathy Clarke; Courtesy of Don Iverson.* $17,600+ set

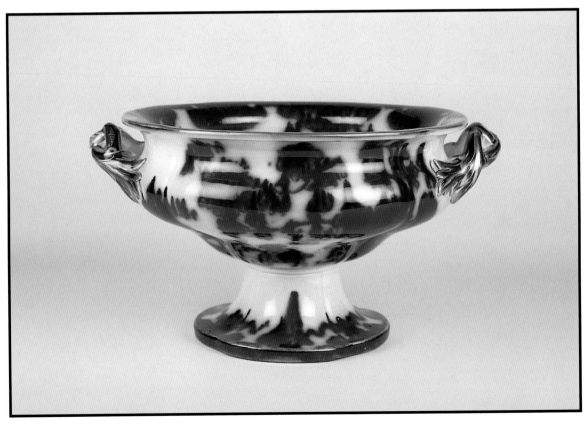

CASHMERE pedestal compote. 6 1/4" high x 9 5/8" in diameter. *Courtesy of Tom and Kathy Clarke.* $4000+

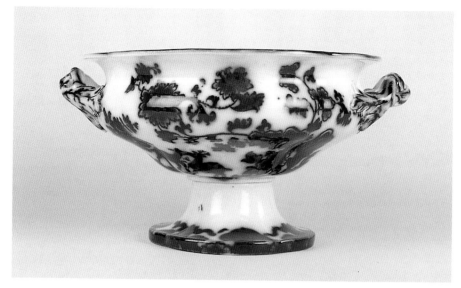

CASHMERE compote with twig handles. 12 1/2″ in length x 6 1/2″ high. *Courtesy of James and Christine Stucko.* $4500-5000

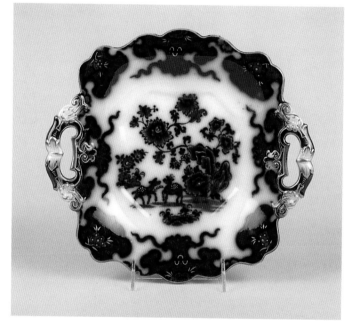

CASHMERE cake plate with reticulated handles. 11″ handle to handle. *Courtesy of Tom and Kathy Clarke.* $1800+

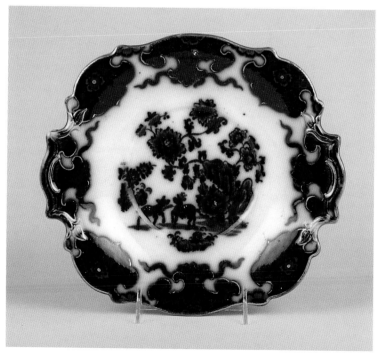

CASHMERE cake plate. 10 1/2″ handle to handle. *Courtesy of Tom and Kathy Clarke.* $1200+

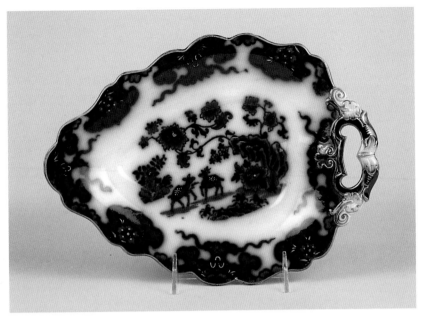

CASHMERE tazza dessert plate. 11″ in length.
Courtesy of Tom and Kathy Clarke. $1500+

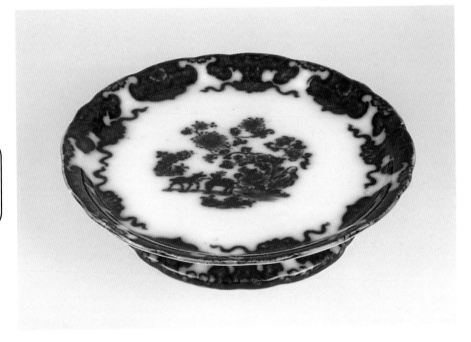

Right and below:
CASHMERE cake plate (pedestaled).
11 7/8″ in diameter. *Courtesy of Tom and Kathy Clarke.* $4000+

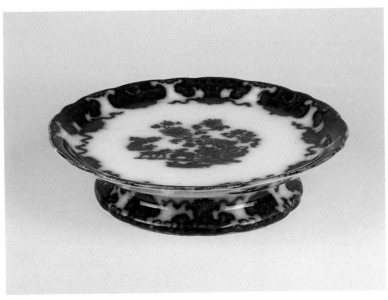

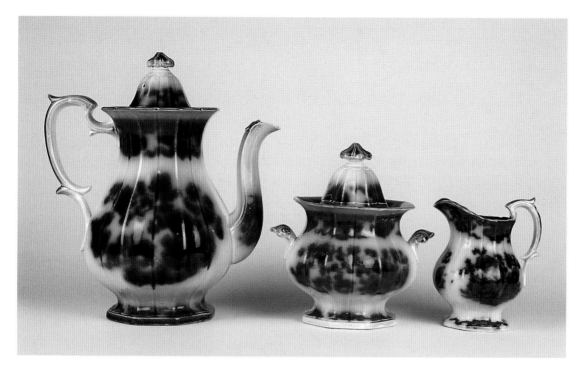

CASHMERE tea set. Teapot: 10 3/4″ high. Sugar: 7 3/8″ high x 4 7/8″ in diameter. *Courtesy of Tom and Kathy Clarke.* Teapot: $2300+. Sugar: $1000+.

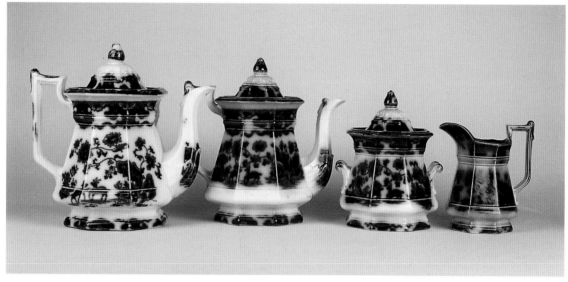

CASHMERE tea set. Two teapots sizes are shown. Teapot: 9 1/2″ high. Teapot: 8 3/4″ high. Sugar: 7 1/4″ high. Creamer: 5 3/8″ high. *Courtesy of Tom and Kathy Clarke.* Teapot, 9 1/2″: $2000+. Teapot, 8 3/4″: $1500+. Sugar: $1000+. Creamer: $1500+.

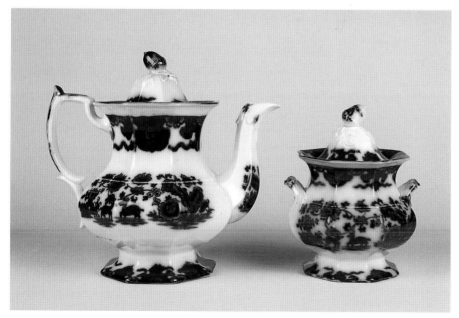

CASHMERE teapot & sugar. Acorn finial teapot: 9 1/4″ high. Sugar: 7 1/8″ high. *Courtesy of Tom and Kathy Clarke.* Teapot: $2000+. Sugar: $1500+

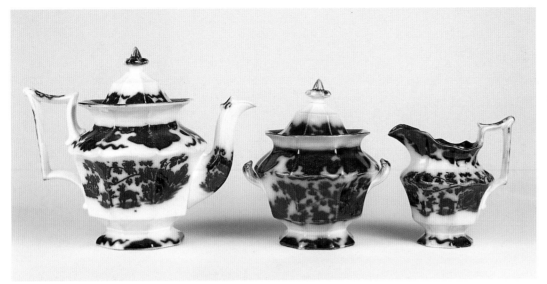

CASHMERE tea set. Teapot: 8 1/2" high. Sugar: 7 1/4" high. Creamer: 4 3/4" high. *Courtesy of Tom and Kathy Clarke.* Teapot: $1800+. Sugar: $1000+. Creamer: $1000+

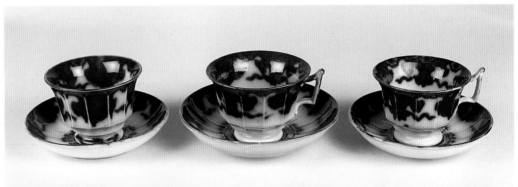

CASHMERE cups & saucers. Paneled handless cup & saucer: cup: 2 7/8" high x 4" in diameter, saucer: 6" in diameter. Paneled coffee: cup: 3" high x 4 1/4" in diameter, saucer: 6 1/2" in diameter. Paneled handled cup & saucer: cup: 2 3/4" high x 4" in diameter, saucer: 5 7/8" in diameter. *Courtesy of Don Iverson.* $225-275

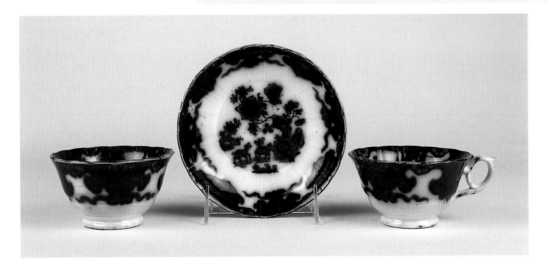

CASHMERE handleless and handled cups and saucer. Saucer: 5 3/4" in diameter. Cups: 2 1/4" high x 4" in diameter. *Courtesy of Tom and Kathy Clarke.* Handleless cup & saucer: $225+. Handled cup & saucer: $350+

CASHMERE teacup and saucer, round with no handle. Saucer: 5 7/8" in diameter. Cup: 2 1/2" high x 4" in diameter. *Courtesy of Tom and Kathy Clarke.* $225+

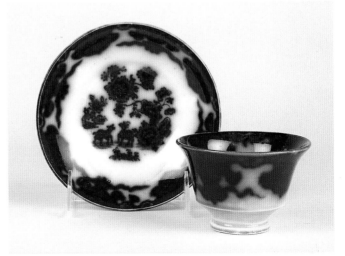

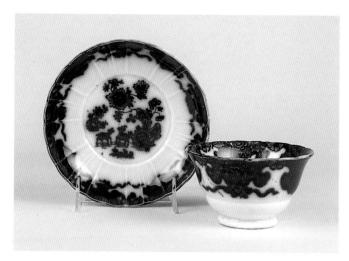

CASHMERE handleless coffee cup and saucer. Saucer: 6 1/4" in diameter. Cup: 2 1/2" high x 4 1/2" in diameter. *Courtesy of Tom and Kathy Clarke.* $350+

CASHMERE chocolate pot. 10 1/2" high. *Courtesy of Tom and Kathy Clarke.* $5000+

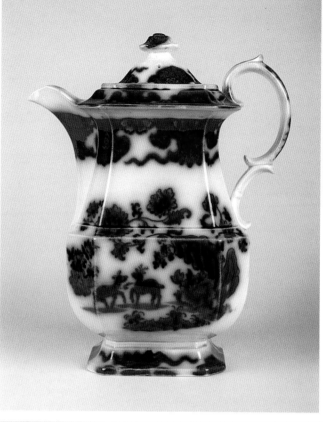

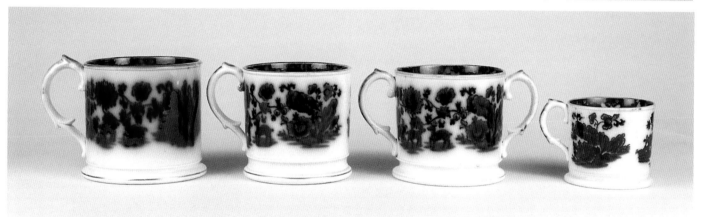

CASHMERE mugs, including one two handled loving cup and a small mug (possibly a shaving mug). Left to right: 4 1/2" high, 4 1/4" high, 4 1/4" high, 3 1/8" high. *Courtesy of Tom and Kathy Clarke.* Left to right: $2000+, $1500+, $2000+, $1000+

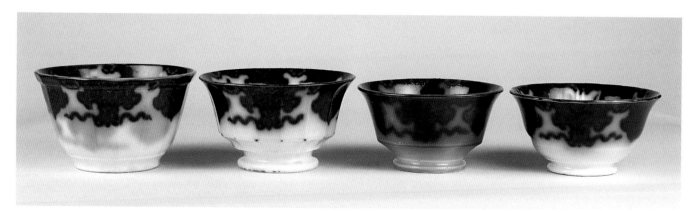

CASHMERE waste bowls of different designs. Left to right: 16 panel waste bowl: 5 3/4" in diameter x 3 1/2" high. 15 panel: 5 3/4" x 3 1/4". Round: 5 1/4" x 3". Scalloped: 5 1/2" x 2 7/8". *Courtesy of Tom and Kathy Clarke.* $600-750 each

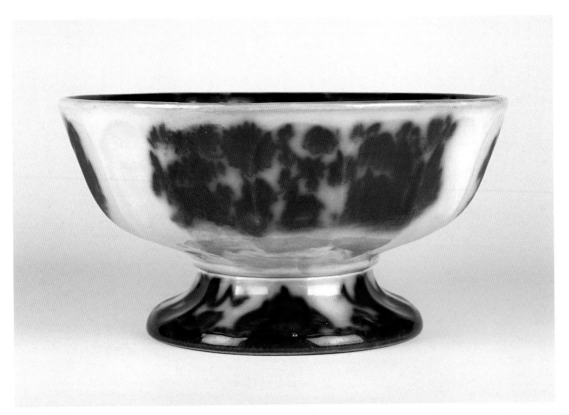

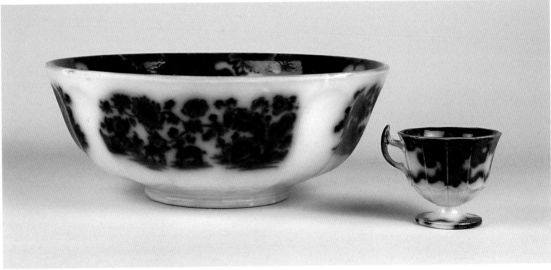

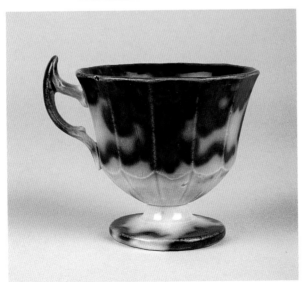

Top:
CASHMERE pedestaled punch bowl. 5 1/2″ high x 10 5/8″ in diameter. *Courtesy of Don Iverson.* $5000+

Center:
CASHMERE punch cup shown with a CASHMERE punch bowl (without pedestal). *Courtesy of Tom and Kathy Clarke.* Punch bowl: $5000+. Punch cup: $1000+

Left:
CASHMERE punch cup. 2 3/4″ high. *Courtesy of Tom and Kathy Clarke.* $1000+

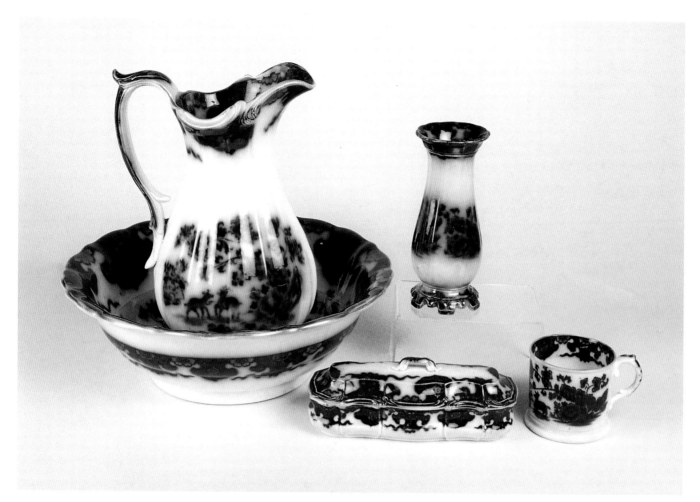

CASHMERE wash pitcher and basin, mug, toothbrush holder, and razor box. Pitcher: 11 3/4" high. Basin: 4 3/4" high x 14" in diameter. Razor box: 8 1/2" in length. *Courtesy of Tom and Kathy Clarke; Courtesy of Don Iverson.* Pitcher & basin: $4500+. Mug: $1000+. Toothbrush holder: $2500+. Razor box: $1500+

CASHMERE wash pitcher and basin, a closer look. *Courtesy of Tom and Kathy Clarke.* $4500+

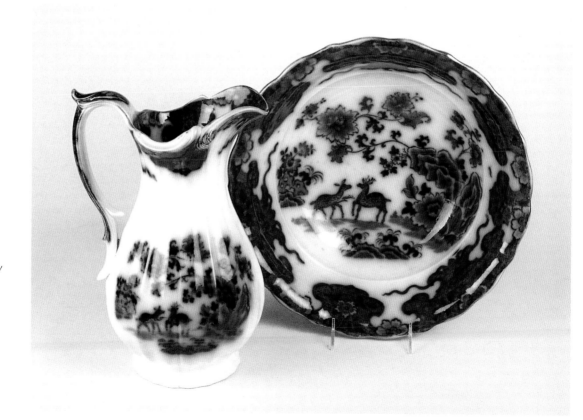

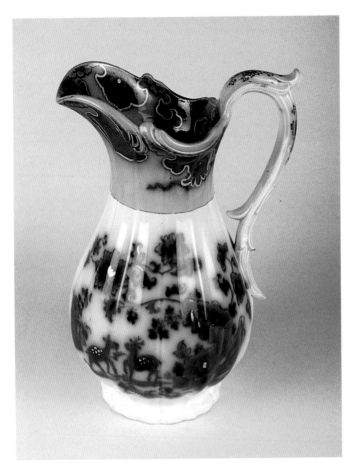

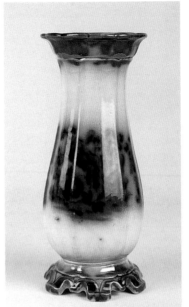

CASHMERE wash pitcher with green ground around the neck. 11 1/2" high. *Courtesy of Tom and Kathy Clarke.* $1500+

CASHMERE wash pitcher and basin. Basin: 13" in diameter. Pitcher: 11" high. *Courtesy of James and Christine Stucko.* $4500+

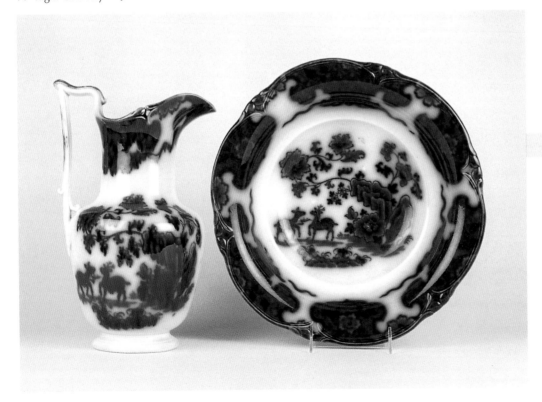

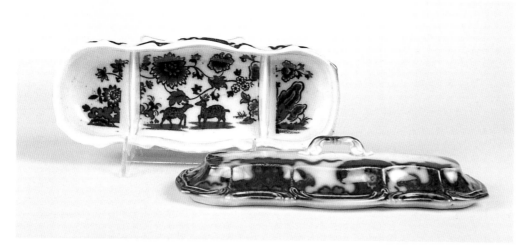

CASHMERE razor box with lid. *Courtesy of Tom and Kathy Clarke.* $1500+

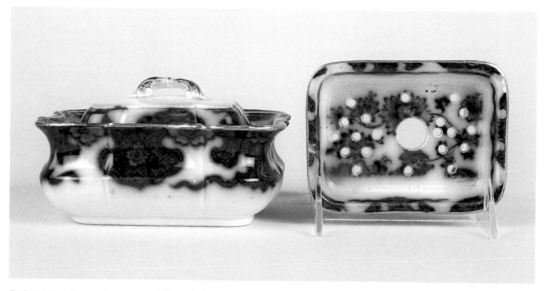

CASHMERE three piece soap dish with liner. 5 1/2" in length. *Courtesy of James and Christine Stucko.* $1200-1500

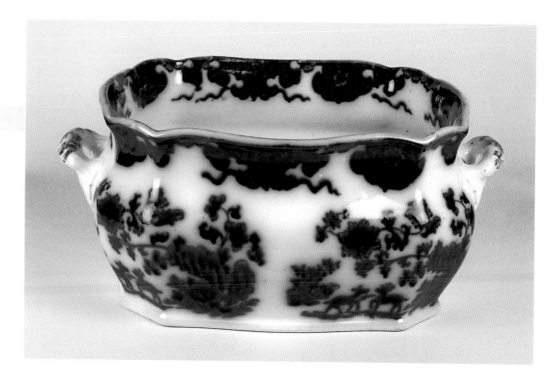

CASHMERE footbath. 8 1/4" high x 15 1/2" in length x 13 3/8" in width. *Courtesy of Tom and Kathy Clarke.* $8000+

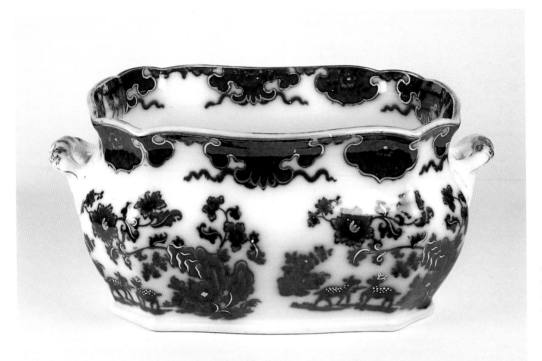

CASHMERE footbath with gold trim. 8 1/2" high x 15 1/2" in length x 12.5/8" in width. *Courtesy of Don Iverson.* $8000+

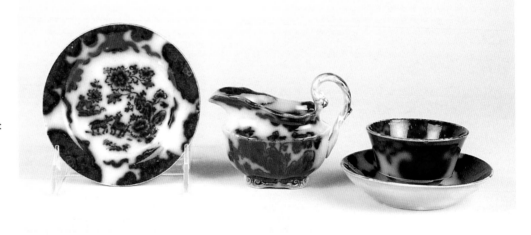

CASHMERE children's pieces. Plate: 4 1/2" in diameter. Creamer: 2 1/2" to spout. Saucer: 4 1/8" in diameter. Cup: 1 3/4" high x 2 3/4" in diameter. *Courtesy of Tom and Kathy Clarke.* Plate: $700+. Creamer: $1500+. Cup and saucer: $1000+

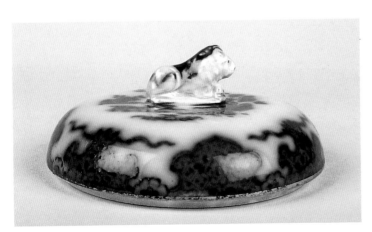

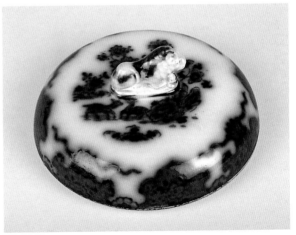

CASHMERE lid with lion finial. This lid is very similar in design to a jam dish dating from c. 1860, decorated in the BLUE BELL pattern found in my volume *Historic Flow Blue*, p. 123. 5 3/4" in diameter. *Courtesy of Tom and Kathy Clarke.* $500+

Chapoo

The vast majority of the Chapoo decorated wares presented were produced by the English potter John Wedg Wood, whose pottery was located in Tunstall in the Staffordshire potting district. John Wedg Wood produced his wares from 1841 to 1875(76) and employed printed "J. Wedgwood" manufacturer's marks. John Wedg Wood registered his Chapoo pattern dinner set on October 8, 1847. He registered a sixteen panel Chapoo pattern tea set earlier that year, on September 25, 1847. (Kowalsky 1999, 467)

CHAPOO plate. 10 1/4" in diameter. *Courtesy of James and Christine Stucko.* $175-200.

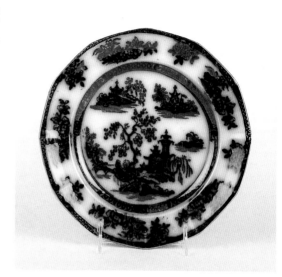

Left:
John Wedg Wood, Tunstall, Staffordshire, 1841-1875(76), printed "J. Wedgwood" manufacturer's mark in use from 1841-1875, with CHAPOO pattern name. John Wedg Wood registered his CHAPOO pattern dinner set on October 8, 1847. *Courtesy of James and Christine Stucko.*

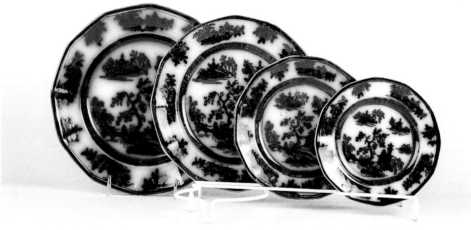

CHAPOO plates. 10 1/4", 9 1/4", 7 1/2", 6 1/2" in diameter. *Courtesy of James and Christine Stucko.* Left to right: $175-200+; $150+; $125+; $100+.

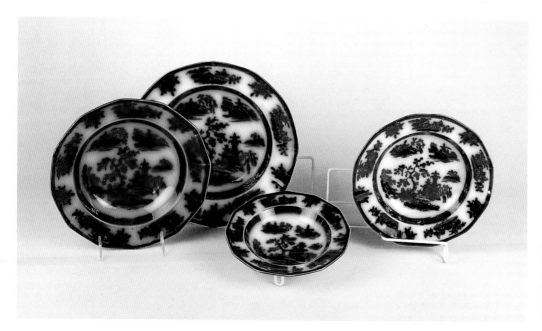

CHAPOO soup dishes. 10 1/2", 9 1/2", 8 1/2", 7 1/4" in diameter. *Courtesy of James and Christine Stucko.* Left to right: $200+; $175+; $175+; $250+ (rare).

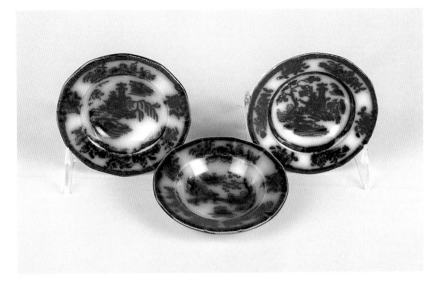

CHAPOO sauce dish. 5 1/4″ in diameter. *Courtesy of James and Christine Stucko.* $100+.

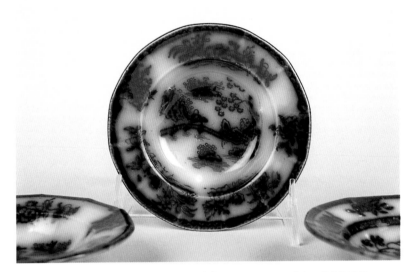

CHAPOO honey dishes. Each reflect different portions of the CHAPOO pattern. Only one has a decorated inner rim. 4 1/4″ in diameter each. *Courtesy of James and Christine Stucko.* $250-300 each.

CHAPOO toddy plate. 5 1/4″ in diameter. *Courtesy of James and Christine Stucko.* $225-275.

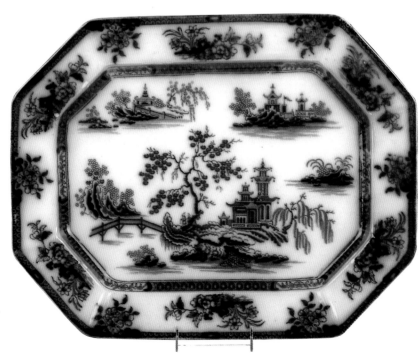

CHAPOO platter. 20″ in length. *Courtesy of James and Christine Stucko.* $2000+.

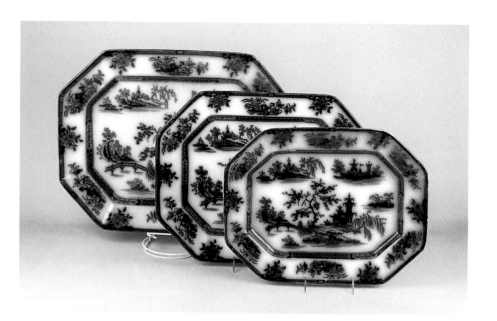

Right and below:
CHAPOO platters. 20", 18", 16", 14", 12 1/2", 11", 9 1/4" in length. *Courtesy of James and Christine Stucko.* 20": $2000+; 18": $1500+; 16": $850+; 14": $650+; 12 1/2": $500+; 11": $450+; 9 1/4": $400+.

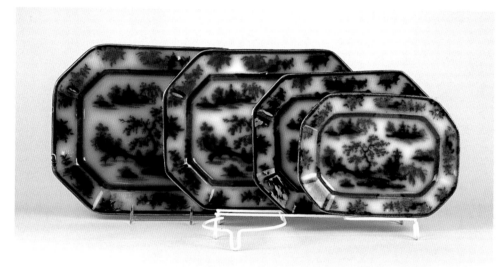

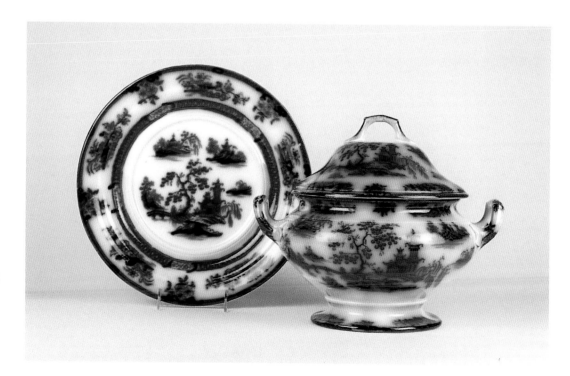

CHAPOO chowder style soup tureen with undertray. Undertray: 13 1/4" in diameter. Tureen: 10 1/4" high x 12 3/4" handle to handle. *Courtesy of James and Christine Stucko.* 6000+

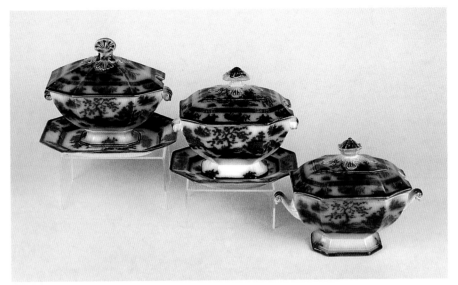

Three CHAPOO sauce tureens. Left: casket shaped sauce tureen with straight sided undertray, 8" in length x 7" to top of fan finial (restored). Middle: casket shaped, flared sides, flared undertray, pagoda finial, 7 1/2" in length x 7" high to finial. Right: CHAPOO sauce tureen on a Henry Alcock & Co. body, 8" in length x 6 3/8" high. *Courtesy of James and Christine Stucko.* $1200+ each with undertray; $1000+ each without undertray

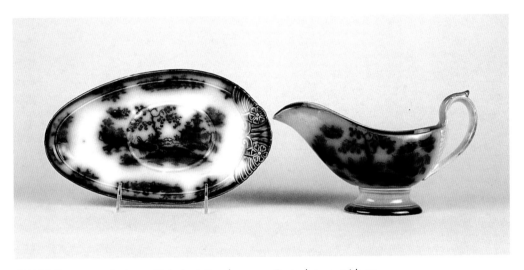

CHAPOO gravy undertray with indentation for gravy. Footed gravy with an embossed handle. Undertray: 9 1/2" in length. Gravy boat: 9" in length x 4 3/8" high to spout. *Courtesy of James and Christine Stucko.* $1000-1100

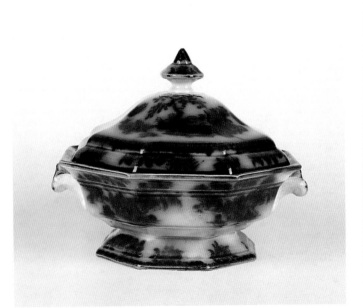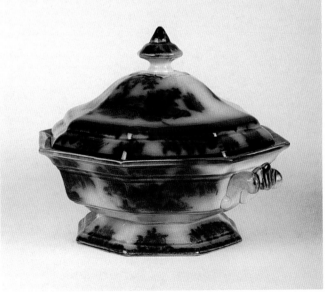

CHAPOO covered eight sided vegetable dish. Round finial and separate handles attached (vs. tab handles). 9" in diameter. *Courtesy of James and Christine Stucko.* $1200+

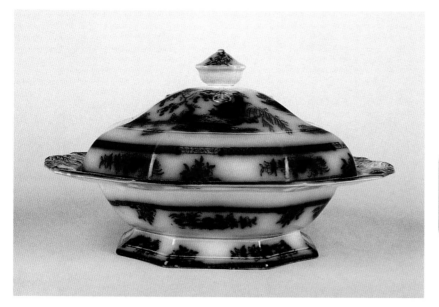

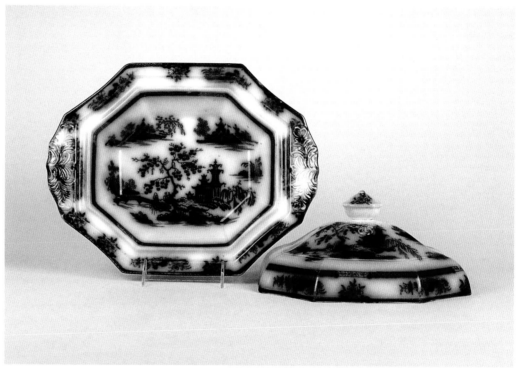

Left and below:
CHAPOO oval, octagonal covered vegetable dish with flared sides and embossed handles. 13" in diameter. *Courtesy of James and Christine Stucko.* $1200+

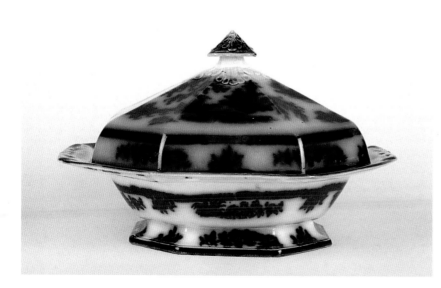

CHAPOO oval, octagonal covered vegetable dish with smooth sides and embossed handles. 12" in diameter. *Courtesy of James and Christine Stucko.* $1200+

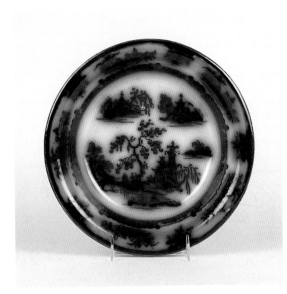

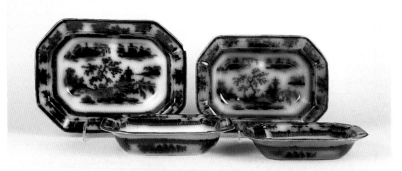

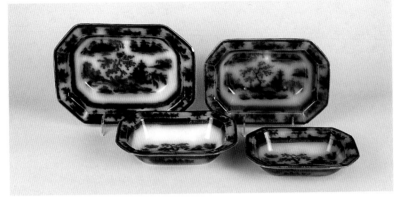

CHAPOO open vegetable (or potato) bowl. *Courtesy of James and Christine Stucko.* $600+.

CHAPOO open vegetable dishes. 10 1/2″, 8 1/2″, 9 1/2″, 7 3/4″ in diameter. *Courtesy of James and Christine Stucko.* 10 1/2": $650+; 8 1/2": $450+; 9 1/2": $450+; 7 3/4": $400+.

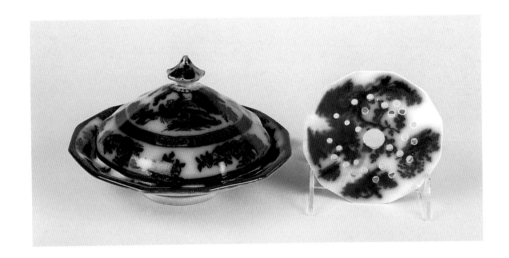

Above and right:
CHAPOO covered butter dish with insert. Insert: 4 1/2″ in diameter. Covered butter: 7″ in diameter x 4 1/4″ high. *Courtesy of James and Christine Stucko.* $1500+

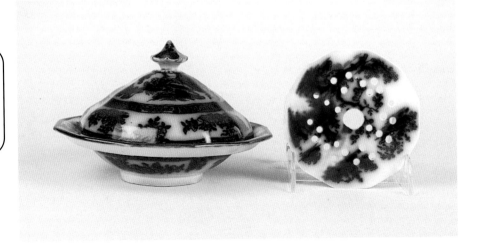

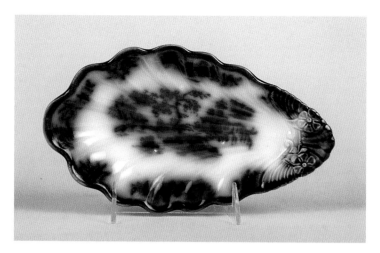

CHAPOO relish dish, fluted with scalloped edges, footed at base with embossed handle. 9" in length. *Courtesy of James and Christine Stucko.* $250-275

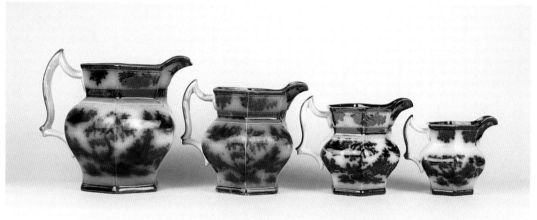

CHAPOO six sided pitchers. Standard shape: 8" to spout, 6 1/2" to spout, 5 1/2" to spout, 4 1/2" to spout. *Courtesy of James and Christine Stucko.* Left to right: $950+; $850+; $650+; $650+

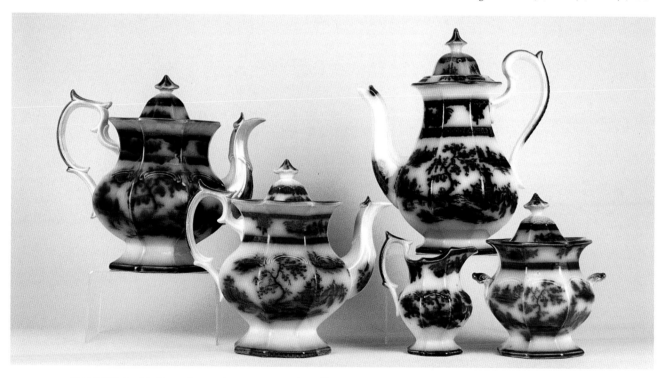

CHAPOO double line primary shape tea set with coffee pot. Large teapot: 10" to finial. Teapot: 9" to finial. Sugar: 7 1/2" to finial. Creamer: 5" to lip. Large coffee pot: 11 1/2" to finial. *Courtesy of James and Christine Stucko.* Large teapot: $1200+; teapot: $1200+; sugar: $750+; creamer: $750-825; coffee pot: $3000+

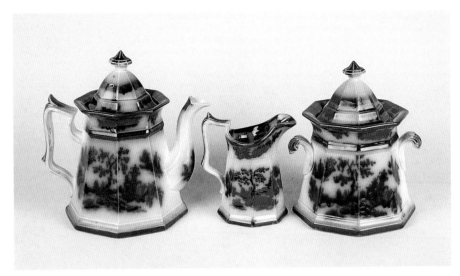

CHAPOO full panel Gothic tea set. Creamer: 5" high to lip. Teapot: 8 1/4" to finial. Sugar: 8" high to finial. *Courtesy of James and Christine Stucko.* Creamer: $750-825; teapot: $1200+; sugar: $750-825

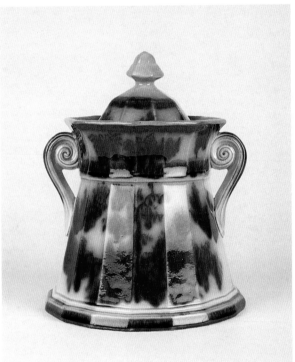

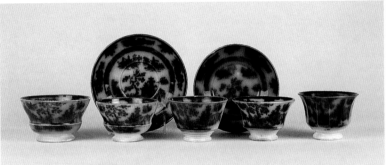

CHAPOO cups in several forms. Flared smooth sided cup: 4" in diameter x 2" high. Straight smooth sided cup: 4" in diameter x 3" high. Twelve paneled cup: 2 3/4" high x 3 3/4" in diameter. Handleless farmer's cup: 4 1/2" in diameter x 2 3/4" high. Curved unpaneled cup: 3 7/8" in diameter x 2 1/2" high. Saucers, paneled: 6 1/2" in diameter. Saucers, smooth: 6" in diameter. *Courtesy of James and Christine Stucko.* $200-250 each

CHAPOO 16 panel Gothic shape sugar bowl. Very rare. *Courtesy of James and Christine Stucko.* $1100+

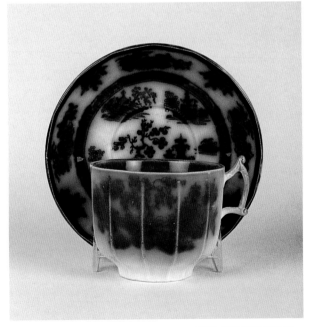

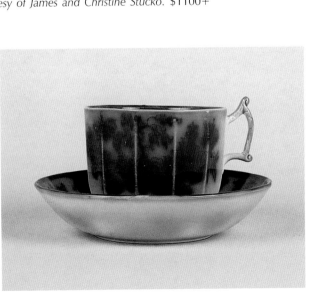

Left and above:
CHAPOO paneled, handled farmer's cup. Cup: 4" in diameter x 3 1/4" high. Paneled saucer: 6 1/2" in diameter. *Courtesy of James and Christine Stucko.* $275-350 (rare)

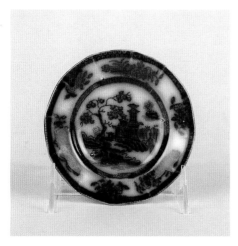

CHAPOO cup plate. Among earlier tea drinkers, it was common to pour tea from the cup into a large saucer to cool and drink it while the cup was then placed upon a cup plate. 4 1/4" in diameter. *Courtesy of James and Christine Stucko.* $175-225.

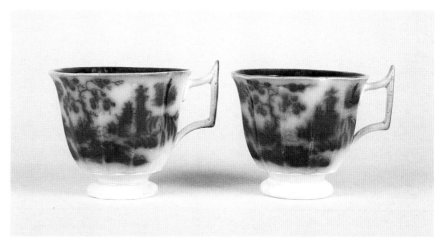

CHAPOO handled posset cups. 2 3/4" high x 3" in diameter. *Courtesy of James and Christine Stucko.* $325+

Right and below:
CHAPOO paneled waste bowls, the panels extend almost to the lip and have no band below the lip. Left, 14 panels: 5" in diameter x 3 1/4" high. Right, 16 panels: 6 1/4" x 3 3/4" high. *Courtesy of James and Christine Stucko.* Left to right: $450+; $475+

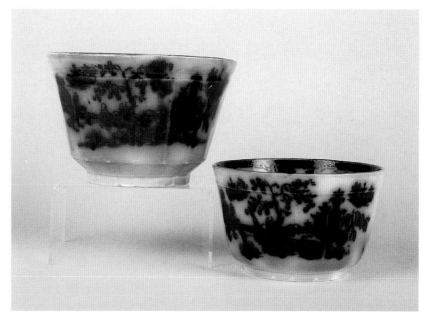

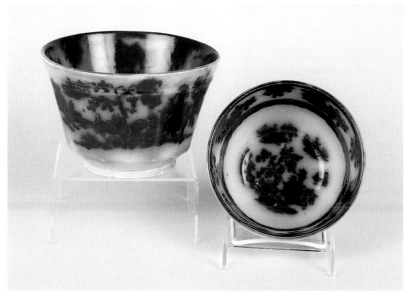

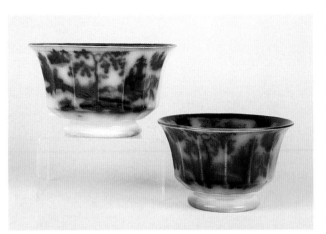

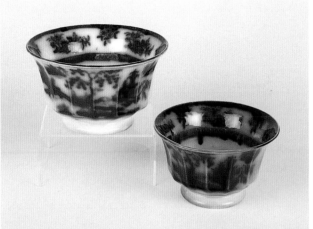

CHAPOO 16 paneled waste bowls. The panels do not come up to lip and are met by a band. Left: 5 1/2" in diameter x 3 3/4" high. Right: 6 1/4" high x 4 1/4" high. *Courtesy of James and Christine Stucko.* $450+ each

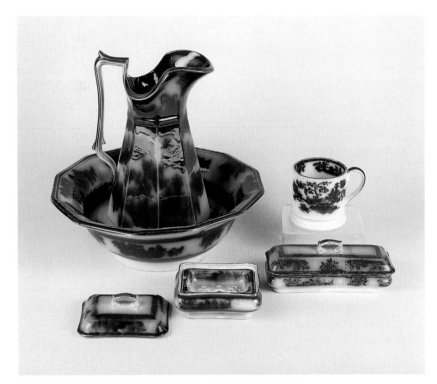

CHAPOO bath set. Paneled Gothic shape basin and pitcher. Basin: 13 1/4" in diameter. Eight sided pitcher: 11 1/2" high. Shaving mug: 3 1/2" high x 3 1/2" in diameter. Soap dish with insert: 5 1/4" in length. Toothbrush holder: 8" in length. *Courtesy of James and Christine Stucko.* Pitcher & basin: $4000+; shaving mug: $850; soap dish: $1100; toothbrush holder: $1100

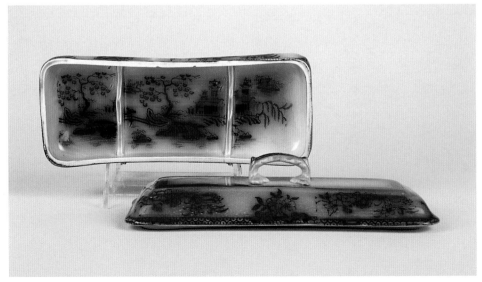

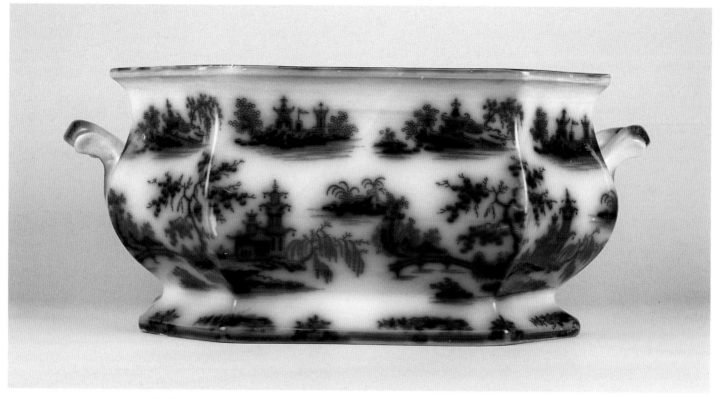

CHAPOO footbath. 20 1/2″ in length x 8 3/4″ high. *Courtesy of James and Christine Stucko.* $6500-7000

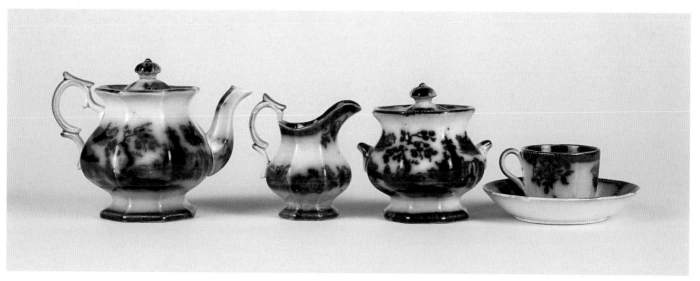

CHAPOO children's set. Teapot: 4" to finial. Creamer: 2 7/8" high. Sugar: 3 1/4″ to finial. Cup: 1 1/2″ high. Saucer: 4″ in diameter. Note: 3 pieces of the tea set are in the primary body shape. *Courtesy of James and Christine Stucko.* $7000-7700 set

Late Victorian Wares in the La Belle and Touraine Patterns

La Belle

All of the La Belle China shown here was produced by the Wheeling Pottery Company of Wheeling, West Virginia. The company was in business from 1879 to 1910. The firm's name was changed to Wheeling Potteries Company in c. 1904. La Belle China was adorned with Flow Blue decoration in what the company termed "Royal La Belle Blue." The range of wares produced was vast, including dinnerware, "Virginia Girl" plates, "High Art" and "Royal" plaque assortments, tea, coffee, and chocolate sets, toilet sets including the impressive "Millionaires Pride," children's sets, and jardinieres and jardiniere stands, including the magnificent "Admiral Dewey" jardiniere and stand—sold in 1906 for $75. Collectors and dealers alike have used the "La Belle" name in direct association with the Flow Blue decoration appearing on the La Belle China produced by this prolific American firm. That tradition is continued here.

Wheeling Pottery Company, Wheeling, West Virginia, 1879-1903(10), printed "La Belle China" mark in use from 1893-c. 1903. *Courtesy of Tom and Kathy Clarke.*

Wheeling Pottery Company printed manufacturer's mark in use from 1893-1903. This mark would continue to be used without the letter "S" (found to the left of the center torch) from c. 1904-1910. *Courtesy of Tom and Kathy Clarke.*

Wheeling Potteries Company, Wheeling, West Virginia, 1903-1908(10), printed "The Wheeling Potteries Co. Bonita Semi Porcelain" manufacturer's mark in use from c. 1903-1910. *Courtesy of Tom and Kathy Clarke.*

Wheeling Pottery Company printed manufacturer's mark in use from c. 1893-1910. *Courtesy of Tom and Kathy Clarke.*

Wheeling Pottery Company printed manufacturer's mark in use from c. 1893 onward. This mark was placed on a salad bowl. *Courtesy of Tom and Kathy Clarke.*

The Wheeling Pottery Company changed the color of their mark depending on the type of ware the mark was placed upon. This mark was placed on a spittoon. Wheeling Pottery Company printed manufacturer's mark in use from c. 1893 onward. *Courtesy of Tom and Kathy Clarke.*

Royal LA BELLE/Wheeling Potteries Company printed mark in use from c. 1904-1910 by the Wheeling Potteries Company, Wheeling, West Virginia, 1903-1908(10). This mark was placed on one of the firm's portrait chargers. *Courtesy of Tom and Kathy Clarke.*

Wheeling Potteries Company printed "The Wheeling Pottery Co." manufacturer's mark in use from c. 1904-1910. *Courtesy of Warren and Connie Macy.*

LA BELLE plate. 9 7/8" in diameter. *Courtesy of Tom and Kathy Clarke.* $150+

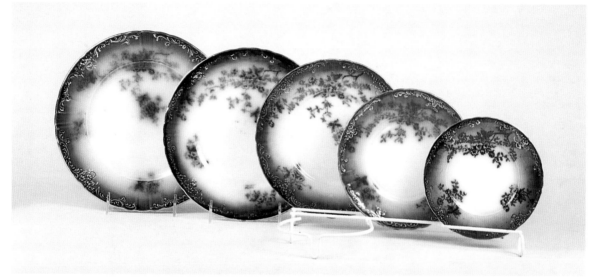

Five LA BELLE plates. 9 7/8" in diameter, 9 1/8" in diameter, 8 1/8" in diameter, 7" in diameter, 6" in diameter. *Courtesy of Tom and Kathy Clarke.* $100-150+ (value increases with size)

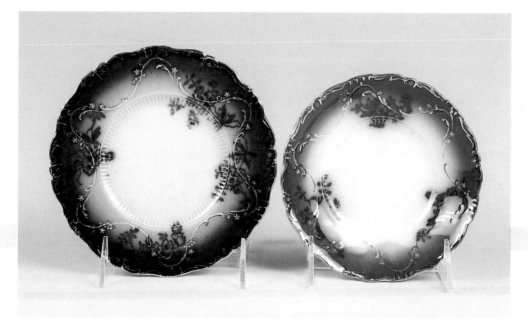

LA BELLE plate and berry bowl in the Virginia style on the blue diamond pattern. Plate: 6 1/8" in diameter. Berry bowl: 5 1/2" in diameter. *Courtesy of Tom and Kathy Clarke.* $100+ each

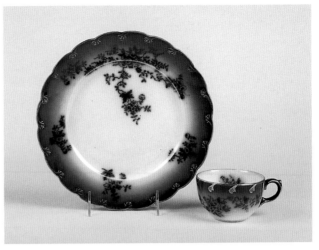

LA BELLE twelve sided plate. 10 3/4" in diameter. *Courtesy of Tom and Kathy Clarke.* $300+ (rare)

LA BELLE Serilla pattern plate and cup. This is a later pattern. Plate: 9 1/2" in diameter. Cup: 3 5/8" in diameter x 2 1/8" high. *Courtesy of Tom and Kathy Clarke.* $100+ each

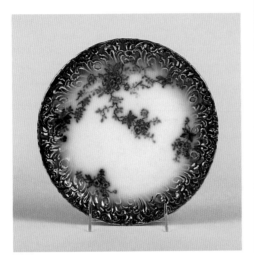

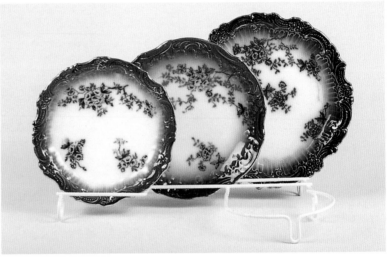

LA BELLE fancy luncheon plate. 8 3/4" in diameter. *Courtesy of Tom and Kathy Clarke.* $150+

LA BELLE fancy plates. 8 1/2" in diameter, 7 3/8" in diameter, 6 1/2" in diameter. *Courtesy of Tom and Kathy Clarke.* $150-200+

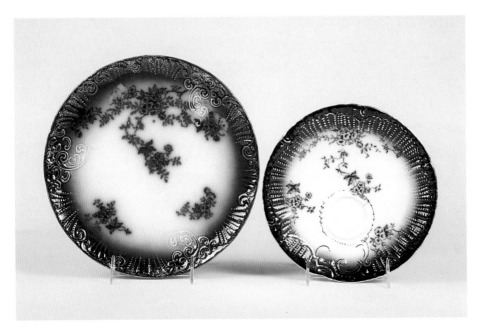

LA BELLE fancy dinner plate and a fancy luncheon plate with a cup indentation. Fancy dinner plate: 10" in diameter. Luncheon plate: 8 1/2" in diameter. *Courtesy of Tom and Kathy Clarke.* Rare luncheon plate: $250+

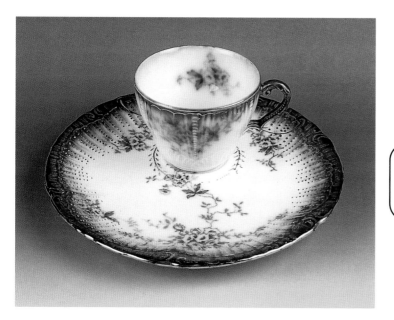

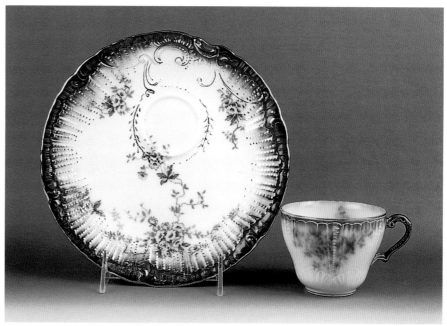

Left and below:
LA BELLE fancy luncheon plate with cup. Plate: 8 1/2"
in diameter. *Courtesy of Warren and Connie Macy.*
$450-550 set

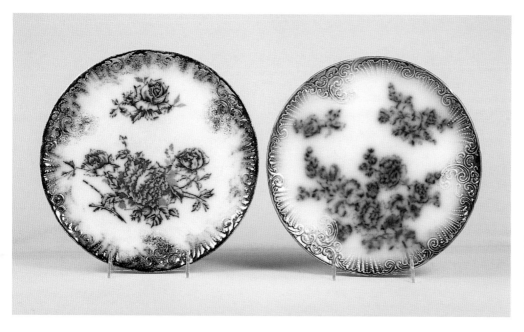

LA BELLE plates. Left: 10 1/2" in
diameter, with detailed floral
displays of what appear to be roses
& chrysanthemums. Right: 10 1/4"
in diameter. *Courtesy of Tom and
Kathy Clarke.* $150+ each

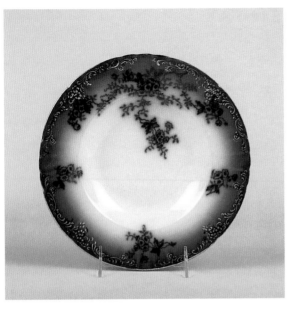

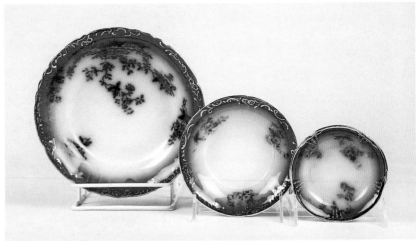

LA BELLE bowls. Rimless soup: 7 1/2" in diameter. Berry bowl: 5 1/8" in diameter. Sauce: 4" in diameter. *Courtesy of Tom and Kathy Clarke.* $100+

LA BELLE flanged rim soup. 9 1/4" in diameter. *Courtesy of Tom and Kathy Clarke.* $125+

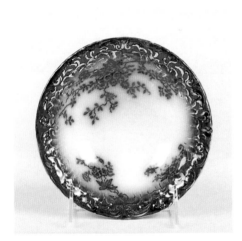

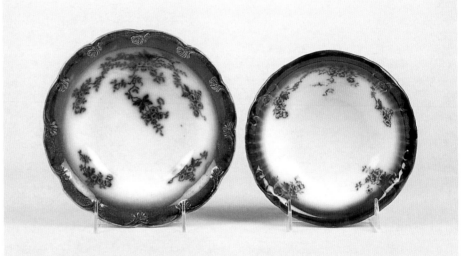

LA BELLE cereal bowl. 6 1/4" in diameter. *Courtesy of Tom and Kathy Clarke.* $100+

LA BELLE bowls: 8 1/4" in diameter; 7 1/4" in diameter. *Courtesy of Tom and Kathy Clarke.* $100+ each

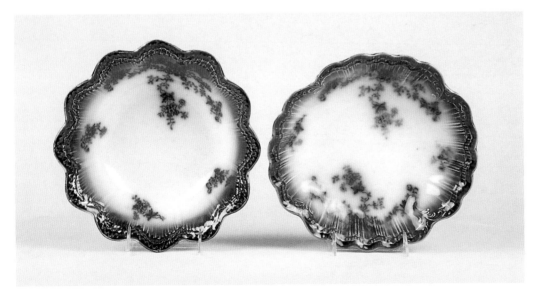

LA BELLE bowls. Many of the bowls shown with imaginative and decorative shapes were referred to in company catalogs as "salad plates." Left: 10 1/2" , right: 10 3/4" x 10. *Courtesy of Tom and Kathy Clarke.* $250+ each

LA BELLE bowls. Left: 10 1/4" x 8 1/4". Right: 11 x 9 3/4. *Courtesy of Tom and Kathy Clarke.* $250+ each

LA BELLE bowls, the rectangular bowl is listed in the catalogs as a slaw dish. Left: 9" x 8". Right: 9 1/2" x 9 1/4". *Courtesy of Tom and Kathy Clarke.* $250+ each

LA BELLE bowls. Left: 11 1/2" x 8 1/4". Right, very detailed floral design: 11 1/2" x 9 1/2". *Courtesy of Tom and Kathy Clarke.* $250+ each

LA BELLE oval bowls, possibly ice cream dishes or baking dishes. Top: 12 1/4" x 6 1/8". Bottom left: 8 1/2" x 5". Bottom right: 6 x 3 3/4". *Courtesy of Tom and Kathy Clarke.* $125-250+

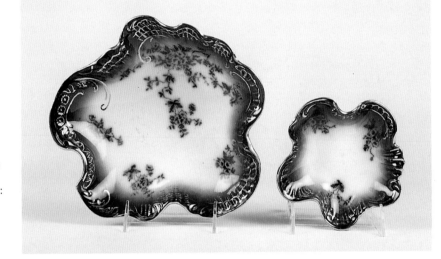

LA BELLE master berry bowl and berry bowl. Master berry bowl: 9 1/8" x 8 1/2". Berry bowl: 5 5/8" x 5 1/2". *Courtesy of Tom and Kathy Clarke.* Master berry bowl: $350+. Berry bowl: $100+

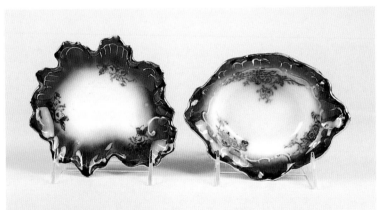

LA BELLE small dishes. Left: 6 1/4" in length. Right, free form leaf shape: 6" in length. *Courtesy of Tom and Kathy Clarke.* $125+ each

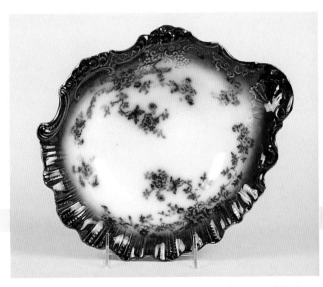

LA BELLE oval bowl. 11" x 9 1/4". *Courtesy of Tom and Kathy Clarke.* $250+

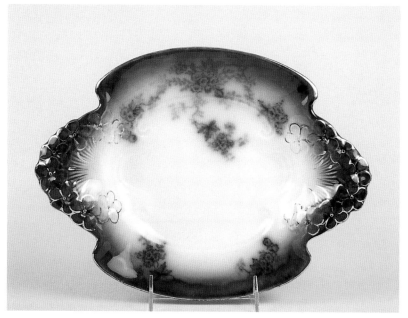

LA BELLE special salad bowl. 11 3/4" x 8 3/4".
Courtesy of Tom and Kathy Clarke. $350+

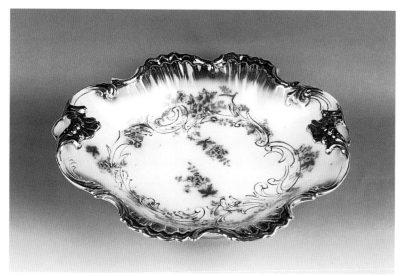

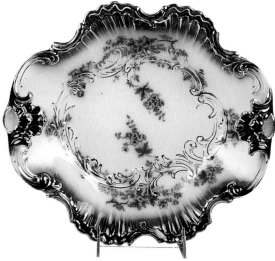

LA BELLE inverted handled bowl, "Bride's Basket." 11 1/2" across. *Courtesy of Warren and Connie Macy.* $600-750

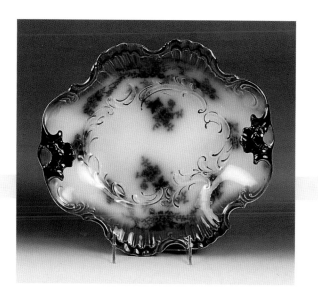

LA BELLE bowl with inverted handles. It is hard to find
inverted handles intact. 11 1/2" in length x 10 1/4" wide.
Courtesy of Tom and Kathy Clarke. $600+

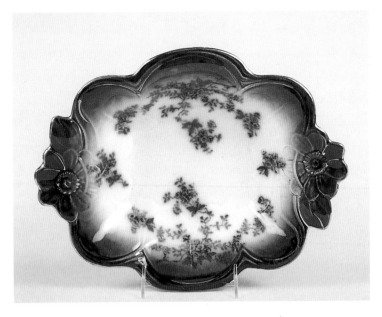

LA BELLE daisy handled bowl. 12 1/2" x 9 1/2". *Courtesy of Tom and Kathy Clarke.* $300+

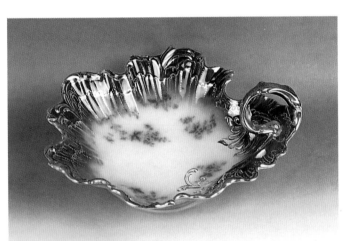

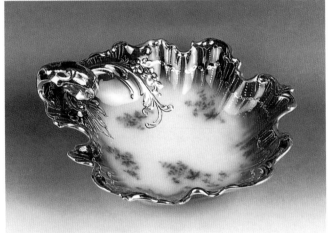

LA BELLE loop handled tray. *Courtesy of Warren and Connie Macy.* $350-450

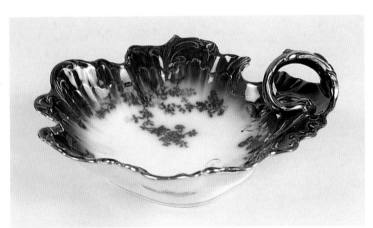

Loop handled LA BELLE tray. 11 1/2" x 11". *Courtesy of Tom and Kathy Clarke.* $300+

LA BELLE ribbon handled tray (possibly a candy dish?). 9 1/2" in diameter. *Courtesy of Warren and Connie Macy.* $900-1000

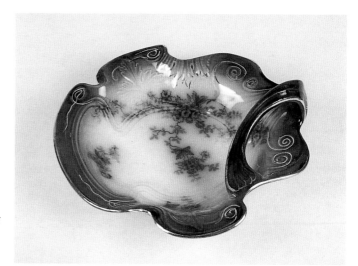

LA BELLE ribboned handled
tray. 9 1/4" x 9 1/4". *Courtesy of
Tom and Kathy Clarke.* $1000+
(rare)

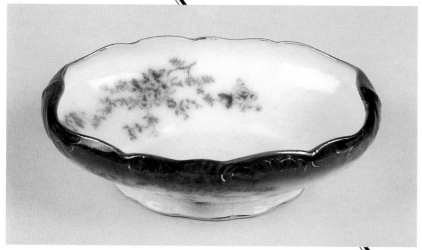

LA BELLE bowl with inverted handles,
possibly a console bowl. 10 x 7 1/8". *Courtesy
of Tom and Kathy Clarke.* $500+

Right and below:
LA BELLE possible console bowl. 9 3/4" in length.
Courtesy of Warren and Connie Macy. $550-650

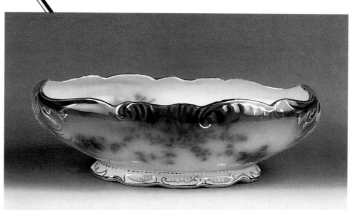

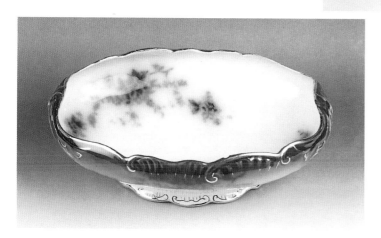

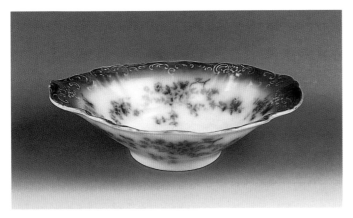

LA BELLE bowl. 11 1/4" in length. *Courtesy of Warren and Connie Macy.* $750-850

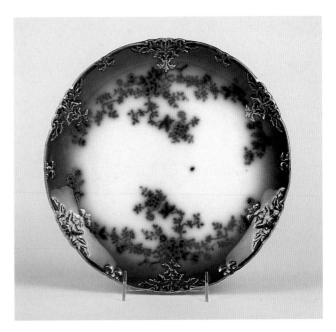

Above and left:
LA BELLE embossed charger. 11 1/4" in diameter. *Courtesy of Tom and Kathy Clarke.* $250+

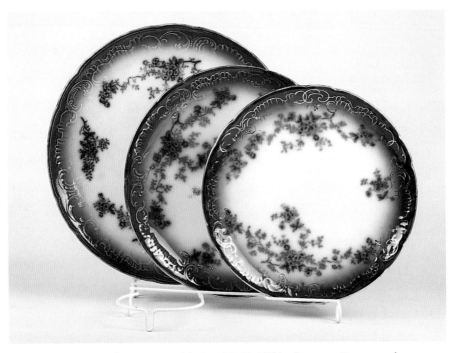

LA BELLE chargers. 14 1/2", 12 1/2", 11 1/2" in diameter. *Courtesy of Tom and Kathy Clarke.* $150-300 (value increases with size)

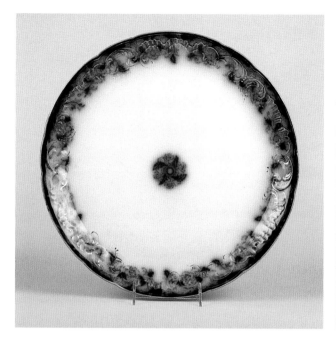

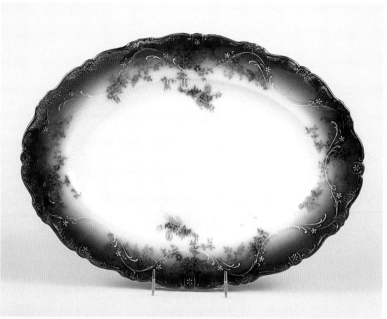

LA BELLE charger. 14 5/8″ in diameter. *Courtesy of Tom and Kathy Clarke.* $200+

LA BELLE Virginia platter. 17 1/2″ in length. *Courtesy of Tom and Kathy Clarke.* $400+

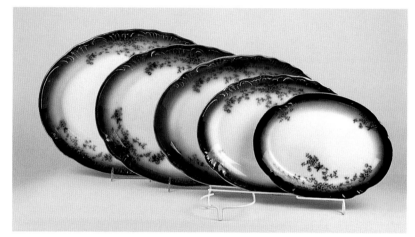

LA BELLE nested platters. 18 1/4″, 16 3/4″, 15 1/4″, 13 5/8″, 11 5/8″ in length. *Courtesy of Tom and Kathy Clarke.* $250-650+ (value increases with size)

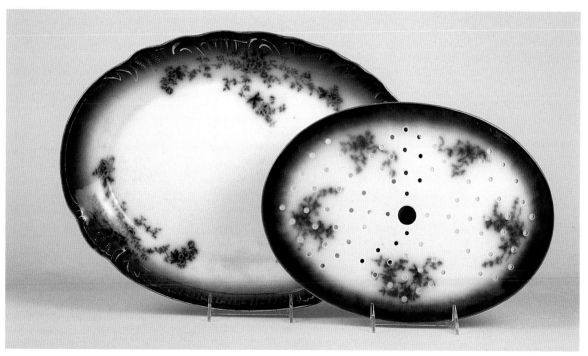

LA BELLE platter with drainer. Drainer: 9 1/2″. Platter: 16 3/4″. *Courtesy of Tom and Kathy Clarke.* Platter: $400+. Drainer: $1000+ (very rare)

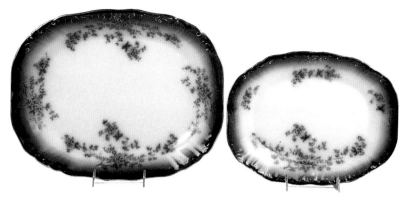

LA BELLE rectangular platters. 15 5/8" & 12 3/8" in length. *Courtesy of Tom and Kathy Clarke*. Left to right: $500+, $350+

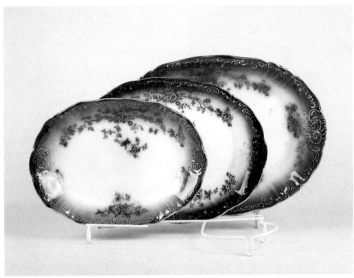

LA BELLE platters. 14 7/8", 13", & 11 1/2" in length. *Courtesy of Tom and Kathy Clarke*. $400+; $300+; $200+

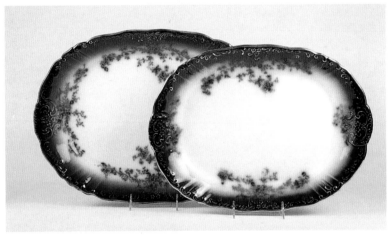

LA BELLE platters. 18 5/8", 16 7/8" in length. *Courtesy of Tom and Kathy Clarke*. 11 1/2": $450+. 18 5/8": $800+

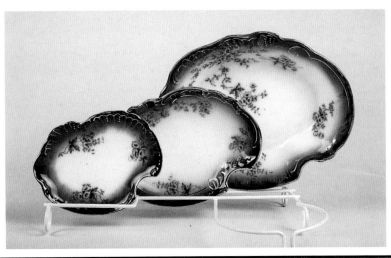

LA BELLE trays with a distinctive indentation. 9 1/2" x 7 3/8"; 7 3/8" x 5 3/8"; 5 3/4" x 4 1/4". *Courtesy of Tom and Kathy Clarke*. $100-200+

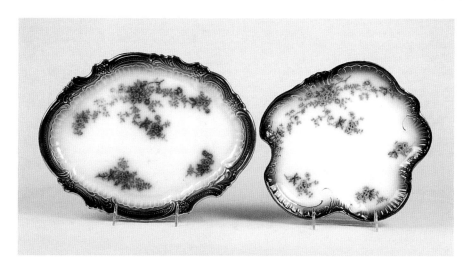

LA BELLE trays. Left, dresser: 13" x 10". Right, free form: 10 1/4" x 9 1/4". *Courtesy of Tom and Kathy Clarke.* $200+ each

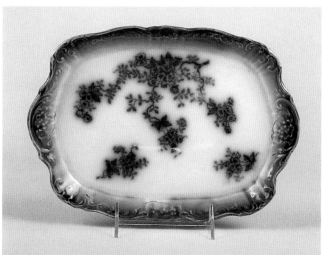

LA BELLE tray. 10 1/2" x 7 1/2". *Courtesy of Tom and Kathy Clarke.* $200+

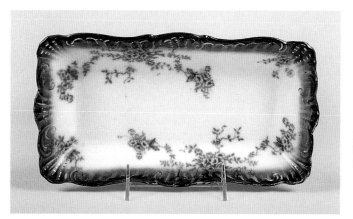

LA BELLE bread tray. 10 3/4" x 6". *Courtesy of Tom and Kathy Clarke.* $300+

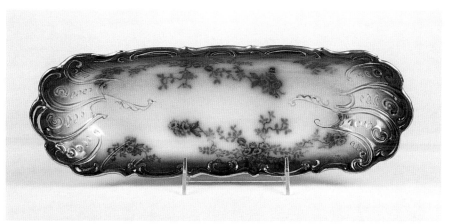

LA BELLE celery. 13 1/2" x 4 3/4". *Courtesy of Tom and Kathy Clarke.* $250-300+

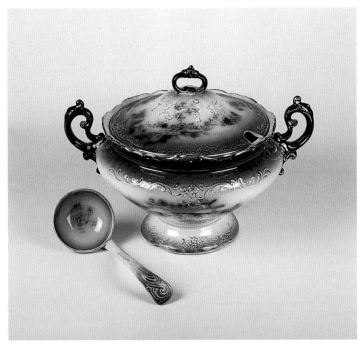

LA BELLE round soup tureen and ladle. Tureen: 9 1/4"
high x 13" handle to handle. Ladle: 8 1/2" in length.
Courtesy of Tom and Kathy Clarke. Tureen: $4000+.
Ladle: $1200+

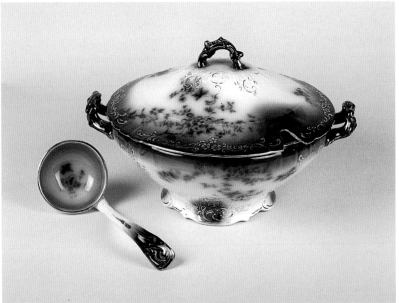

LA BELLE soup tureen & ladle. A shorter round
tureen, possibly an oyster tureen. Tureen: 7 3/4" high
x 12 1/2" handle to handle. Ladle: 8 1/2" in length.
Courtesy of Tom and Kathy Clarke. Tureen: $4000+.
Ladle: $1200+

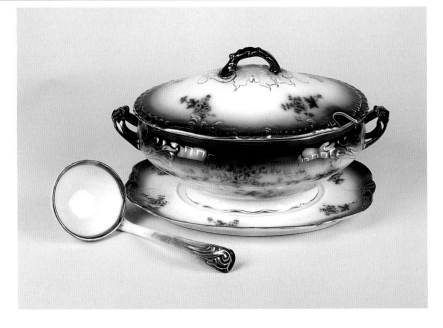

LA BELLE oval soup tureen and ladle. Tureen: 7" high
x 7 1/2" handle to handle. Undertray: 11 1/2". Ladle:
8 1/2". *Courtesy of Tom and Kathy Clarke.* Tureen &
undertray: $3000+. Ladle: $1200+

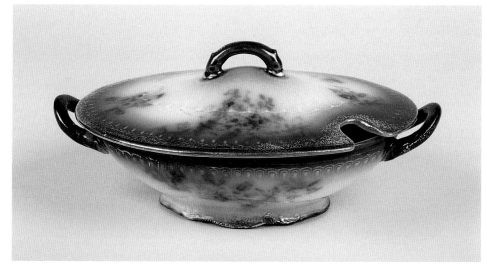

LA BELLE sauce tureen. 3 5/8" high x 8 1/8" handle to handle. *Courtesy of Tom and Kathy Clarke.* $2000+ (very rare)

Five different LA BELLE gravy boats. Left to right. First: Attached undertray: 3 5/8" high x 6 3/4" in length handle to spout. Second: 4" high x 7 3/4" in length, Third: Virginia pattern 4" high x 8 1/4" in length. Fourth: 4" high x 7 5/8" in length. Fifth: (under the first): 3 3/4" high x 9" in length. *Courtesy of Tom and Kathy Clarke.* These gravy boats range in value from $350 to $700+.

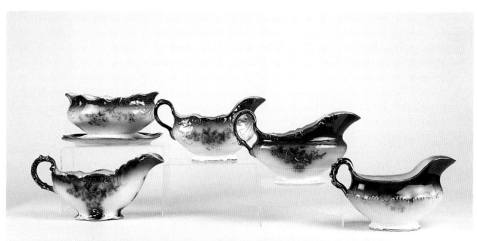

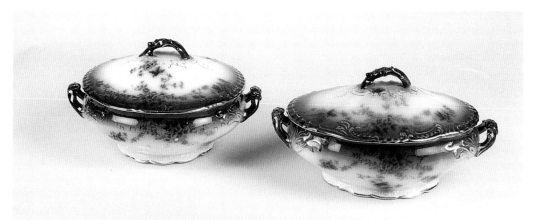

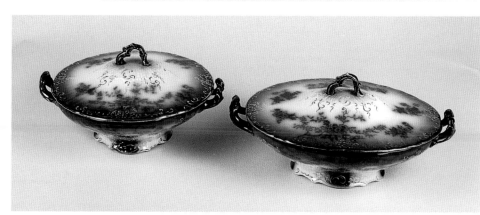

LA BELLE covered vegetable dishes in oval and round forms. Round: 5 1/2" high x 8 1/4" in diameter. Oval: 5 3/4" high x 10 3/4" in length handle to handle. *Courtesy of Tom and Kathy Clarke.* Round: $550+. Oval: $450+

LA BELLE oval and round covered vegetables. Round: 5 1/2" high x 9 3/4" in length with handles. Oval: 5 1/2" high x 11 1/4" handle to handle. *Courtesy of Tom and Kathy Clarke.* Round: $550+. Oval: $450+

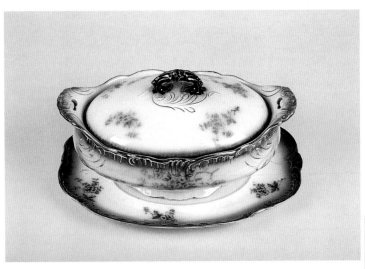

Above and right:
LA BELLE covered vegetable dish with undertray. 5 3/4"
high x 10 5/8" in length. Undertray: 11 1/2" in length.
Courtesy of Tom and Kathy Clarke. $800+

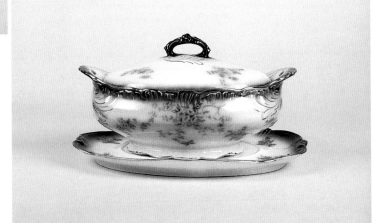

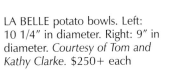

Three LA BELLE open vegetable bowls or
bakers. Large: 10" in length; medium: 9 1/4"
in length; small (rare): 6" in length. *Courtesy of
Tom and Kathy Clarke.* Large & medium:
$200+ each. Small: $400+

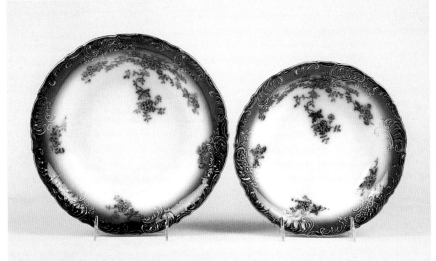

LA BELLE potato bowls. Left:
10 1/4" in diameter. Right: 9" in
diameter. *Courtesy of Tom and
Kathy Clarke.* $250+ each

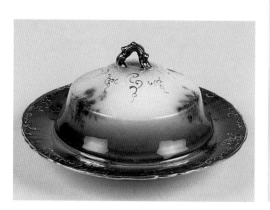

LA BELLE butter dish and drainer. 4 3/8" high. Base: 7 3/4" in diameter. *Courtesy of Tom and Kathy Clarke.* $750+

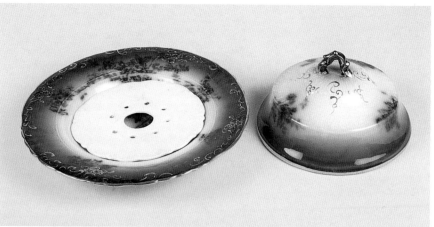

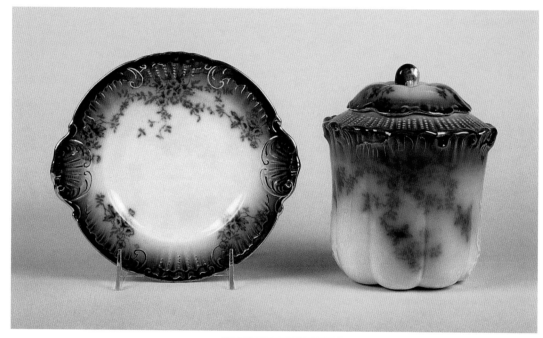

LA BELLE cracker jar and undertray/butter plate. The undertray/butter plate is marked. Jar: 7 1/4" high. Undertray/butter plate: 8 1/4" in diameter. *Courtesy of Tom and Kathy Clarke.* Cracker jar: $750+. Undertray/butter plate: $500+ (very rare)

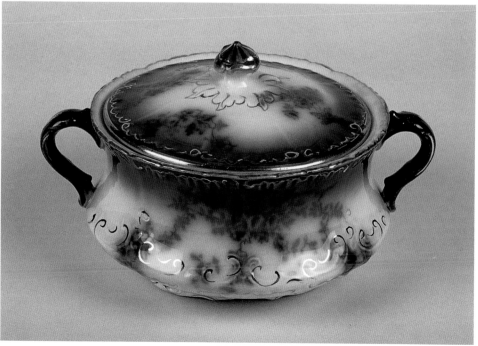

LA BELLE biscuit jar. 5" high x 6 1/4 diameter *Courtesy of Tom and Kathy Clarke.* $1000+

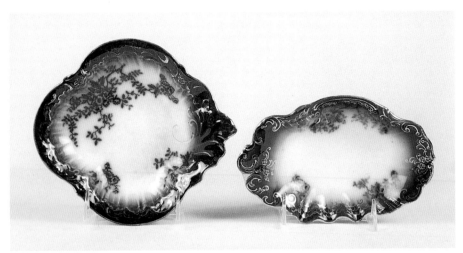

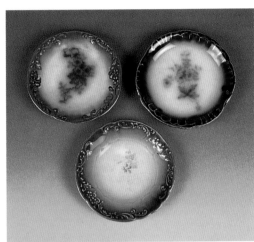

LA BELLE butter pats. 3 1/4", 3 1/2", & 3 1/4" in diameter. *Courtesy of Tom and Kathy Clarke.* $100+ each

LA BELLE relish dish and oval tray. Relish dish: 8 1/8" x 5 1/4"; oval tray: 8 1/4" x 7 3/8". *Courtesy of Tom and Kathy Clarke.* $200+ each

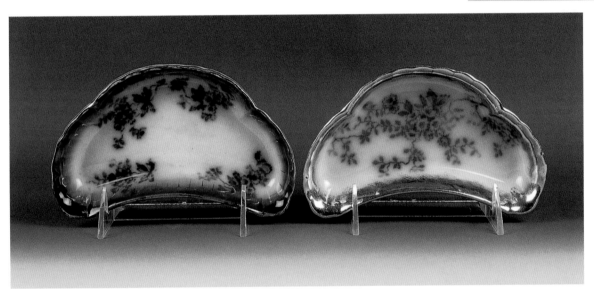

LA BELLE bone dishes. 6 3/8" across each. *Courtesy of Tom and Kathy Clarke.* $150+ each

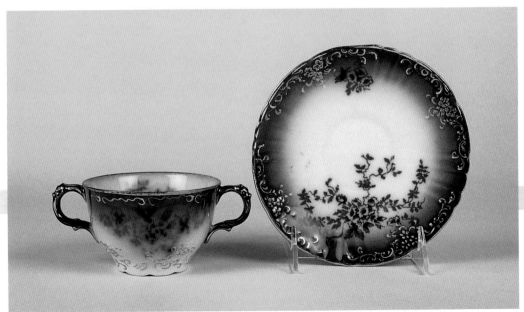

LA BELLE bouillon cup with saucer. Cup: 2 1/2" high. Saucer: 6 1/4" in diameter. *Courtesy of Tom and Kathy Clarke.* $750+

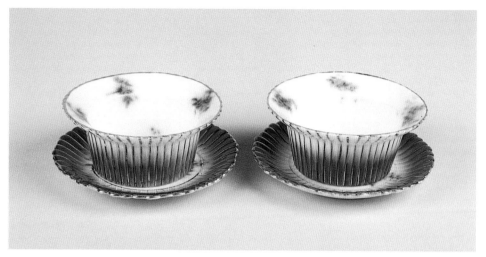

Right and center right:
LA BELLE ramekins with saucers.
Ramekin: 3 1/2″ in diameter x 1 1/2″
high. Saucer: 4 1/2″ in diameter.
Courtesy of Warren and Connie Macy.
$350-450 each

LA BELLE salt dip. 1″ high x 2″
wide. *Courtesy of Tom and
Kathy Clarke.* $500+ (extremely rare)

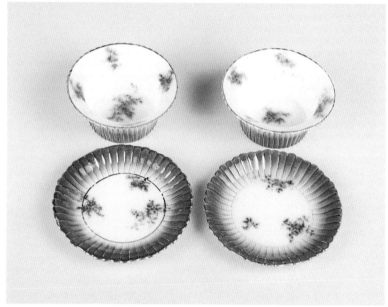

LA BELLE triangular "trivet" with
bamboo decoration. 11″ x 10 3/4″ x 10
1/2″. *Courtesy of Tom and Kathy Clarke.*
$1000+ (very rare)

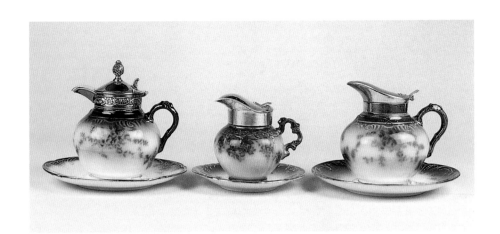

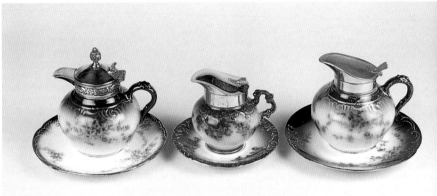

Above and right:
LA BELLE syrups and undertrays. Left, fancy: 4 1/4" to lip. 7 1/2" in diameter undertray. Center: 4" to lip. 6" in diameter undertray. Right, plain: 5" to lip. 7 1/2" in diameter undertray. *Courtesy of Warren and Connie Macy.* Fancy: $950-1150; Plain: $700-850; Small: $550-650

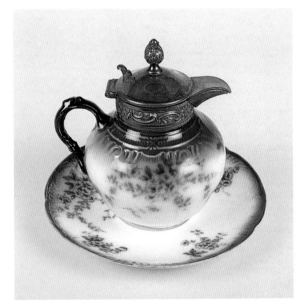

Left and below:
LA BELLE syrup pitcher. This is the fanciest syrup Wheeling Pottery Company made. 6 1/2" high to finial. 7 1/4" in diameter undertray. *Courtesy of Tom and Kathy Clarke.* Pitcher: $1000+. Undertray: $300+

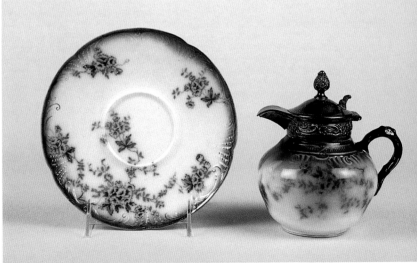

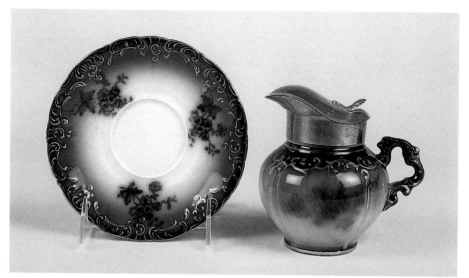

LA BELLE syrup and undertray. Syrup: 4 5/8" high. Undertray: 6 1/2" in diameter. *Courtesy of Tom and Kathy Clarke.* $650+ set

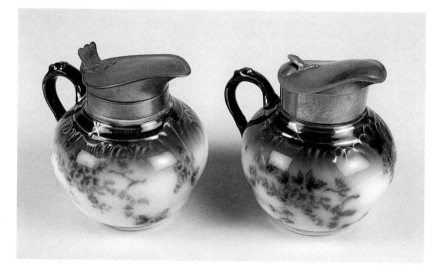

Two LA BELLE syrups. Note the two different spouts and thumb tabs. 5" high to spout each. *Courtesy of Tom and Kathy Clarke.* $800+

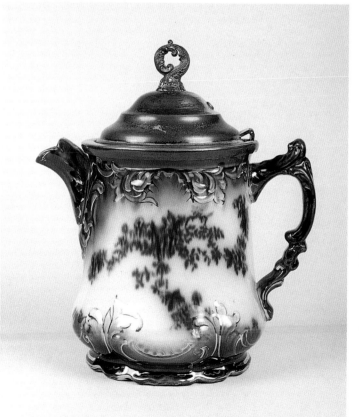

LA BELLE strawberry decorated syrup. 4" high. *Courtesy of Jerry and Margaret Taylor.* $700-770

LA BELLE ice pitcher. 11 3/4" high to finial. *Courtesy of Tom and Kathy Clarke.* $2000+

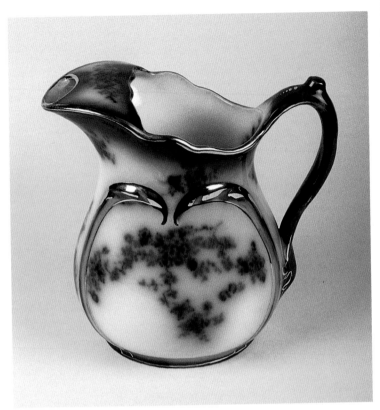

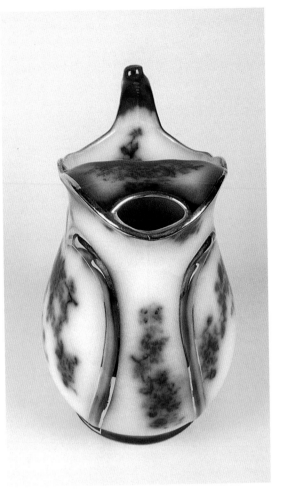

LA BELLE pitcher with an ice lip and gold gilt. The very completeness of the gold shows the limited use of this piece. Part of the company's hotel & restaurant ware line in the Gibraltar body style. 9" high. *Courtesy of Tom and Kathy Clarke.* $2000+

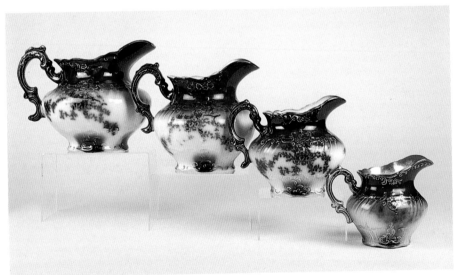

Above and right:
LA BELLE pitchers featuring the printed "La Belle China" mark and gold "A B" initials. 7", 6 1/2", 5 1/2", & 4 1/2" high. *Courtesy of Tom and Kathy Clarke.* $400-700+

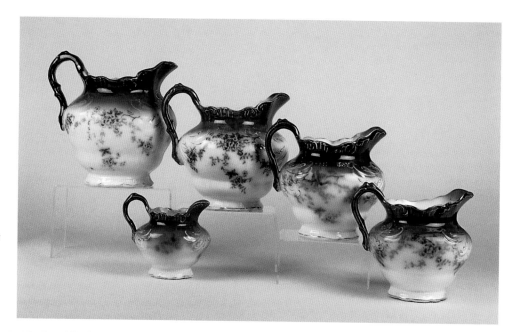

LA BELLE pitchers including the creamer (the smallest piece). 7 1/2", 6 3/4", 6", 5 1/2", & 4 1/4" high to spout. *Courtesy of Tom and Kathy Clarke.* $350-600+

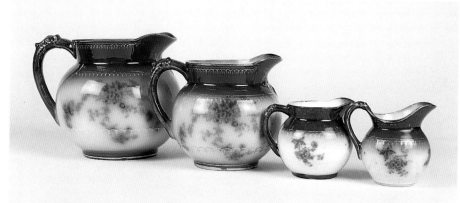

Left to right: Two LA BELLE pitchers in the "Dolphin" shape, featuring this dolphin handle. Two smaller LA BELLE creamers. Smallest: 3 3/4" high. *Courtesy of Tom and Kathy Clarke.* $300-600+

Left:
LA BELLE card cake plate. 12" handle to handle. *Courtesy of Warren and Connie Macy.* $700-800

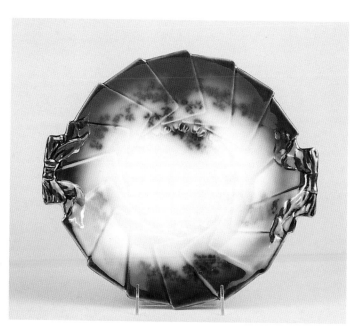

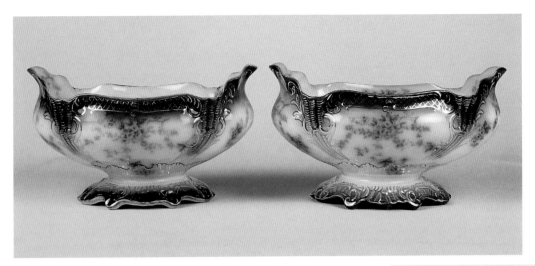

LA BELLE orange bowls, open (lidless) & oval in shape with upward flaring rims. 6 1/4" high x 11 1/2" in length. *Courtesy of Tom and Kathy Clarke.* $2500+

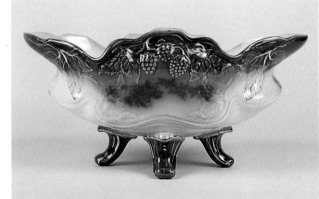

LA BELLE raspberry bowl, open (lidless) & oval in shape with raspberries molded into the side. 5 5/8" high x 12 1/2" in length. *Courtesy of Tom and Kathy Clarke.* $3000+

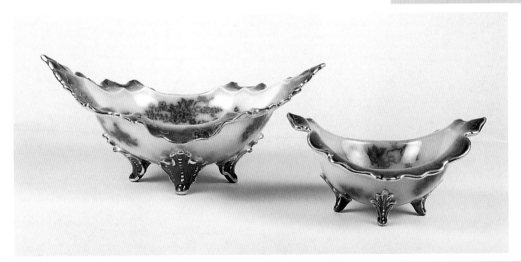

Above and right:
LA BELLE "Oriental" fruit and nut bowls (a.k.a. "helmet bowls").
Fruit: 5 1/2" high x 13" in length.
Nut: 4" high x 8 1/4" in length.
Courtesy of Tom and Kathy Clarke. Fruit bowl: $300+. Nut bowl: $250+

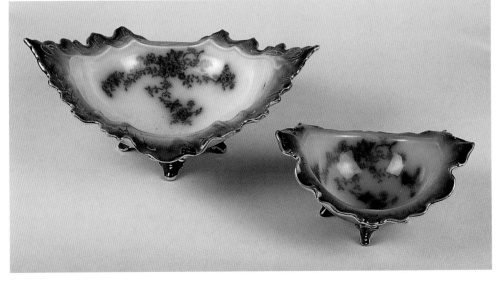

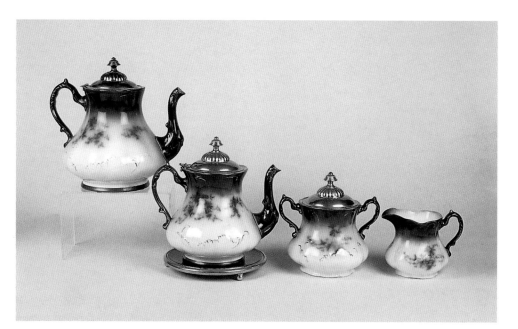

LA BELLE tea set, metal lidded set with two sizes of teapot. Included trivet for the teapot. Teapot: 8 1/2" high. Teapot: 7 3/4" high. Sugar: 6 1/2" high. Creamer: 3 3/4" high. Trivet: 6 5/8". *Courtesy of Tom and Kathy Clarke.* Teapot, 8 1/2": $3000+. Tea set, four piece: $5000+

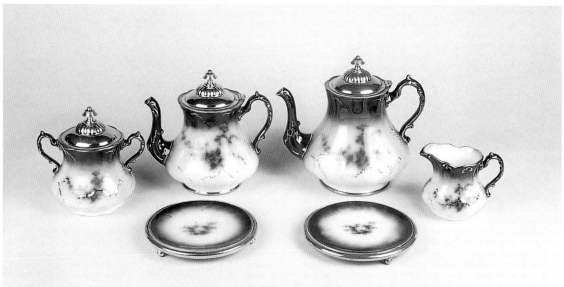

LA BELLE tea set with metal lids. Stamped into the metal base is the patent date "Dec. 24, 1895." 7 1/2" high teapot & 8 1/2" high teapot. *Courtesy of Warren and Connie Macy.* Teapots: $3000+ each; trivets: $750-1000 each; cups and saucers: $1000-1100; six piece set: $9000-9900

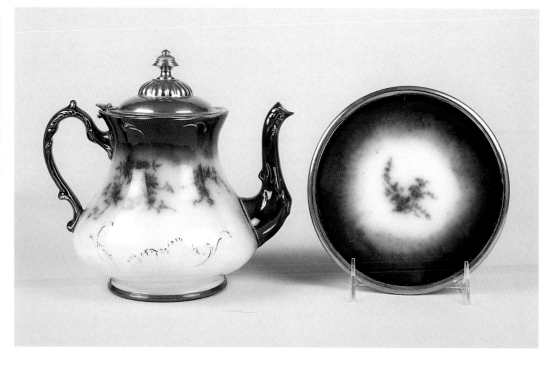

A closer look at the LA BELLE teapot and trivet. *Courtesy of Tom and Kathy Clarke.*

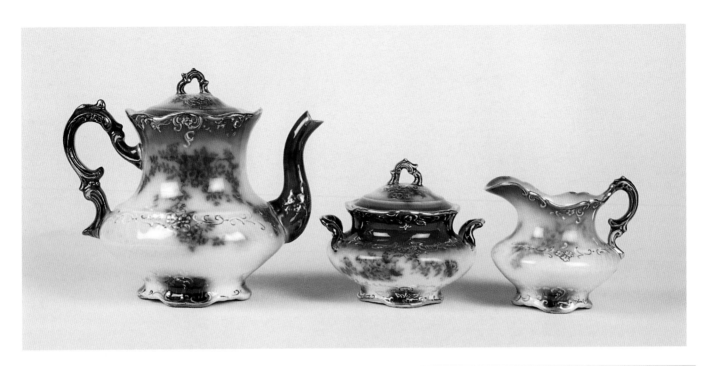

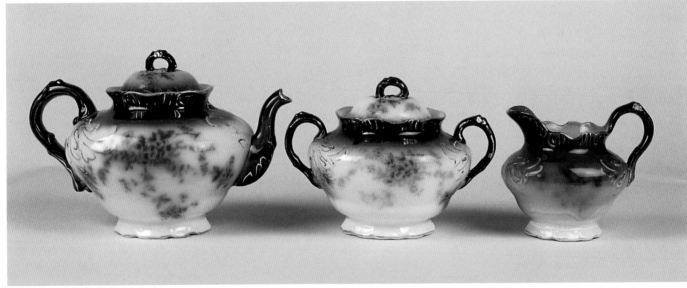

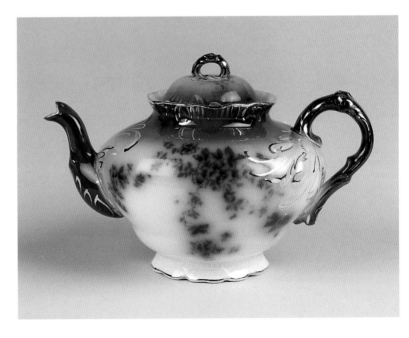

Top:
LA BELLE tea set. Teapot: 7 3/4" high. Sugar: 5" high.
Creamer: 4" high. *Courtesy of Tom and Kathy Clarke.*
$4000+

Center:
LA BELLE tea set. Teapot: 6 1/2" high. Sugar: 5 3/8" high.
Creamer: 4 1/4" high. *Courtesy of Tom and Kathy Clarke.*
$4000+

Right:
LA BELLE teapot. 6" high. *Courtesy of Warren and Connie Macy.* $3000+

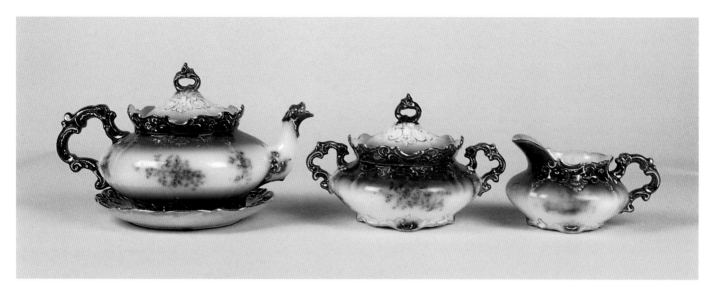

LA BELLE rare tea set from Wheeling's Cameo line of china. Teapot: 5 1/4" high. Sugar: 4 1/2" high. Creamer: 3" high. Teapot's underplate: 6" in diameter. *Courtesy of Tom and Kathy Clarke.* $5000+ set

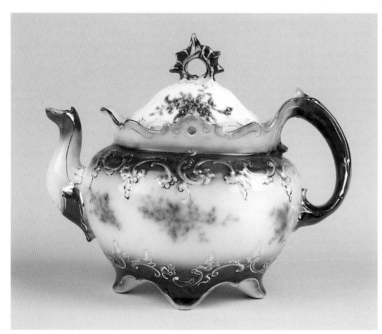

Left and below:
Ornate LA BELLE teapot. 6 3/4" high to finial. *Courtesy of Warren and Connie Macy.* $3000+

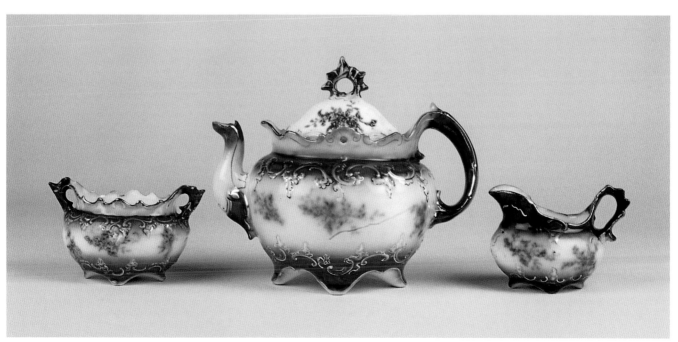

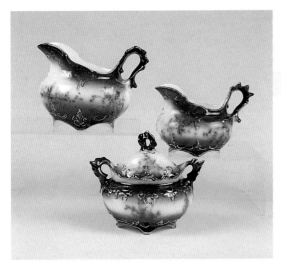

Two ornate creamers & a sugar. Note the distinctive handles. Creamers: 3 1/2" & 2 7/8" high respectively. Sugar: 4" high. *Courtesy of Tom and Kathy Clarke.* $350+ each

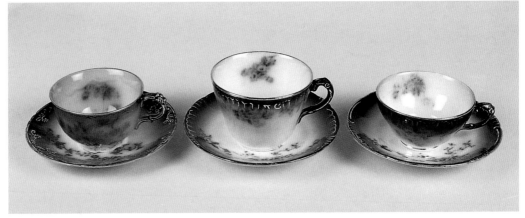

LA BELLE cups and saucers. Left: cup: 3 3/4" in diameter x 2 1/4" high, saucer: 6 1/4" in diameter. Middle: coffee cup: 3 3/4" in diameter x 3 1/4" high, saucer: 6 1/4" in diameter. Right: cup: 3 7/8" in diameter x 2 1/8" high, saucer: 5 7/8" in diameter. *Courtesy of Tom and Kathy Clarke.* Left: $150+. Middle: $300+. Right: $150+

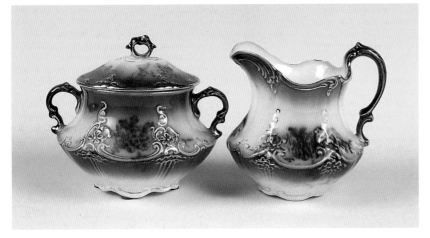

LA BELLE sugar and creamer. Creamer: 4 1/8" high. Sugar: 4 7/8" high. *Courtesy of Tom and Kathy Clarke.* $800+ set

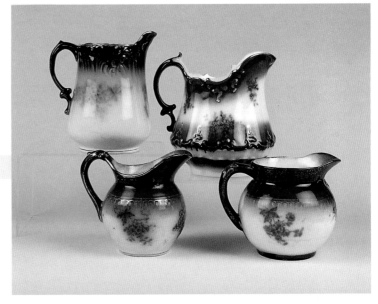

LA BELLE creamers. Top: 5" each to spout. Bottom: 3 7/8" & 3 3/4" high to spout. *Courtesy of Tom and Kathy Clarke.* $350-650

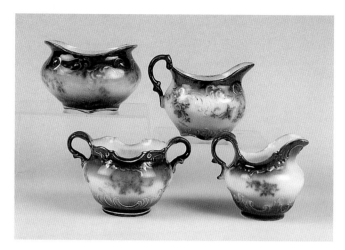

LA BELLE sugars and creamers (2 sets). Top: creamer: 3 3/8" high to spout; sugar: 3" high. Bottom: creamer: 3" high to spout; sugar: 2 7/8" high. *Courtesy of Tom and Kathy Clarke.* $600+ per set

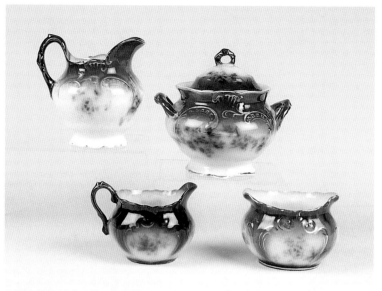

LA BELLE creamers & sugars. Top: cream: 3" h., sugar: 2 7/8" high. Bottom: cream: 3 7/8" high. sugar 5". *Courtesy of Tom and Kathy Clarke.* $600+ per set

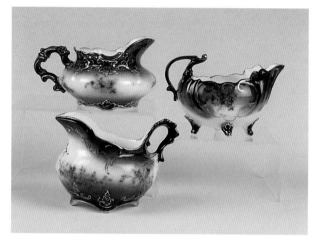

LA BELLE creamers. Top left: cameo creamer, 3" high. Top right: shell creamer, 3 7/8" high. Bottom: creamer, 3 5/8" high. *Courtesy of Tom and Kathy Clarke.* $350-600+

In some cases, Wheeling Pottery Company covered their marks in this way. *Courtesy of Tom and Kathy Clarke.*

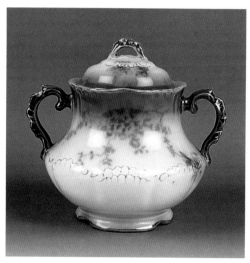

LA BELLE sugar bowl. 6 1/4" high. *Courtesy of Tom and Kathy Clarke.* $500+

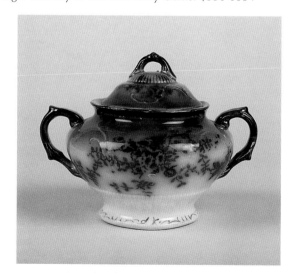

LA BELLE sugar bowl. *Courtesy of Tom and Kathy Clarke.* $350+

Three LA BELLE waste bowls. Left to right: 5 3/4" in diameter x 2 3/4" high, 5 1/2" in diameter x 2 3/4" high, 5 3/4" in diameter x 2 3/4" high. *Courtesy of Tom and Kathy Clarke.* $700+ each

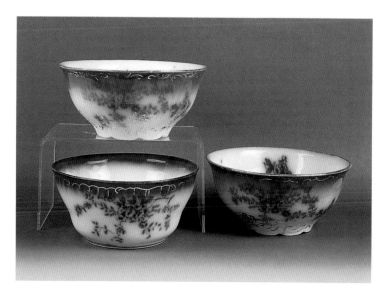

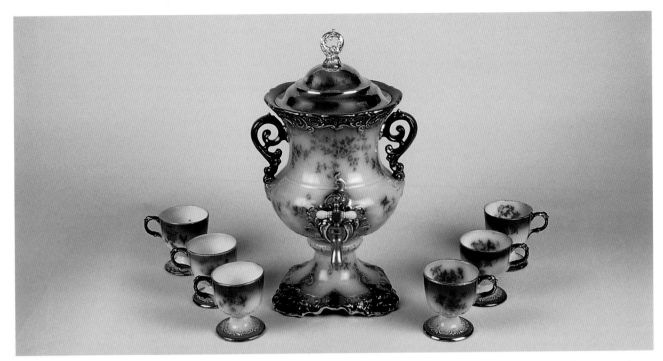

LA BELLE samovar (with a replacement silver lid—original lids are always the most likely pieces to be broken over time) with cups. Samovar: 15" high. Cups: 3 3/8" high. *Courtesy of Tom and Kathy Clarke.* Samovar: $5000+. Cups: $650+

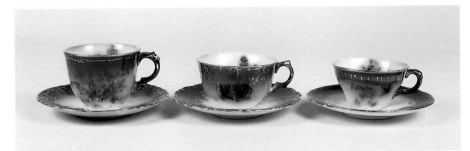

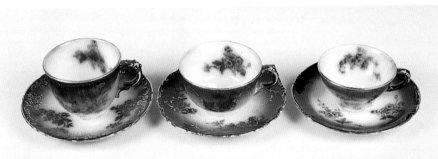

Center left, bottom left, and bottom right:
Three demitasse cups and saucers. Left: cup: 2 1/4" high, saucer: 5 1/8" in diameter. Middle: cup: 1 7/8" high, saucer: 5" in diameter. Right: cup: 1 3/4" high, saucer: 5" in diameter. *Courtesy of Tom and Kathy Clarke.* $350+ each style

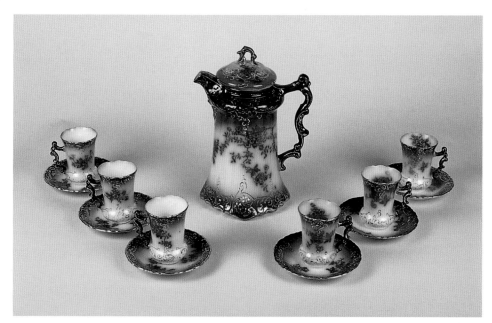

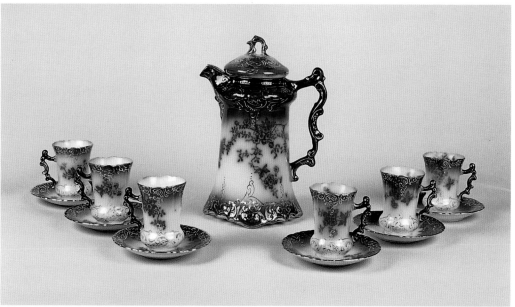

Above and right:
LA BELLE chocolate set.
Chocolate pot: 9 3/4" high.
Cup: 3 1/4" high. *Courtesy of Tom and Kathy Clarke.* $4500+ set. Cups & saucers: $500+ each. Cups and saucers are very hard to find.

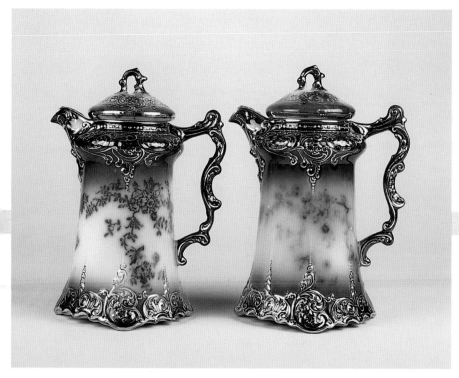

LA BELLE chocolate pots. 9 1/2" high to finial. *Courtesy of Warren and Connie Macy.* $1200-1500 each

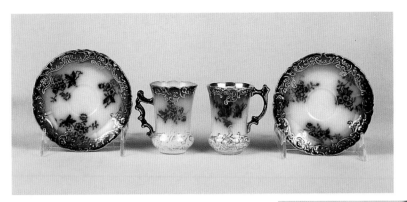

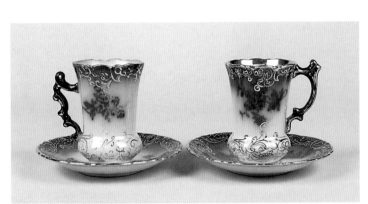

LA BELLE chocolate cups with different handle styles. Cups: 3 1/8" high. Saucers: 4 3/4" in diameter. *Courtesy of Tom and Kathy Clarke.* $500+ each

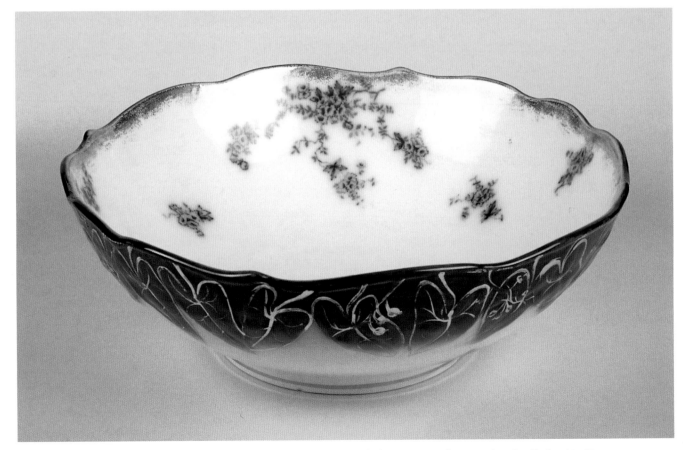

LA BELLE possible punch bowl. 15" in diameter x 5 1/8" high. *Courtesy of Tom and Kathy Clarke.* $2500+

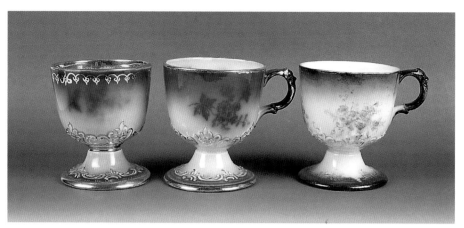

Above two photos:
LA BELLE punch cups. 3 3/8" high
each. *Courtesy of Tom and Kathy
Clarke.* $550-650+

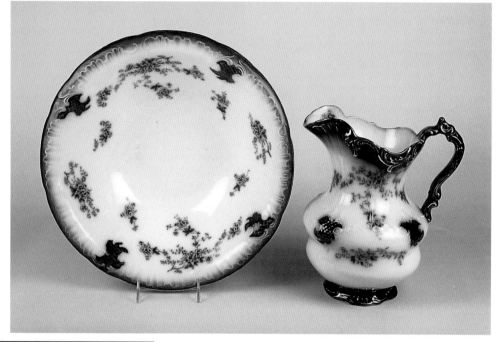

LA BELLE "Blue Diamond" wash pitcher and basin. Pitcher: 10 1/
2" high. Basin: 15 1/2" in diameter. *Courtesy of Tom and Kathy
Clarke.* $3000+ set

LA BELLE hot water pitcher from a toilet set. 5 3/4"
high. *Courtesy of Tom and Kathy Clarke.* $500+

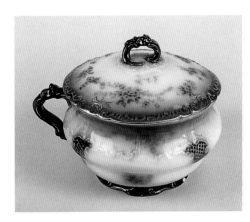

LA BELLE "Blue Diamond" chamber pot.
8 3/4" high x 8 3/4" in diameter. *Courtesy of Tom and Kathy Clarke.* $1000+

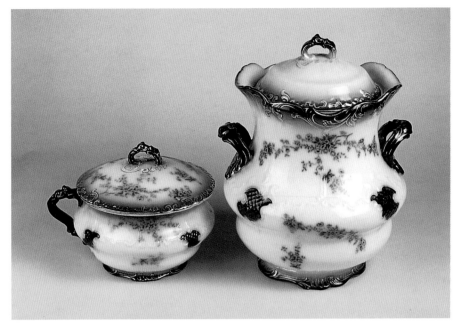

LA BELLE "Blue Diamond" chamber pot and slop jar. Chamber pot: 8" high. Slop jar: 14 1/2" high. *Courtesy of Warren and Connie Macy.* Chamber pot: $750-1000; slop jar: $1500-2000

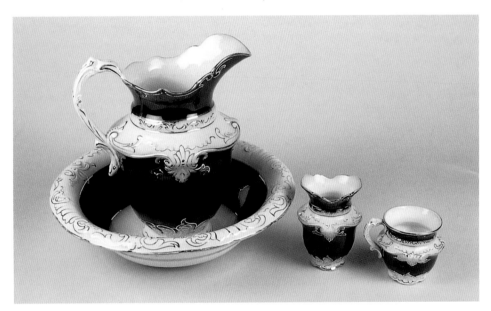

Above and right:
LA BELLE toilet ware. Pitcher and basin, toothbrush holder & shaving mug. *Courtesy of Tom and Kathy Clarke.* $4000+ set

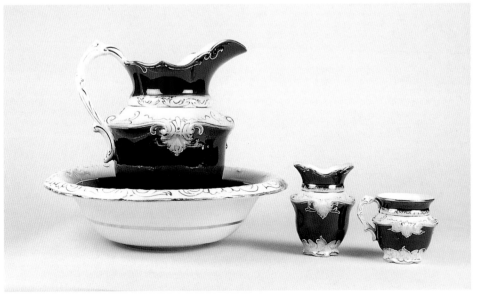

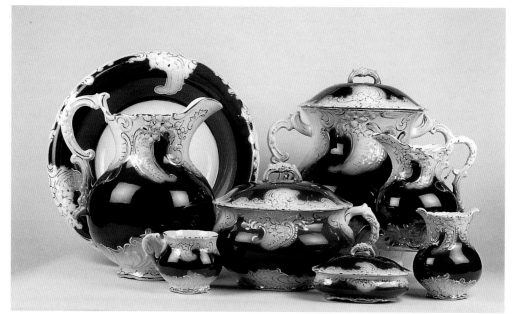

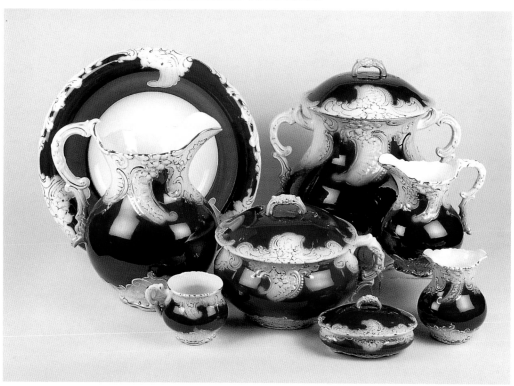

Left and below:
Full twelve piece LA BELLE "Millionaires Pride" toilet ware set. Pitcher and bowl, hot water pitcher, three piece soap dish, chamber pot, toothbrush holder. 14 1/2" high waste jar. *Courtesy of Tom and Kathy Clarke.* $10,000+ set

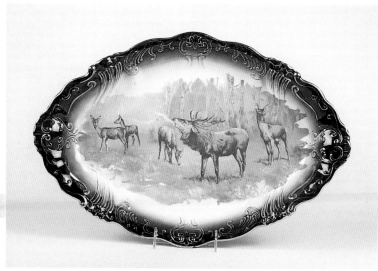

LA BELLE game set. Platter: 19 1/2" x 12 3/4".
Courtesy of Tom and Kathy Clarke. $1500+

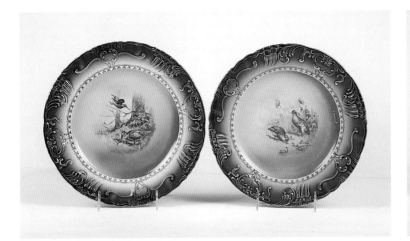

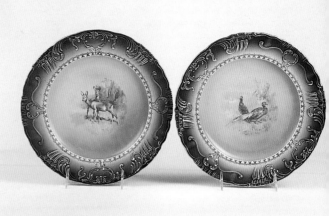

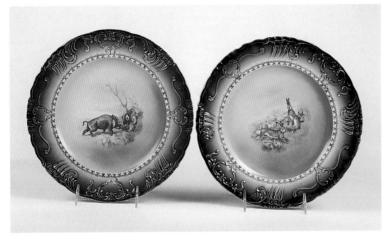

Three photos:
LA BELLE game set plates. 10 3/8" in diameter. *Courtesy of Tom and Kathy Clarke.* $200+ each

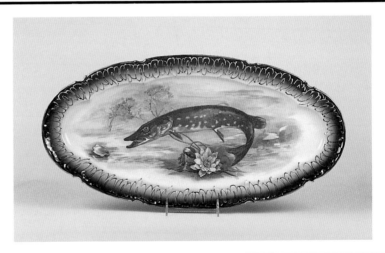

LA BELLE fish set platter featuring the portrait of a northern pike. This is a very rare piece. 22 1/2" x 11". *Courtesy of Tom and Kathy Clarke.* $1500+

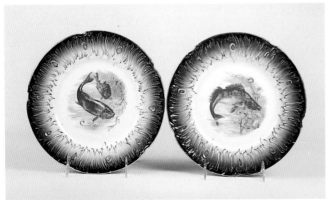

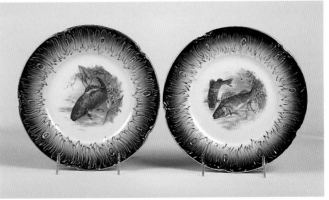

LA BELLE fish set plates. These plates are very rare. 8 3/4" in diameter. *Courtesy of Tom and Kathy Clarke.* $200+ each

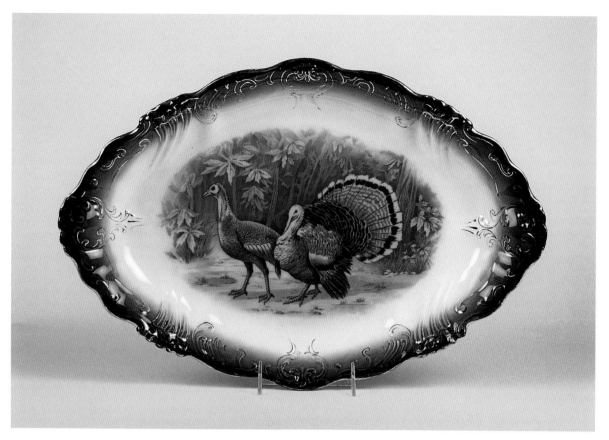

LA BELLE turkey platter. 19 1/2″ in length x 12 3/4″ wide. *Courtesy of Tom and Kathy Clarke.* $1700-2000

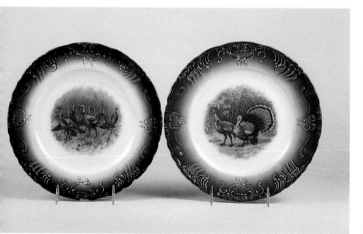

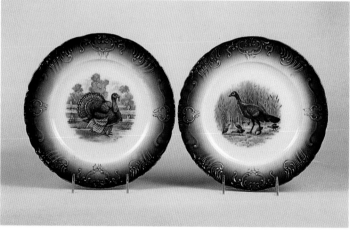

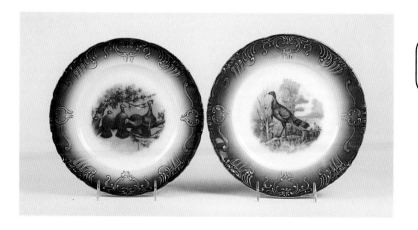

Three photos:
LA BELLE turkey plates. 10 3/8″ in diameter.
Courtesy of Tom and Kathy Clarke. $225+
each

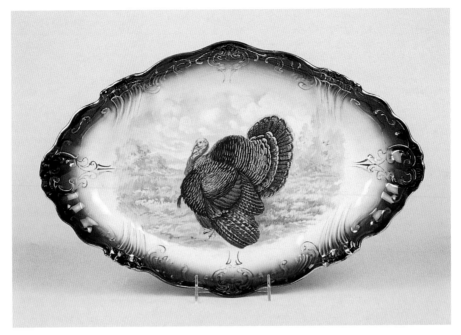

LA BELLE turkey platter. 19 1/2" x 12 3/4". *Courtesy of Tom and Kathy Clarke.* $1700+

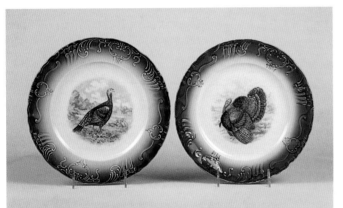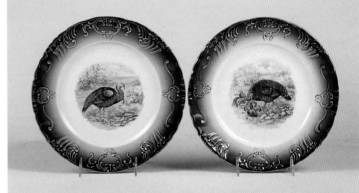

LA BELLE turkey plates. 10 1/4″ in diameter. *Courtesy of Tom and Kathy Clarke.* $225+ each

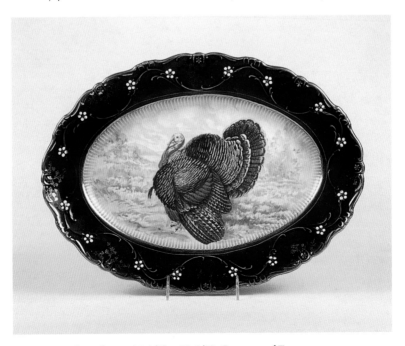

LA BELLE turkey platter. 17 1/4" x 12 1/2". *Courtesy of Tom and Kathy Clarke.* $1200+

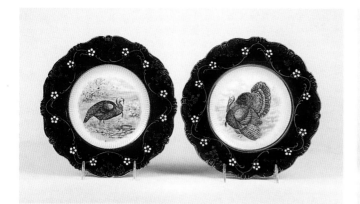
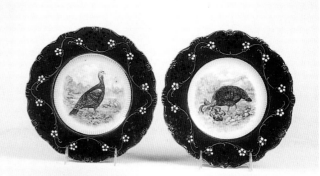

LA BELLE turkey plates. 9 7/8" in diameter. *Courtesy of Tom and Kathy Clarke.* $200+ each

The company divided the portrait plates, trays, and chargers, into the "High Art" Plaque Assortment and the "Royal" Plaque Assortment. About the High Art Plaque Assortment was written, "The heads and figures were adopted after a most thorough search through the choicest specimens exhibited in both American and foreign art studios. ... The Borders all have a ground work of the celebrated Royal LA BELLE Blue. ... The assortment consists of Large Round Plaque, 11 1/4 inches; Oval Plaque Tray, 10 x 13 inches; Coupe Plaque, 10 inches; and Square Tray, 8 1/2 x 10 inches." Of the Royal Plaque Assortment, the company stated, "The figures in this assortment are of particularly desirable subjects, each being regarded by critics as a famous work of art. ... The assortment consists of Virginia Plaque, 10 inch; Coupe Plaque, 7 1/2 inch; Card Plaque, 8 inch; and Oblong Plaque, 7 1/2 x 10 1/2 inch." (Wheeling Potteries Company 1906)

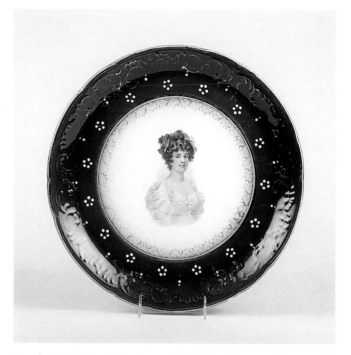

Royal LA BELLE portrait charger. 14 1/2" in diameter. *Courtesy of Tom and Kathy Clarke.* $500+

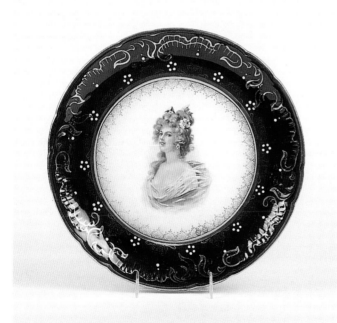

Royal LA BELLE portrait charger. These chargers feature holes in the foot rim, allowing the chargers to be hung on the wall. 12 5/8" in diameter. *Courtesy of Tom and Kathy Clarke.* $350+

Royal LA BELLE portrait charger. 14 1/2" in diameter. *Courtesy of Tom and Kathy Clarke.* $500+

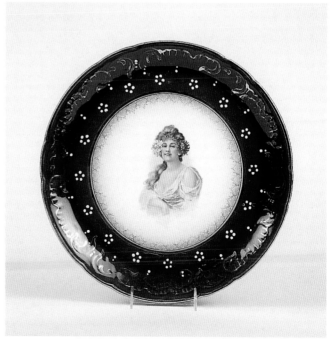

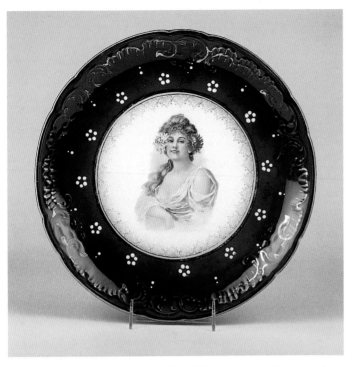

Royal LA BELLE portrait charger. 12 3/4" in diameter. *Courtesy of Warren and Connie Macy.* $300-400

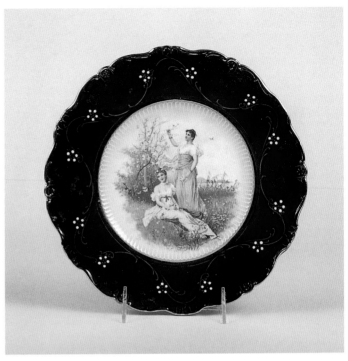

Royal LA BELLE charger. 11 1/4" in diameter. *Courtesy of Tom and Kathy Clarke.* $175+

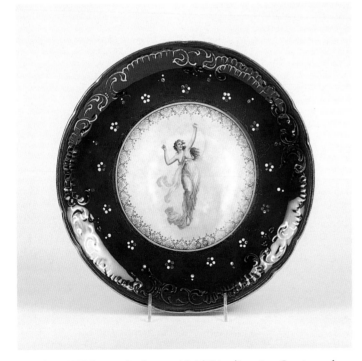

Royal LA BELLE portrait charger. 12 3/4" in diameter. *Courtesy of Tom and Kathy Clarke.* $350+

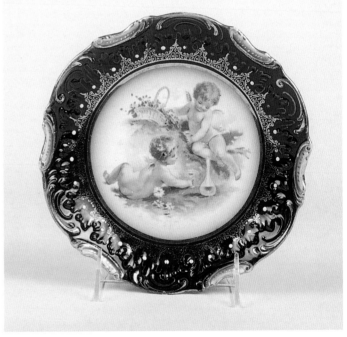

LA BELLE portrait tray with cherubs. 7 1/4" in diameter. *Courtesy of Tom and Kathy Clarke.* $400+

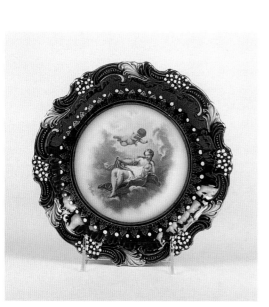

LA BELLE portrait tray featuring a reclining woman & cherub (featuring either a signature or the name of the character portrayed). 8 1/4″ in diameter. *Courtesy of Tom and Kathy Clarke.* $400+

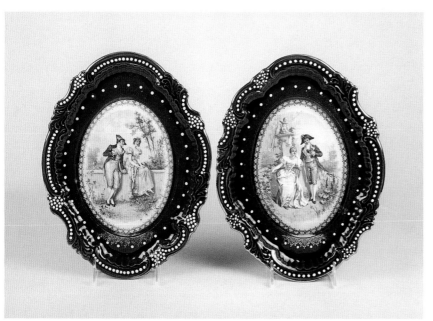

LA BELLE portrait trays. Left: 13″ x 10″. Right: 13″ x 10″. *Courtesy of Tom and Kathy Clarke.* $400+ each

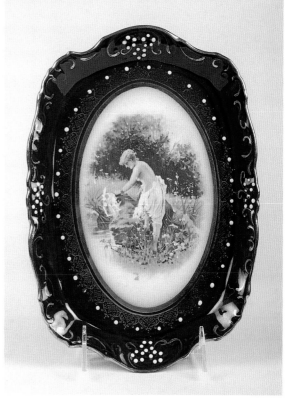

LA BELLE portrait tray. 10 1/2″ x 7 1/2″. *Courtesy of Tom and Kathy Clarke.* $400+

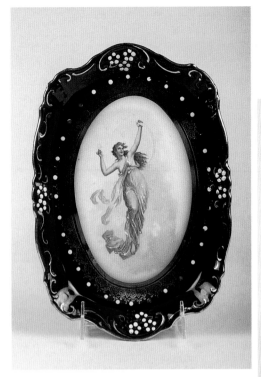

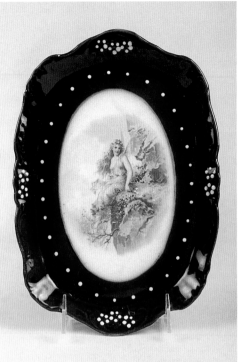

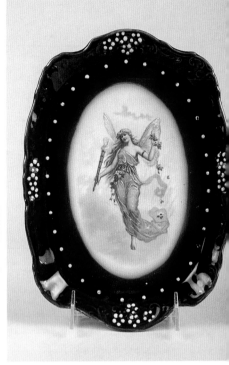

Three photos:
Three LA BELLE portrait trays. 10 1/2" x 7 1/2". *Courtesy of Tom and Kathy Clarke.* $400+ each

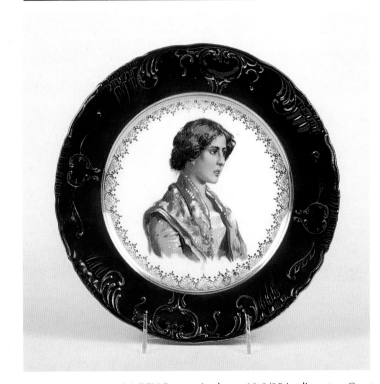

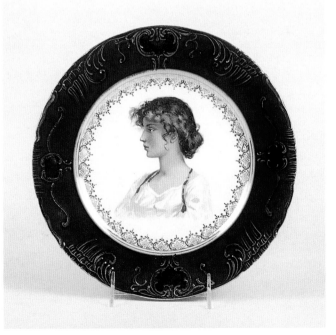

LA BELLE portrait plates. 10 3/8" in diameter. *Courtesy of Tom and Kathy Clarke.* $250-300 each

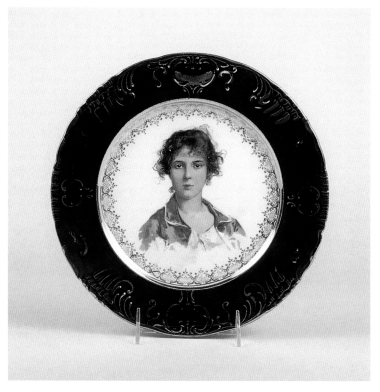

LA BELLE portrait plate. 10 3/8" in diameter. *Courtesy of Tom and Kathy Clarke.* $250-300

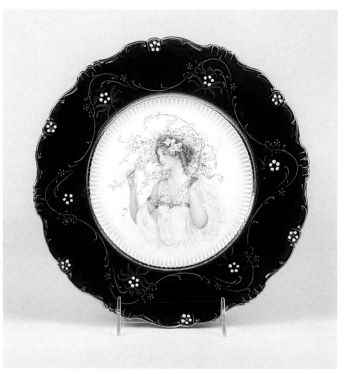

LA BELLE portrait plate. 10" in diameter. *Courtesy of Warren and Connie Macy.* $250-300

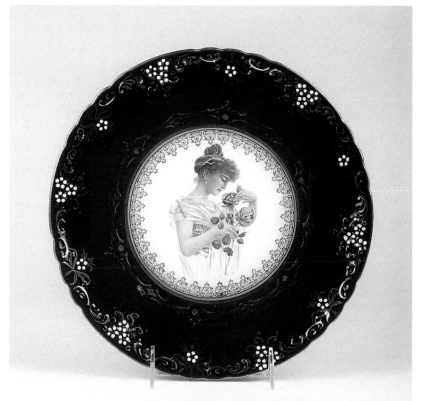

LA BELLE portrait plate. This plate once graced the shelves of a department store in Crawfordsville, Indiana. 10 3/4" in diameter. *Courtesy of Warren and Connie Macy.* $250-300

Wheeling Pottery Co., Wheeling, West Virginia, printed manufacturer's mark, c. 1904-1910. Included is a retailer's sticker reading, "L. Bischof / The Big Store / 127-129 E. Main St. / Crawfordsville, IND." *Courtesy of Warren and Connie Macy.*

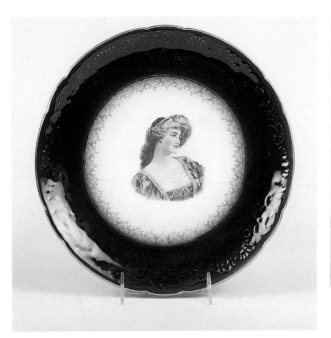

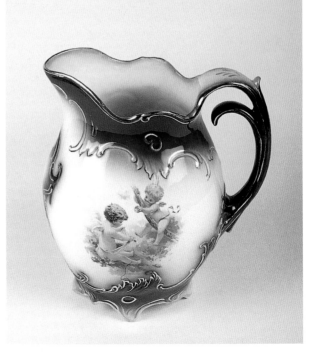

Above left and above:
LA BELLE portrait plates. 11 1/4" in diameter.
Courtesy of Tom and Kathy Clarke. $250+ each

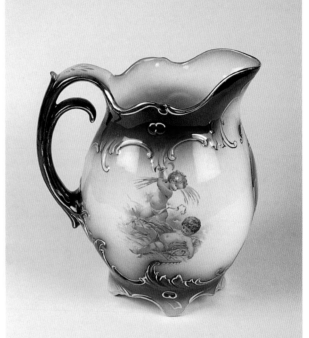

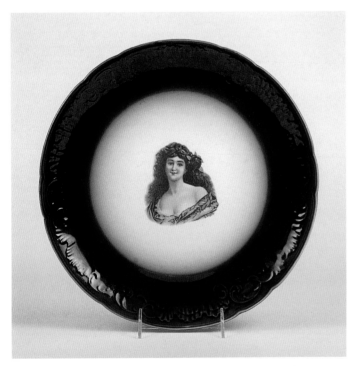

One last look at a Royal LA BELLE portrait charger. 12 5/8" in diameter. *Courtesy of Tom and Kathy Clarke.* $250+

Right and center right:
LA BELLE portrait pitcher. 9 3/4" high. *Courtesy of Tom and Kathy Clarke.* $1000+

Covered waste jar in LA BELLE with portraits of cherubs. 13 1/2" high. *Courtesy of Warren and Connie Macy.* $3000+

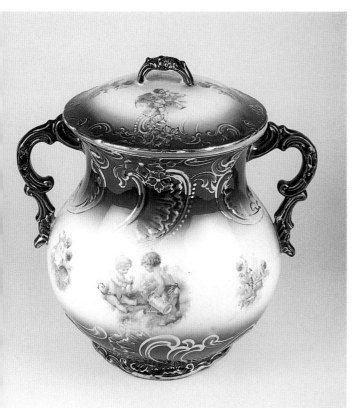

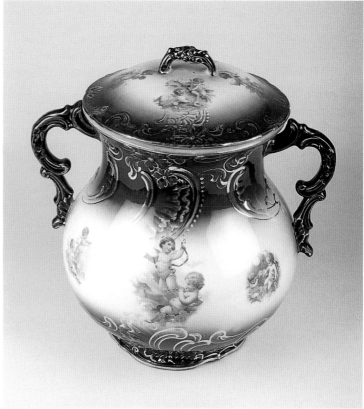

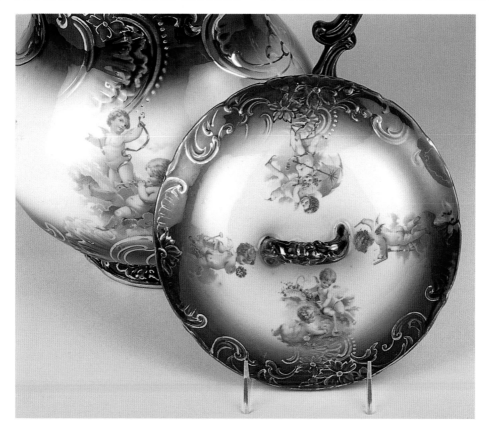

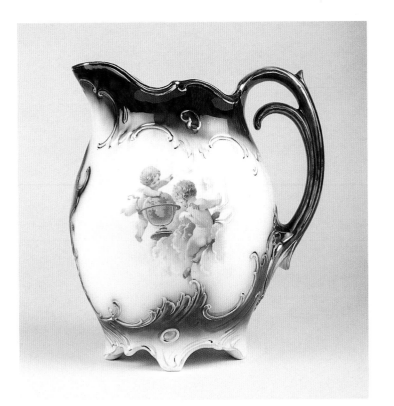

These two pages:
LA BELLE portrait pitchers. 10"
to lip. *Courtesy of Warren and
Connie Macy.* $800-900 each

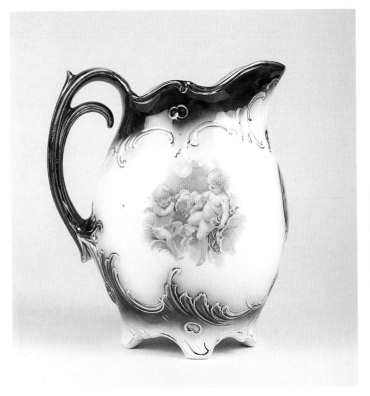

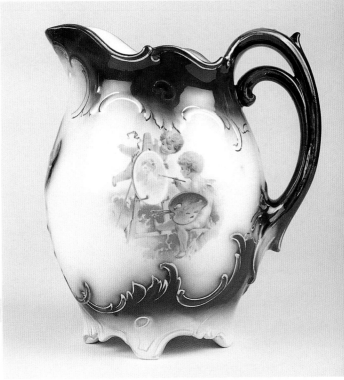

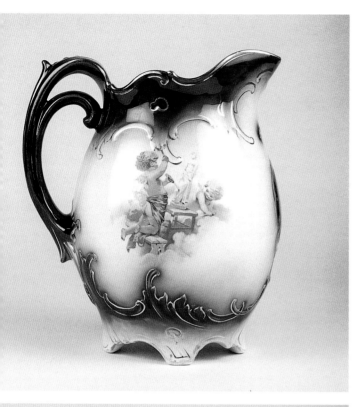

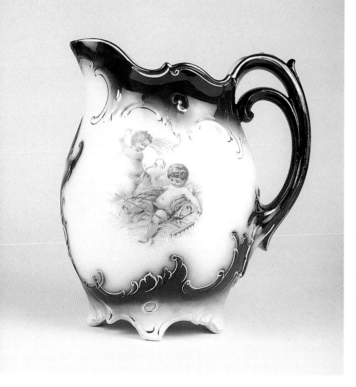

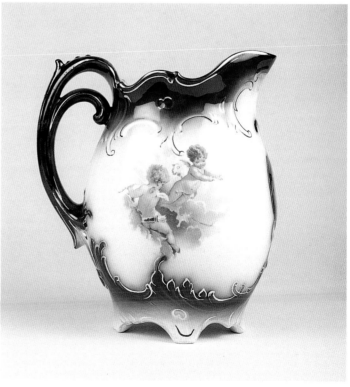

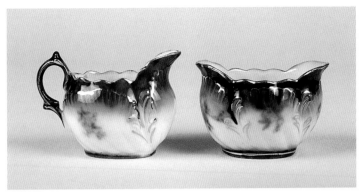

LA BELLE child's creamer and sugar. Creamer: 2 1/4" high. Sugar: 2" high. *Courtesy of Tom and Kathy Clarke.* $500+ each

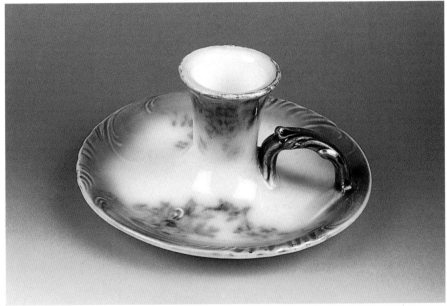

LA BELLE candle holder. 5 1/2" diameter base. *Courtesy of Warren and Connie Macy.* $2000+

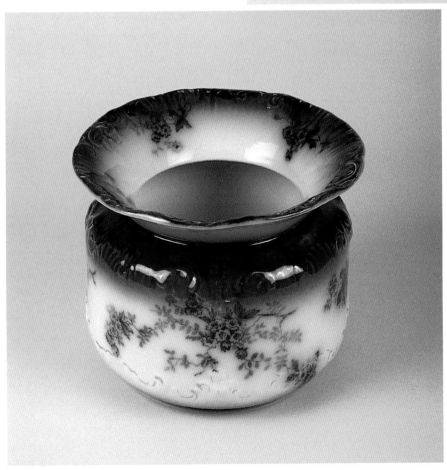

LA BELLE spittoon. 6" high x 7" in diameter. *Courtesy of Tom and Kathy Clarke.* $1300+

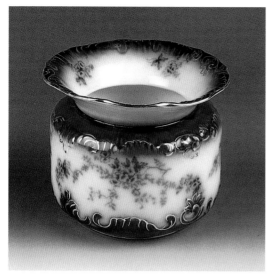

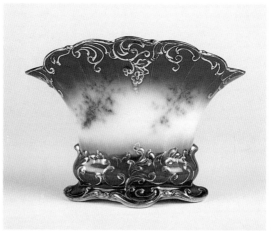

LA BELLE fan vase. 4 1/2"
high. *Courtesy of Warren
and Connie Macy.* $1500+

LA BELLE spittoon. 6" high x 7" in diameter.
Courtesy of Warren and Connie Macy. $900-1100

Chicago style LA BELLE vase. 12" high. *Courtesy of
Tom and Kathy Clarke.* $2000+

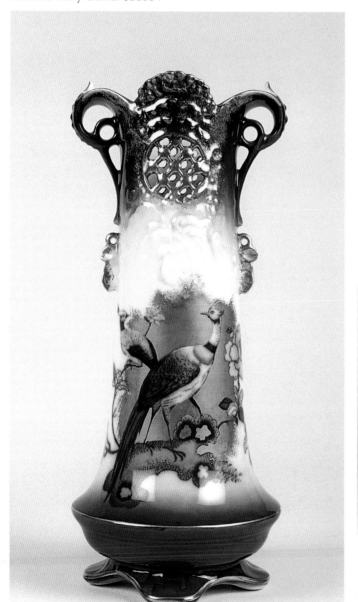

Right:
Small LA BELLE bud
vase with two handles.
7" high. *Courtesy of
Tom and Kathy Clarke.*
$2000+

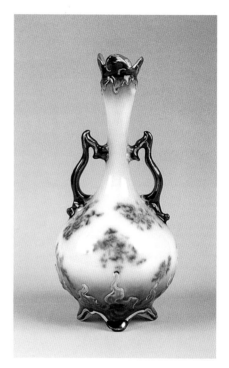

LA BELLE vase. 10 3/4" high. *Courtesy of
Warren and Connie Macy.* $2000+

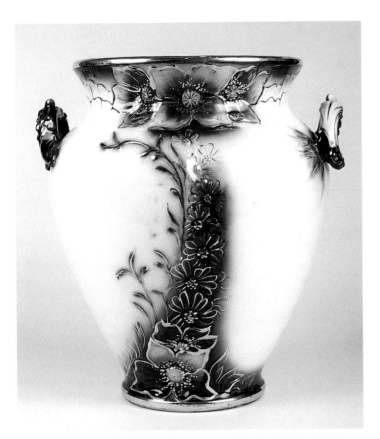

LA BELLE vase. 12" high. *Courtesy of Tom and Kathy Clarke.* $3000+

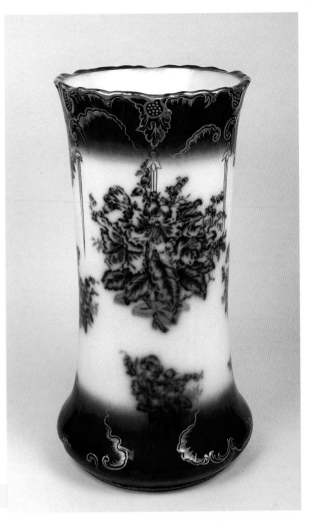

LA BELLE umbrella stand. 22 1/2" high. *Courtesy of Warren and Connie Macy.* $3000+

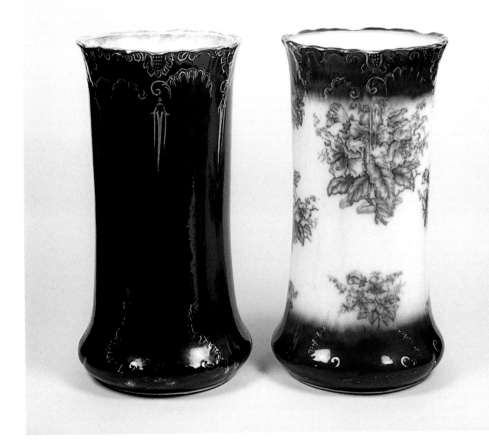

Two LA BELLE umbrella stands (same body style, different decoration). Left, cobalt & gold decoration: 22 1/2" high x 11" in diameter. Right, with chrysanthemums: 22 1/2" high x 11" in diameter. *Courtesy of Tom and Kathy Clarke.* Left: $3000+. Right: $2500+

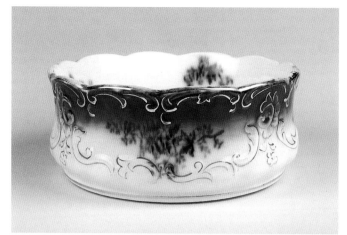

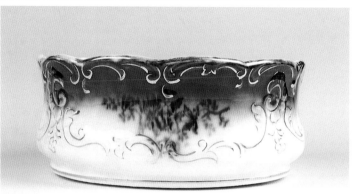

LA BELLE ferner. 8 1/2″ in diameter x 3 1/2″ high. *Courtesy of Warren and Connie Macy.* $700-800

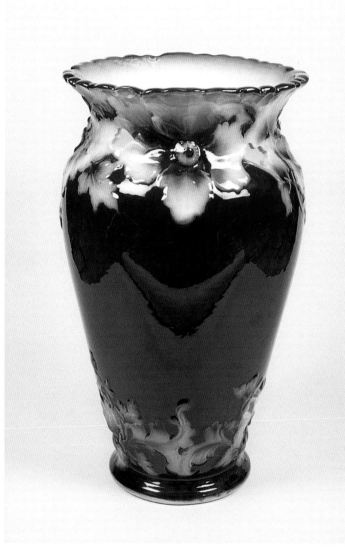

LA BELLE King Henry umbrella stand. This impressive piece is reticulated around some of the flower outlines. 22″ high x 12″ in diameter. *Courtesy of Tom and Kathy Clarke.* $4000+

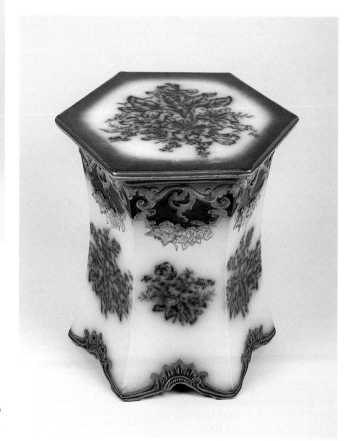

LA BELLE garden seat. 15 3/4″ high, 6 sided top, 12 5/8″ across top. *Courtesy of Tom and Kathy Clarke.* $2500+

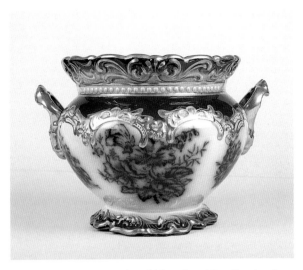

LA BELLE jardiniere with gold handles, Woodland style. 7 1/4" high x 8" in diameter. *Courtesy of Tom and Kathy Clarke.* $1000+

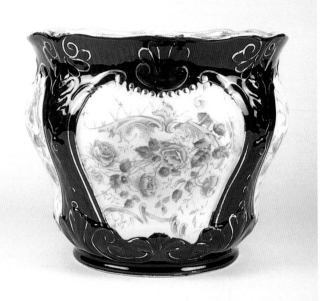

LA BELLE jardiniere identified with The Wheeling Pottery laurel wreath mark. 9 5/8" high x 11 1/4" in diameter. *Courtesy of Tom and Kathy Clarke.* $750+

Two LA BELLE jardinieres in the Senate style. Left: 8" high x 9 3/4" in diameter. Right: 6 3/8" high x 7 1/2" in diameter. *Courtesy of Tom and Kathy Clarke.* $850-1000+ each

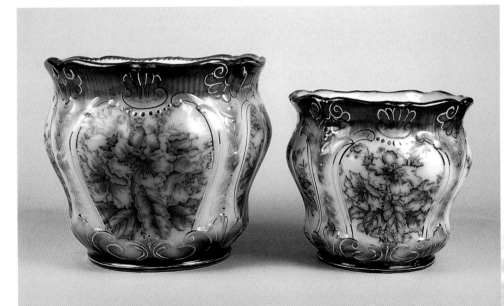

Two LA BELLE jardinieres with identical decoration. Left: 9 3/4" high x 11 1/2" in diameter. Right: 8 1/4" high x 9 1/2" in diameter. *Courtesy of Tom and Kathy Clarke.* $1000+ each

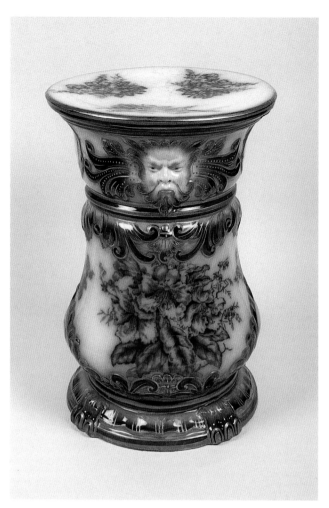

LA BELLE jardiniere stand. Note the distinctive face. Is that Old Man Winter? 18 1/4" high x 12 1/4" in diameter. *Courtesy of Tom and Kathy Clarke.* $2000+

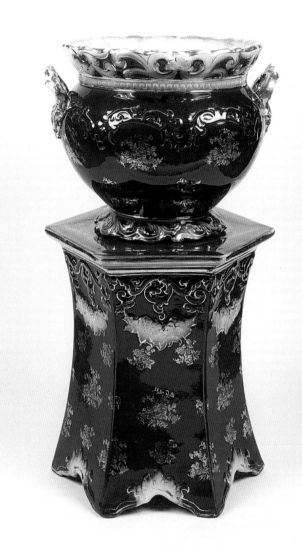

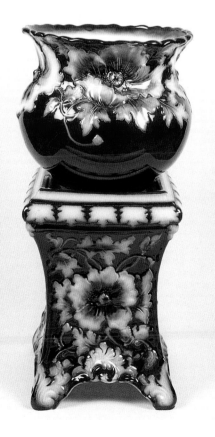

LA BELLE jardiniere stand and handled jardiniere. Stand: 15 1/2" high x 12 1/4" wide. Jardiniere: 10 3/4" high x 11 3/4" in diameter. *Courtesy of Tom and Kathy Clarke.* $6000+

LA BELLE jardiniere stand & jardiniere with relief flowers in the design. Stand: 16 1/8" high x 11 3/4" across widest points. Jardiniere: 10 5/8" high x 12 1/2" in diameter. *Courtesy of Tom and Kathy Clarke.* $7000+

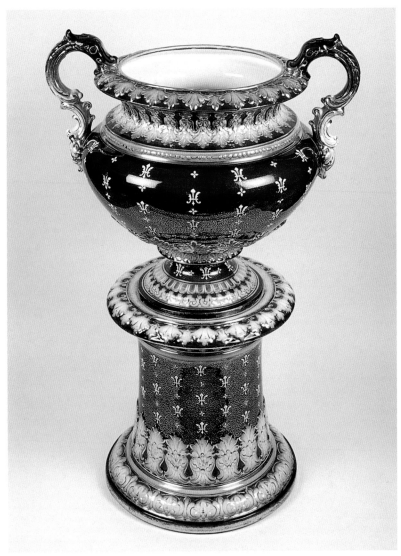

Henry Alcock & Company (Ltd.), Cobridge, Staffordshire, c. 1861-1910, printed manufacturer's mark in use from c. 1891-1910, with TOURAINE pattern name and registration number. According to the registration number, the firm registered its TOURAINE pattern in 1898. *Courtesy of James and Christine Stucko.*

The ever impressive LA BELLE Admiral Dewey jardiniere and stand. Note the gold work in the cobalt blue itself. 36" high together from the stand base to the top of the jardiniere handle. *Courtesy of Tom and Kathy Clarke.* $14,000+

Of the Admiral Dewey jardiniere and pedestal, the Wheeling Potteries Company catalog stated in 1906, "This superb Jardiniere and Pedestal is made in Royal La Belle Blue, and magnificently embellished by hand with the finest grades of colored gold. It stands 36 inches high, and holds a pot measuring 11 inches. It is a beautiful testimonial to our motto, 'The Best Made in America'." (Wheeling Potteries Company 1906)

Touraine

Two companies were largely responsible for the popular Touraine pattern displayed here. Henry Alcock & Company (Ltd.) produced Flow Blue in Cobridge in England's Staffordshire potting district from c. 1861-1910. Henry Alcock & Company registered their Touraine pattern in 1898. The Stanley Pottery Company Ltd. produced Flow Blue wares in Longton, also in the Staffordshire district from 1928-1931. The Stanley Pottery Company's Touraine pattern was registered by its predecessor, Colclough & Co., in 1898 and continued to be used by Stanley Pottery Co. Ltd.

Stanley Pottery Company, Longton, Staffordshire, 1928-1931, printed manufacturer's mark in use from 1928-1931, with "TOURAINE" pattern name and registration number. The Stanley TOURAINE pattern was registered by its predecessor, Colclough & Co., in 1898 and continued by Stanley Pottery Co. Ltd. *Courtesy of James and Christine Stucko.*

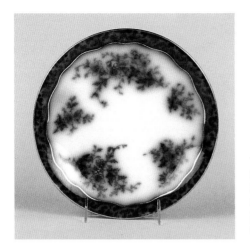

TOURAINE chop plate by Henry Alcock &
Co. This chop plate is an "in between" size
between the two largest plates. It features a
different border and weight than a standard
plate. 9 1/4" in diameter. *Courtesy of James
and Christine Stucko.* $185-200.

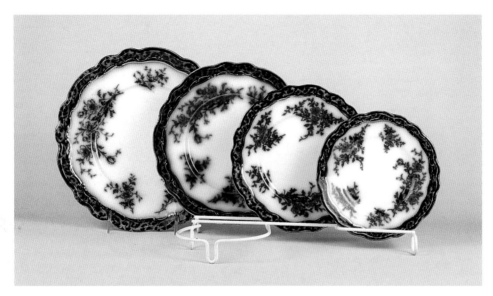

TOURAINE plates by Henry Alcock & Co. and Stanley Pottery Co. 10 1/4", 8 3/4", 7 3/4",
6 1/2" in diameter. *Courtesy of James and Christine Stucko.* Left to right: $125+; $75+;
$60+; $50+.

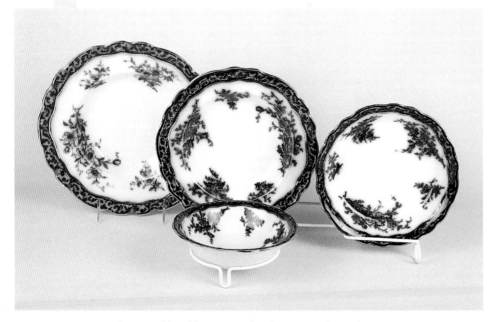

TOURAINE 5 1/4" sauce dish by
Stanley Pottery Co. *Courtesy of James
and Christine Stucko.* $40-45.

TOURAINE soups and a cereal bowl by Henry Alcock & Co. and Stanley Pottery Co. potteries.
10 3/4", 8 3/4", 7 1/2", 6 1/2" in diameter (cereal). *Courtesy of James and Christine Stucko.*
Left to right: $115-125; $85-90; $75-80; $45-50.

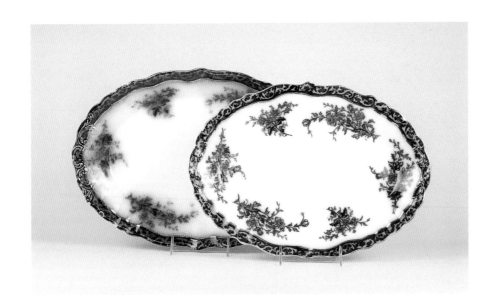

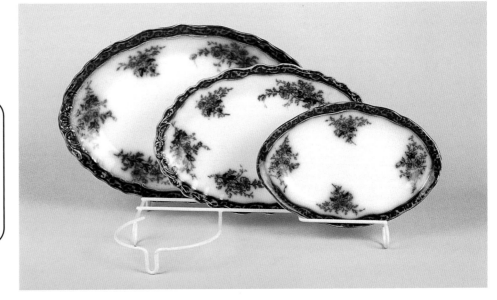

Above and right:
TOURAINE platters by Henry Alcock & Co. and Stanley Pottery Co. 17", 15", 12 1/2", 10 1/2", 8 1/2". *Courtesy of James and Christine Stucko.* 17": $275-300; 15": $250-275; 12 1/2": $200-220; 10 1/2": $165-180; 8 1/2": $100-110.

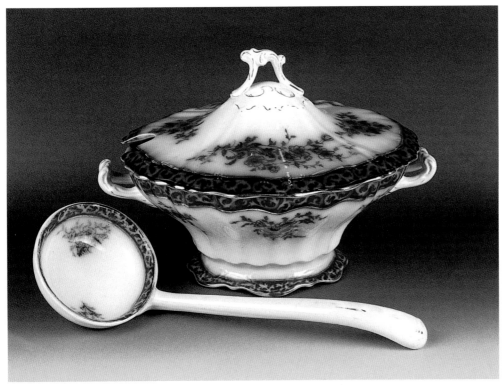

TOURAINE soup tureen by Henry Alcock & Co. 11" in length, 8" high. Ladle unmarked, 12" in length. *Courtesy of James and Christine Stucko.* $9000+

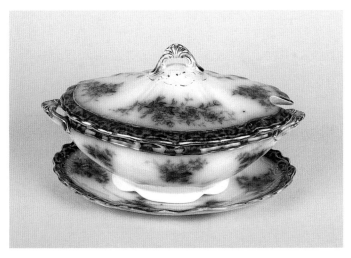

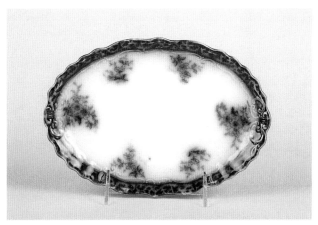

TOURAINE sauce tureen with undertray, Henry Alcock & Co. 9"
handle to handle. 5" high. *Courtesy of James and Christine Stucko.*
$4500+

TOURAINE sauce undertray by Henry Alcock & Co. *Courtesy
of James and Christine Stucko.* 1200+. Very rare.

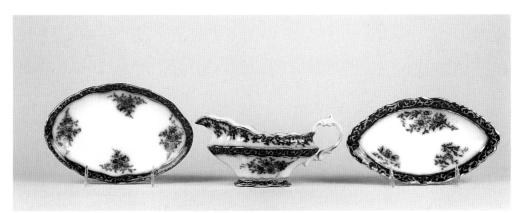

TOURAINE gravy boat by Stanley
Pottery Co. 8 1/2" in length x 3 1/
2" to spout high. The rounded
possible undertray is by Henry
Alcock & Co. and measures 8 1/4"
in length. The pointed undertray is
unmarked and measures 8 1/2" in
length. *Courtesy of James and
Christine Stucko.* $175-190 (gravy
boat & undertray)

TOURAINE covered
vegetable dishes by
Henry Alcock & Co.
Both dishes have fluted
sides. The larger dish
measures 12" in length.
The standard dish
measures 11" in length.
*Courtesy of James and
Christine Stucko.* 12":
$425-465; 11":
$375-410

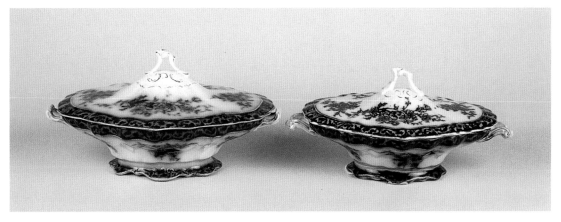

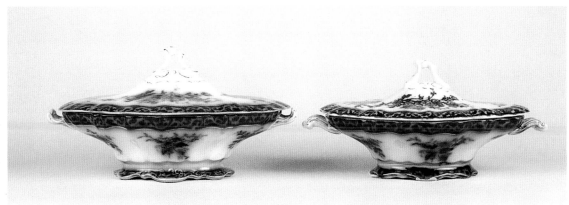

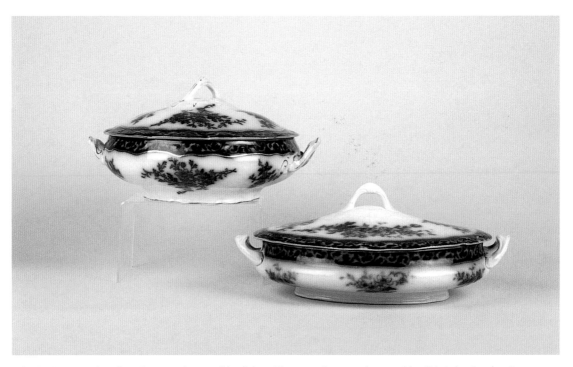

TOURAINE round and oval covered vegetable dishes. The round covered vegetable dish is by Stanley Pottery Co. and measures 11″ in diameter. An unusual oval covered vegetable dish is by Henry Alcock & Co., measuring 12" in length. Smooth sides and different handle, finial, and embossing make this oval covered vegetable dish unusual. *Courtesy of James and Christine Stucko.* Round: $750+ (very rare); Oval: $500+

TOURAINE open vegetables by Stanley Pottery Co. 8 1/2″, 9 3/4″. *Courtesy of James and Christine Stucko.* Left to right: $125+; $150+.

TOURAINE individual open vegetable dishes by Henry Alcock & Co. All these individual open vegetables have different edge treatments (left to right: embossing with tab handles, no embossing, and embossing,) and measure 5 3/4″ in length. *Courtesy of James and Christine Stucko.* $125-135 each.

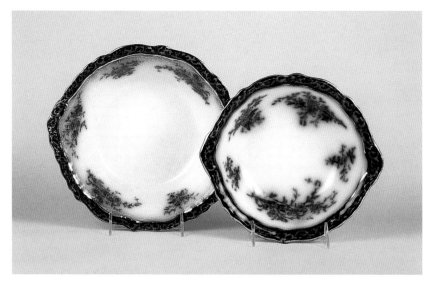

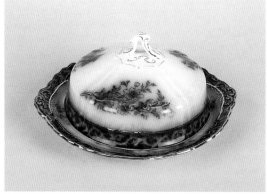

TOURAINE covered butter dish by Henry Alcock & Co. 8" in diameter to embossed handles. Height 4". *Courtesy of James and Christine Stucko.* $375-410

TOURAINE potato bowls by Henry Alcock & Co. 10 1/2" & 9 1/2" in diameter. *Courtesy of James and Christine Stucko.* Left to right: $250-275; $225-250.

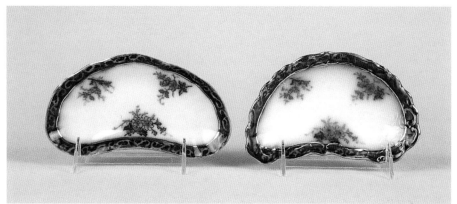

Above and left:
Two TOURAINE bone dishes. The example on the left was produced by Stanley Pottery Co. and measures 6 1/2" in length. The Stanley bone dish has a flat bottom. Henry Alcock & Co. made the footed bone dish on the right, which measures 6 1/4" in length. *Courtesy of James and Christine Stucko.* $125+ each.

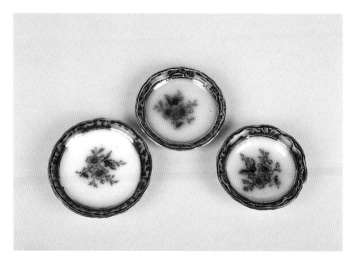

Three TOURAINE butter pats measuring 3 1/4", 2.7/8", and 3" in diameter. None of the butter pats have a manufacturer's mark. The deeper 2 7/8" in diameter piece may be a salt dip rather than a butter pat. *Courtesy of James and Christine Stucko.* $55-75 each.

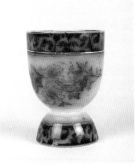

TOURAINE egg cup, no manufacturer's mark. 3 1/4" high. *Courtesy of James and Christine Stucko.* $250-275

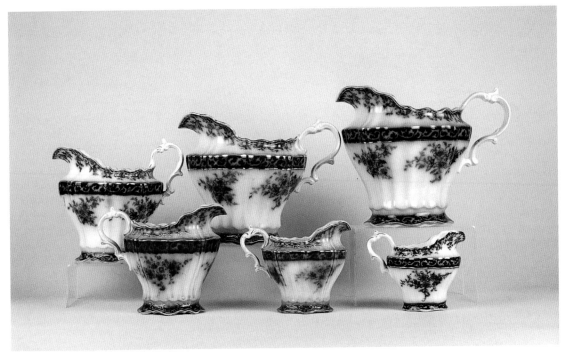

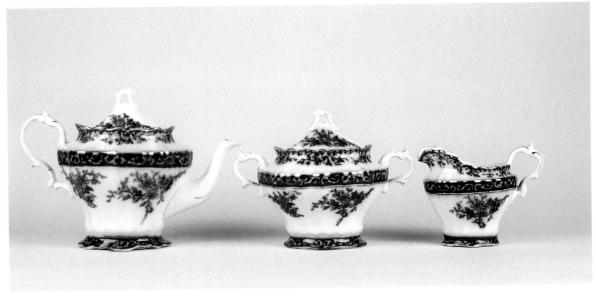

Above:
TOURAINE pitchers. The largest was produced by Stanley Pottery Co., measuring 8 1/2" high to the spout. The rest are as follows: Stanley Pottery Co.: 7 3/4" high to spout; Henry Alcock & Co.: 6 1/2" high to spout; Henry Alcock & Co.: 6" high to spout; Henry Alcock & Co. (sometimes referred to as a large creamer): 5" high to spout; Stanley Pottery Co. creamer: 4 1/4" high to spout. *Courtesy of James and Christine Stucko.* Largest to smallest: $1000-1100; $900-990; $650-715; $600-660; $450-495; $275-300

Left:
TOURAINE rectangular cake plate by Henry Alcock & Co. 10" in diameter. *Courtesy of James and Christine Stucko.* $375+.

Below:
TOURAINE tea set by Stanley Pottery Co. Teapot: 7" high to finial. Sugar: 6" high to finial. Creamer: 4 1/4" high. *Courtesy of James and Christine Stucko.* Teapot: 850+; sugar: $350+; creamer: $300+

Three unusual TOURAINE creamers. The small, unmarked 3 1/2" high creamer is different in form and handle. The center creamer has a fluted body shape, no manufacturer's mark, and measures 5" in height. Henry Alcock & Co. produced the right hand 5" high, fluted body shape creamer identical in form to the center creamer. *Courtesy of James and Christine Stucko.* $400-440 each

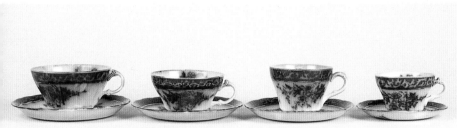

TOURAINE cups and saucers. Left to right: Farmer's cup by Stanley Pottery Co., 4 1/4" in diameter x 2 1/2" high, saucer 6 1/4" in diameter. A standard tea cup by Stanley Pottery Co., 4" in diameter x 4 1/4" high, saucer 6" in diameter. Coffee cup by Stanley Pottery Co., 3 3/8" in diameter x 2 1/2" high, saucer 6" in diameter. Demitasse cup, no manufacturer's mark, 3" in diameter x 2 1/4" high, saucer 4 3/4" in diameter. *Courtesy of James and Christine Stucko.* Left to right: $135-150; $100-110; $125-135; $165-180

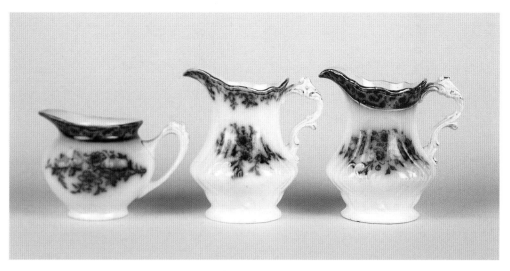

A closer look at the Stanley Pottery Co. TOURAINE coffee cup. *Courtesy of James and Christine Stucko.* $175+

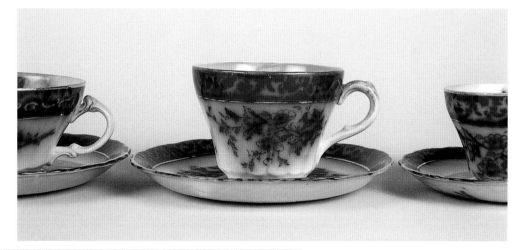

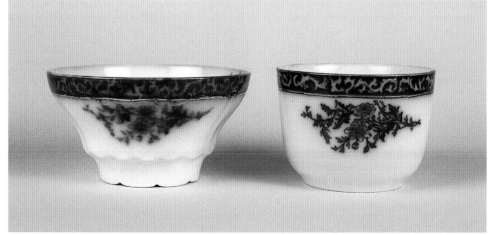

TOURAINE waste bowls, unmarked. The waste bowl with fluted sides measures 6 1/2" in diameter x 3 1/2" high. The smooth sided waste bowl measures 5" in diameter x 3 3/4" high. *Courtesy of James and Christine Stucko.* Left to right: $250+; $225+

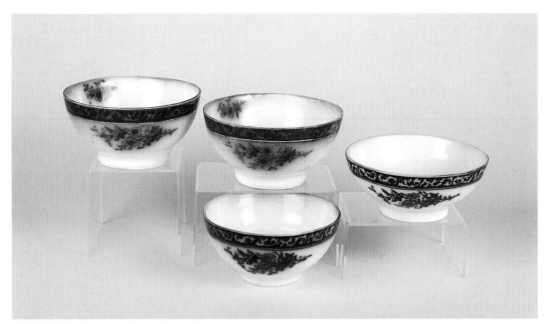

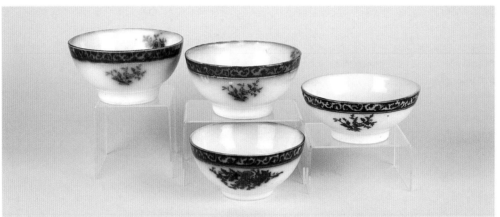

TOURAINE oyster bowls/waste bowls (all with footed bases). The top left and top center bowls measure 6″ in diameter x 3″ high. The far right and bottom center bowls measure 6″ in diameter x 2 3/4″ high. *Courtesy of James and Christine Stucko.* $250+ each

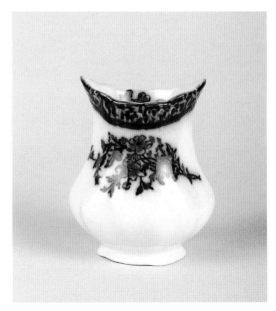

TOURAINE possible spooner or toothbrush holder, simply marked "Touraine England." *Courtesy of James and Christine Stucko.* $650-750

Flow Blue Ceramics
Additional Wares and Patterns

Tea and chocolate sets have long been favorites among Flow Blue collectors. Among the images that follow, readers will find some very unusual and fascinating teapots in a wide variety of patterns. Syrup pitchers and children's sets appeal to collectors with limited display space and come in a wide and appealing variety of patterns and shapes. However, amassing a collection of children's wares will be challenging indeed.

Butter pats and egg cups also are attractive to collectors for whom room is at a premium. These may present a real problem, however, in determining the pattern from the tiny piece presented on these diminutive wares. Included in the Patterns Through Pieces section are examples of many of the most popular patterns found on butter pats and egg cups to assist in that pattern identification.

Finally, Varied Wares, Additional Patterns provides the reader with patterns that have not appeared in my previous books.

Tea and Chocolate Sets

Malachi McCormick, in his book *A Decent Cup of Tea*, provides some instructive notes as to what made a good teapot. According to the author, a decent teapot has a spout that comes up to the same level as the top of the pot, so that the pot may be completely filled. A decent teapot needs to have a deep, tightly fitted lid, possibly a lid with a lip, to prevent the lid from falling out during pouring. The lid should also have a good sized knob on top for easy handling. Finally, the decent teapot has to have a built-in perforated strainer at the base of the spout to keep the tea leaves in the pot. You are about to meet a good many decent teapots from the Victorian era. (McCormick 1991, 40-42)

W.H. Grindley & Co. (Ltd.), Tunstall, Staffordshire, c. 1880-1960, printed manufacturer's mark in use from 1891-1914 with England present in the mark, and Albany pattern name. Without "England" in the mark, this Grindley mark was used beginning in 1880. *Courtesy of Jerry and Margaret Taylor.*

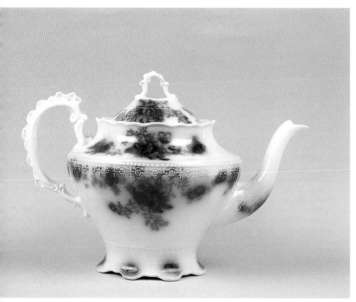

ALBANY teapot by W. H. Grindley & Co. 6 1/2" high. *Courtesy of Jerry and Margaret Taylor.* $850-935

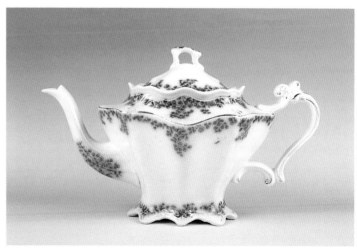

ALDINE teapot by W. H. Grindley & Co., 6 1/4" high. *Courtesy of Warren and Connie Macy.* $400-500

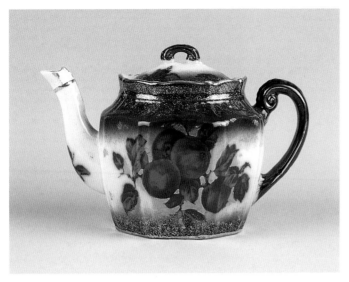

APPLES teapot by Keeling & Co., 5" high. *Courtesy of Warren and Connie Macy.* $300-350

Keeling & Co. (Ltd.), Burslem, Staffordshire, c. 1886-1936, printed trademark in use from 1886-1936.

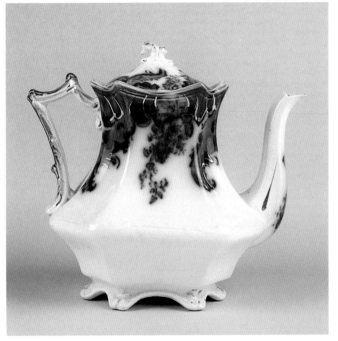

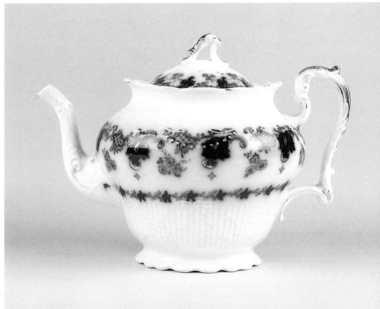

ARGYLE teapot by W. H. Grindley & Co., 7 1/4" high. *Courtesy of Warren and Connie Macy.* $800-950

Right and above right:
ASTORIA teapot by Johnson Bros. Ltd., Hanley, Tunstall, Staffordshire. The company was in production from c. 1883-1968. The Astoria pattern would have been produced during the Late Victorian period. 7" high. *Courtesy of Warren and Connie Macy.* $650-750

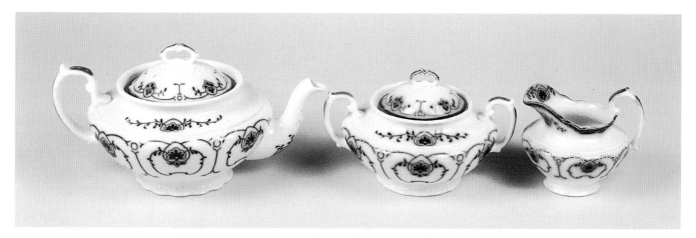

BEAUFORT teapot, cream, & sugar by W. H. Grindley & Co. Teapot: 5" high. *Courtesy of Jerry and Margaret Taylor.* $1400+ set

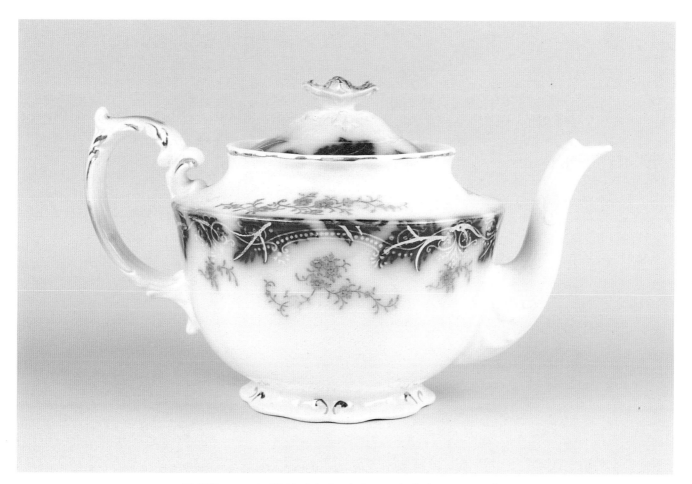

BRAZIL teapot by W. H. Grindley & Co., 5 1/4" high. *Courtesy of Warren and Connie Macy.* $600-700

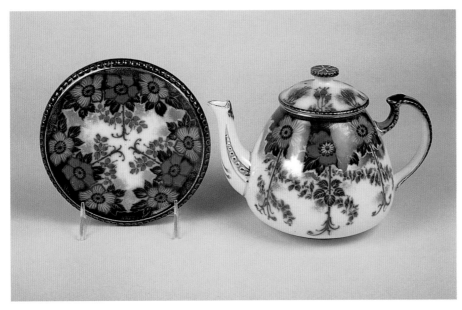

BRIAR teapot & trivet by Burgess & Leigh. Teapot: 6" high. Undertray: 6 1/2" in diameter. *Courtesy of Jerry and Margaret Taylor.* $500-550

Burgess & Leigh (Ltd.), Burslem, Staffordshire, c. 1862-onward, printed "Middleport Pottery / B & L" mark, 1889-1912, and Briar pattern name. The registry number indicates a registration date of 1904. *Courtesy of Jerry and Margaret Taylor.*

CELTIC teapot by W. H. Grindley & Co., 7" high. *Courtesy of Warren and Connie Macy.* $800-1000

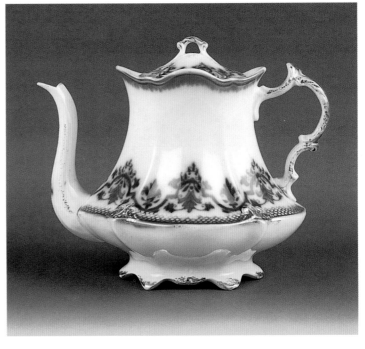

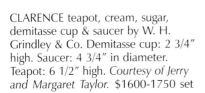

CLARENCE teapot, cream, sugar, demitasse cup & saucer by W. H. Grindley & Co. Demitasse cup: 2 3/4" high. Saucer: 4 3/4" in diameter. Teapot: 6 1/2" high. *Courtesy of Jerry and Margaret Taylor.* $1600-1750 set

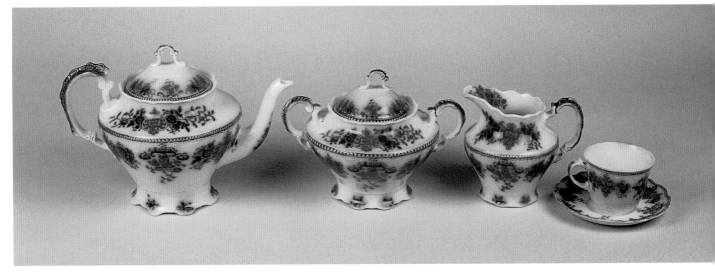

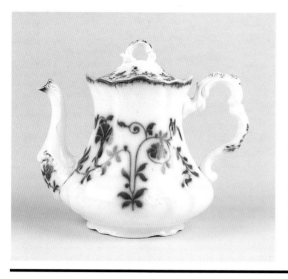

Far left:
COLONIAL teapot by J. & G. Meakin, 7 1/2" high. *Courtesy of Warren and Connie Macy.* $800-1000

Left:
J. & G. Meakin (Ltd.), Hanley, Staffordshire, 1851-1970+, printed manufacturer's mark in use c. 1907+, and Colonial pattern name. *Courtesy of Warren and Connie Macy.*

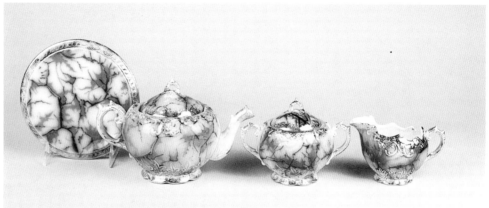

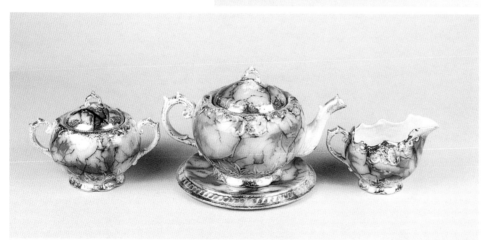

Bottom three photos:
CRACKED ICE teapot, sugar, creamer, and trivet by Warwick China, an American firm from Wheeling, West Virginia. This is Late Victorian ware. Teapot: 6 1/2" high. *Courtesy of Warren and Connie Macy.* $800-1000

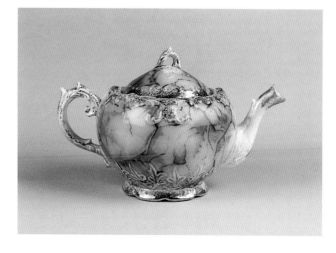

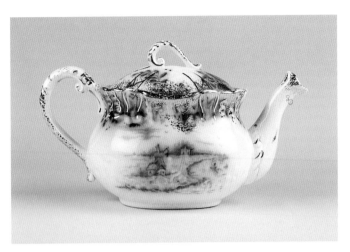

DELFT teapot by Warwick China, 4 1/2". *Courtesy of Warren and Connie Macy.* $600-700

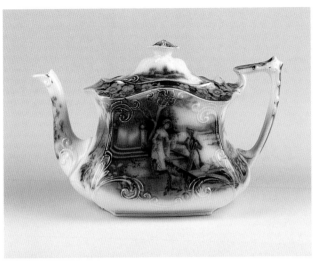

DOVEDALE teapot by Sampson Hancock & Sons, 5 3/4" high. *Courtesy of Warren and Connie Macy.* $400-500

FLORAL teapot by Thomas Hughes, 5 1/2". *Courtesy of Warren and Connie Macy.* $500-600

Sampson Hancock & Sons, Staffordshire, c. 1858-1937, printed "S. H. & S." manufacturer's mark in use from c. 1892-1935, and Dovedale pattern name. *Courtesy of Warren and Connie Macy.*

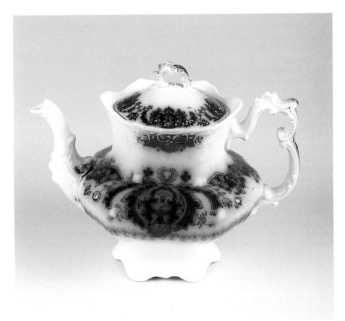

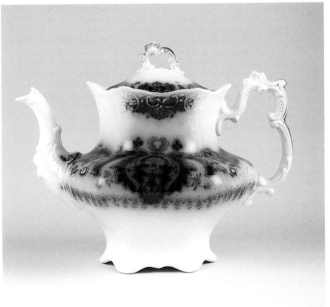

FLORIDA teapot by Johnson Bros. Ltd., 7 1/2" high. *Courtesy of Warren and Connie Macy.* $750-850

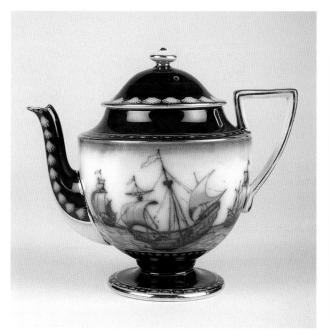

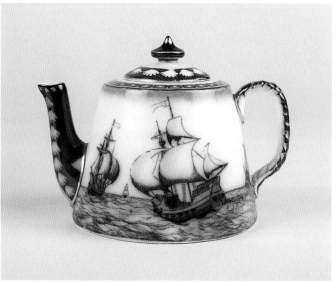

GALLEON teapot by Doulton & Co. These Galleon pieces all fall under the category known as Doulton's series ware. 6 3/4" high. *Courtesy of Warren and Connie Macy.* $650-750

GALLEON teapot by Doulton & Co. 4 1/4" high. *Courtesy of Warren and Connie Macy.* $450-550

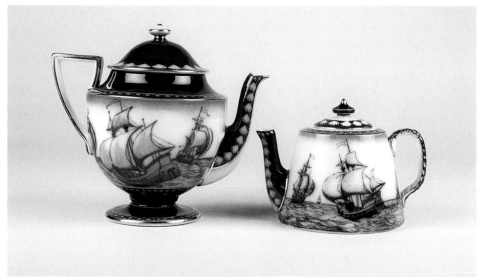

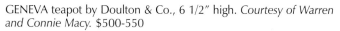

Both GALLEON teapots by Doulton & Co. *Courtesy of Warren and Connie Macy.*

GENEVA teapot by Doulton & Co., 6 1/2" high. *Courtesy of Warren and Connie Macy.* $500-550

Doulton & Co. (Ltd.), Burslem, Staffordshire, c. 1882-1955, printed manufacturer's mark in use from 1891-1902, and the Galleon pattern name. *Courtesy of Warren and Connie Macy.*

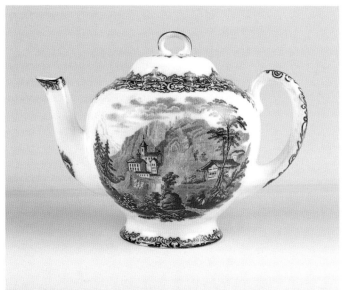

Doulton & Co., Burslem, Staffordshire, c. 1882-1955, printed "Royal Doulton/Burslem, England" manufacturer's mark in use after 1902. *Courtesy of Warren and Connie Macy.*

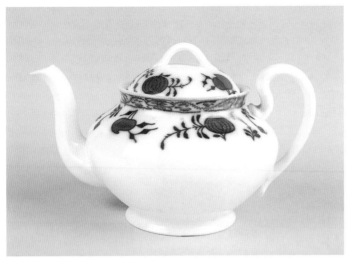

Johnson Bros. Ltd., Hanley, Tunstall, Staffordshire, c. 1883-1968, printed manufacturer's mark in use from c. 1913+, and Holland pattern name. *Courtesy of Warren and Connie Macy.*

HOLLAND teapot by Johnson Bros. Ltd., 4 1/2" high. *Courtesy of Warren and Connie Macy.* $350-450

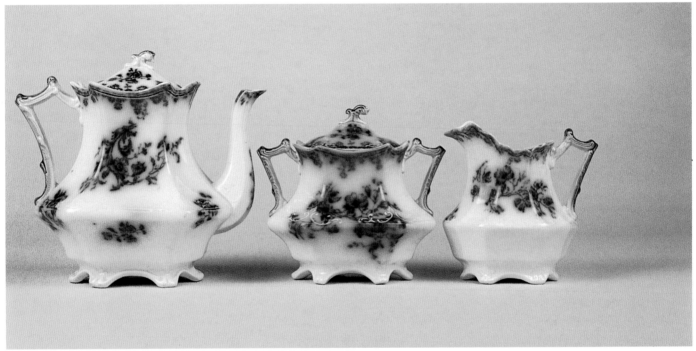

JANETTE tea set by W. H. Grindley & Co. Teapot: 7 1/4" high. *Courtesy of Jerry and Margaret Taylor.* $1400-1500

Left:
Mercer Pottery Company, Trenton, New Jersey, 1868-1930s(37), printed "M.C." manufacturer's mark in use c. 1897, and Luzerne pattern name. *Courtesy of Warren and Connie Macy.*

LUZERNE teapot by Mercer Pottery Company, 6" high. *Courtesy of Warren and Connie Macy.* $550-650

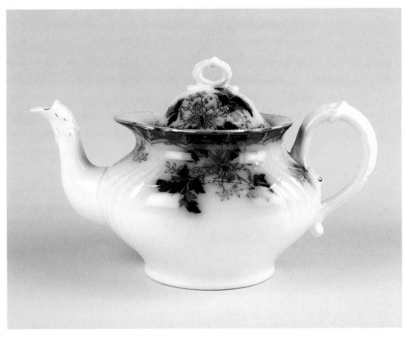

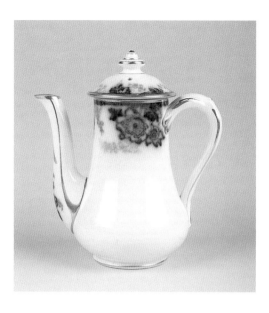

Left:
MACINA teapot by Cauldon Ltd., 7 1/2" high. *Courtesy of Warren and Connie Macy.* $300-350

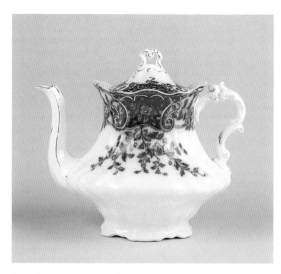

MANHATTAN teapot by Henry Alcock & Co., 7 1/4" high. *Courtesy of Warren and Connie Macy.* $500-600

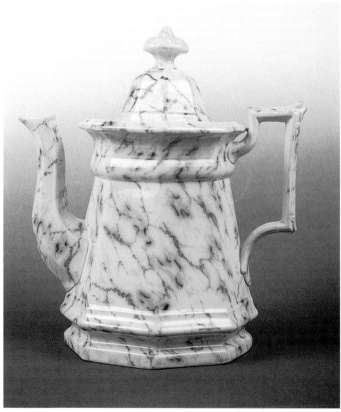

MARBLE teapot by Livesley, Powell & Co., 9" high to finial. *Courtesy of Jerry and Margaret Taylor.* $600-660

Livesley, Powell & Co., Hanley, Staffordshire, c. 1851-1865, printed "L.P. & Co." mark in use from c. 1851-1865, and Marble pattern name. *Courtesy of Jerry and Margaret Taylor.*

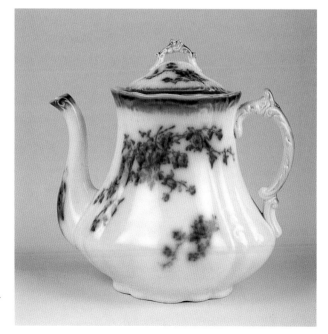

MARECHAL NEIL teapot by W. H. Grindley & Co., 7 1/2" high. *Courtesy of Warren and Connie Macy.* $600-700

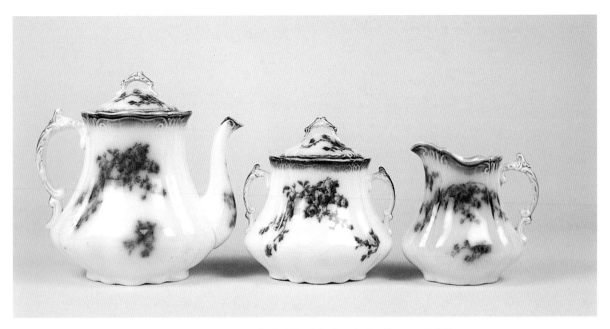

MARECHAL NEIL tea set by W. H. Grindley & Co. Teapot: 7 1/2"
high. *Courtesy of Jerry and Margaret Taylor.* $1400-1500 set

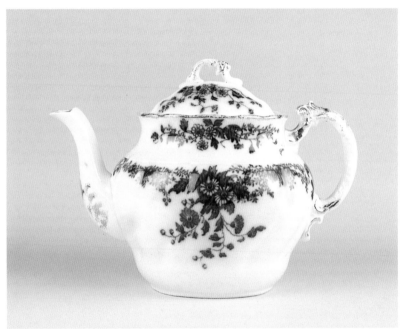

MARGARITE teapot by W. H. Grindley & Co., 7 1/4"
high. *Courtesy of Warren and Connie Macy.* $650-750

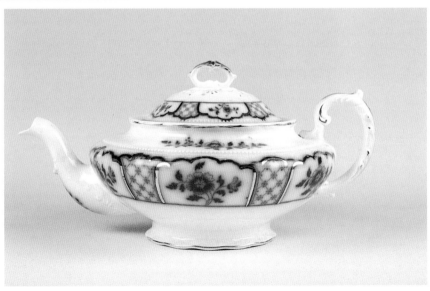

MELBOURNE teapot by W. H. Grindley & Co.,
5" high. *Courtesy of Warren and Connie Macy.*
$1000-1200

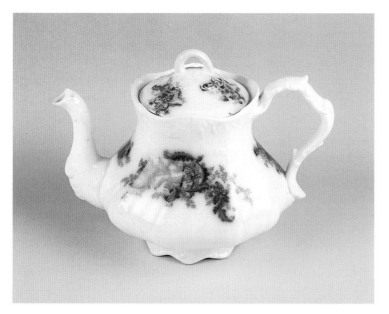

MENTONE teapot by Johnson Bros. Ltd., 7" high. *Courtesy of Warren and Connie Macy.* $550-650

Johnson Bros. Ltd., Hanley, Tunstall, Staffordshire, 1883-1968, printed manufacturer's mark in use from c. 1900+, and Mentone pattern name. *Courtesy of Warren and Connie Macy.*

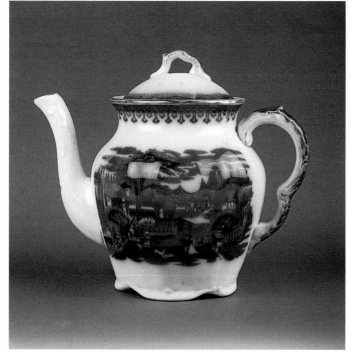

MISSOURI teapot by Edge, Malkin & Co., 7" high. *Courtesy of Warren and Connie Macy.* $450-550

Edge, Malkin & Co., Burslem, England, c. 1870-1903, printed "E. M. & Co." manufacturer's mark in use from c. 1873-1903, and Missouri pattern name. *Courtesy of Warren and Connie Macy.*

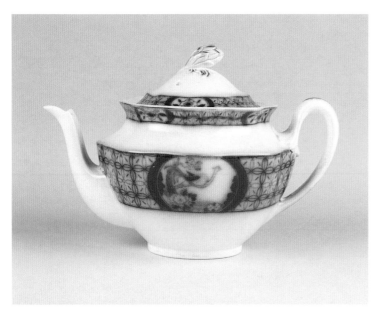

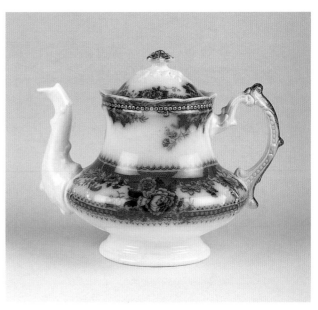

MONGOLIA teapot by Johnson Bros. Ltd., 6" high. *Courtesy of Warren and Connie Macy.* $550-650

MONTANA teapot by Johnson Bros. Ltd., 7" high. *Courtesy of Warren and Connie Macy.* $550-650

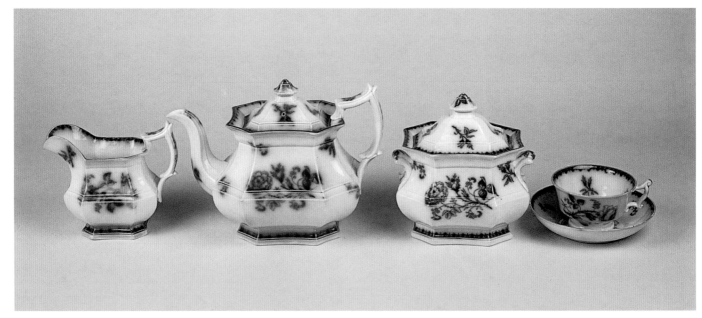

MOSS ROSE tea set including teapot, sugar, creamer, cup and large saucer by Ridgway & Morley. Teapot: 7 1/4" high. This is an Early Victorian period set. *Courtesy of Jerry and Margaret Taylor.* $1600 set

Ridgway & Morley, Shelton, Hanley, Staffordshire, c. 1842-1845, printed "R & M" manufacturer's mark in use from c. 1842-1845, and Moss Rose pattern name. *Courtesy of Jerry and Margaret Taylor.*

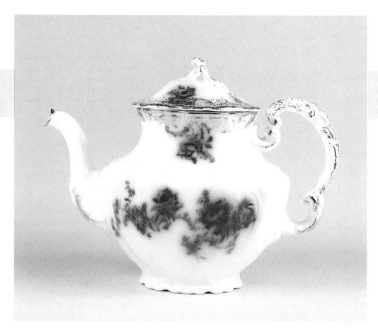

NEOPOLITAN teapot by Johnson Bros. Ltd., 7 1/2"
high. *Courtesy of Warren and Connie Macy.* $550-650

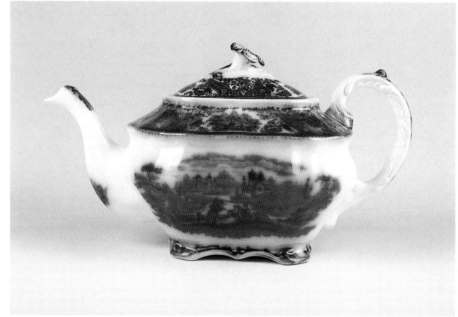

NON PARIEL teapot by Burgess & Leigh, 6"
high. *Courtesy of Warren and Connie Macy.*
$750-850

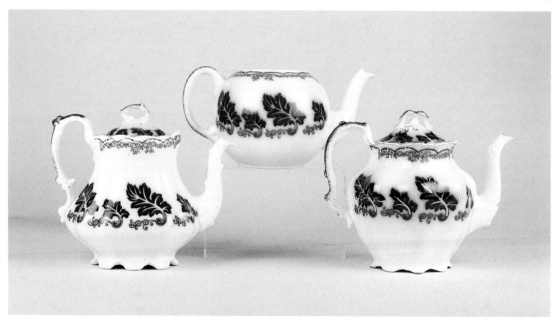

Three different
NORMANY teapots by
Johnson Bros. Ltd.
*Courtesy of Warren and
Connie Macy.*

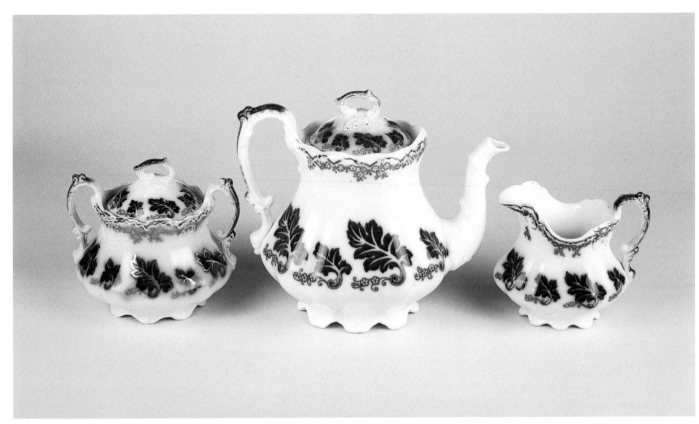

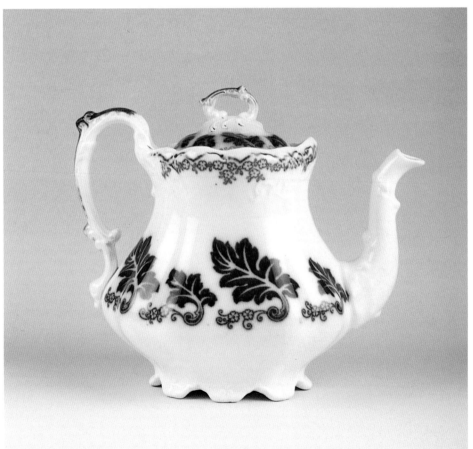

Standard NORMANDY pattern tea set by Johnson Bros. Ltd. Teapot: 7 1/2" high. *Courtesy of Warren and Connie Macy.* $2800-3000

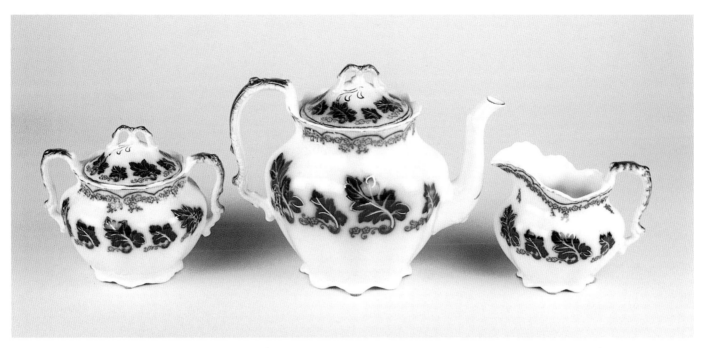

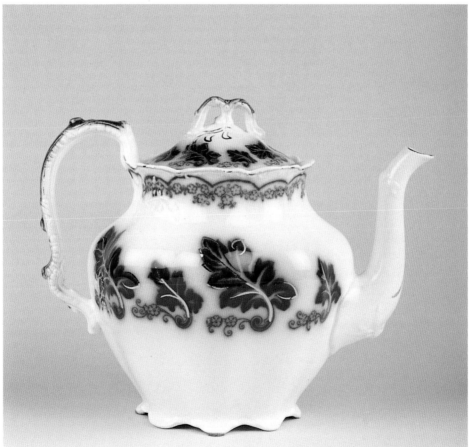

Rare NORMANDY pattern teapot shape by Johnson Bros. Ltd., 7 1/2" high. *Courtesy of Warren and Connie Macy.* $2800-3000

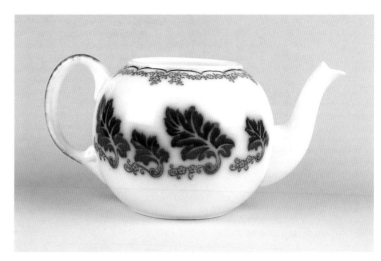

Rare NORMANDY teapot shape, without its lid, by Johnson Bros. Ltd., 5 1/2" high. *Courtesy of Warren and Connie Macy.* $800-1000

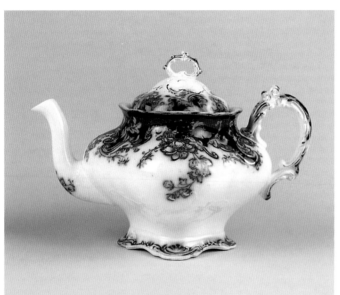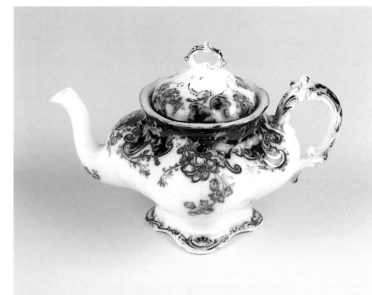

ORMONDE teapot by Alfred Meakin, 7" high. *Courtesy of Warren and Connie Macy.* $650-750

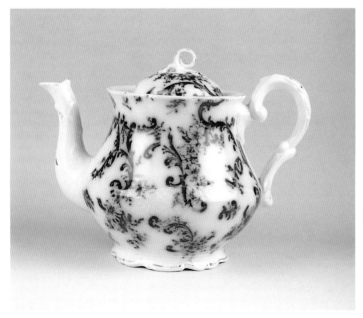

PAISLEY teapot by Mercer Pottery Co., 7 1/2" high. *Courtesy of Warren and Connie Macy.* $700-800

Mercer Pottery Co., Trenton, New Jersey, 1868-1930s(37), printed "Mercer/Semi-Vitreous" mark in use in the 1890s. *Courtesy of Warren and Connie Macy.*

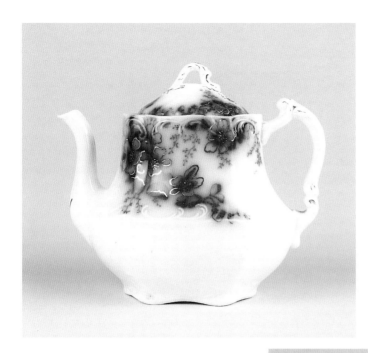

PEACH teapot by Johnson Bros. Ltd., 7 1/4" high. *Courtesy of Warren and Connie Macy.* $700-800

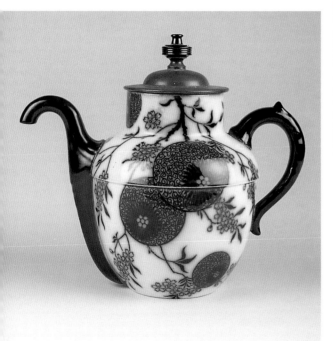

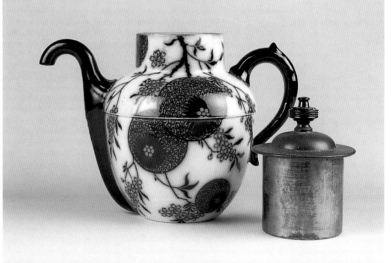

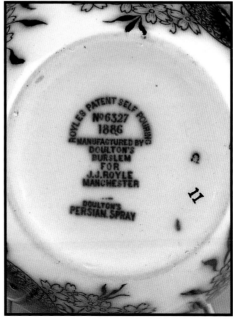

Above and above right:
PERSIAN SPRAY teapot by Doulton & Co., 8 3/4" high. This pot is self pouring when you cover a hole in the top of the lid. *Courtesy of Warren and Connie Macy.* $650-750

Doulton & Co., Burslem, Staffordshire, c. 1882-1955, printed "Doulton's" manufacturer's mark in use from 1882-1886, Persian Spray pattern name, and 1886 patent for the self pouring feature of this unusual teapot. *Courtesy of Warren and Connie Macy.*

PERSIAN SPRAY teapot by Doulton & Co., 7 1/4" high. Unique infuser marked "Cheerup" that rotates tea into and out of the water in the pot. *Courtesy of Warren and Connie Macy.* $1000+

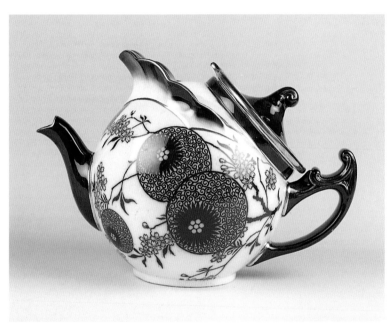

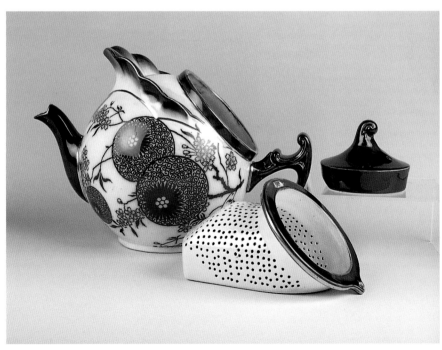

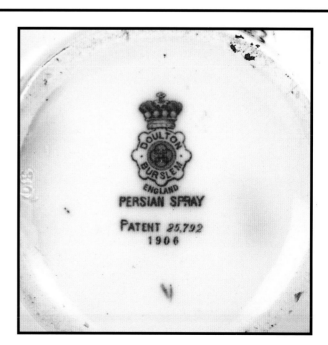

Doulton & Co., Burslem, Staffordshire, c. 1882-1955, printed manufacturer's mark in use from 1891, Persian Spray pattern name, and a patent number. *Courtesy of Warren and Connie Macy.*

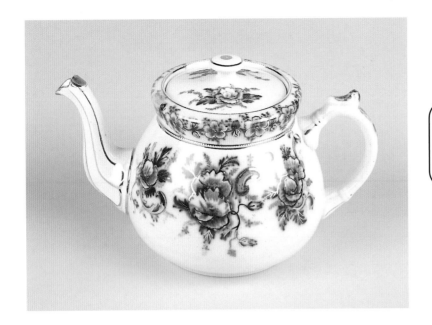

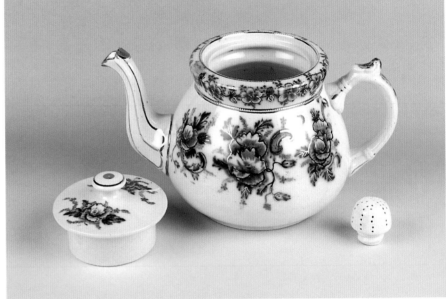

POPPY teapot with a screw-in infuser (the infuser screws into the inside base of the spout) by Arthur Wood. 5 1/4" high. *Courtesy of Warren and Connie Macy.* $500-600

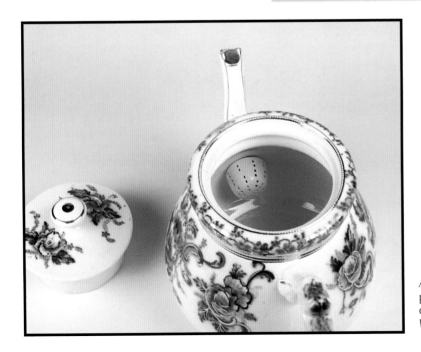

Arthur Wood, Longport, Staffordshire, c. 1904-1928, printed "A.W./L." manufacturer's mark also in use from c. 1904-1928, and Poppy pattern name. *Courtesy of Warren and Connie Macy.*

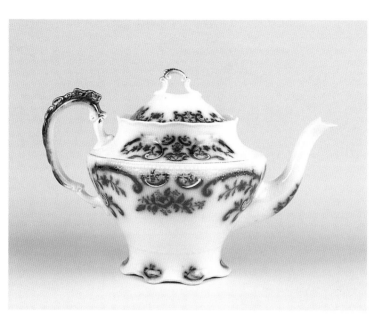

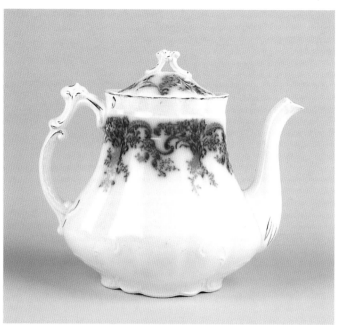

PORTMAN teapot by W. H. Grindley & Co., 6 1/2" high. *Courtesy of Warren and Connie Macy.* $700-800

PROGRESS teapot by W. H. Grindley & Co., 7 1/4" high. *Courtesy of Warren and Connie Macy.* $300-400

Three piece tea set decorated in the SEAWEED brush stroke pattern, with cockscomb handles, no manufacturer's mark. This is a popular Early Victorian period set. Teapot: 10" high to finial, 9 1/2" spout to handle. Sugar: 8 1/4" high to finial. Creamer: 6" high to spout. *Courtesy of James and Christine Stucko.* Teapot: $1250-1375; sugar: $750-825; creamer: $1000-1100

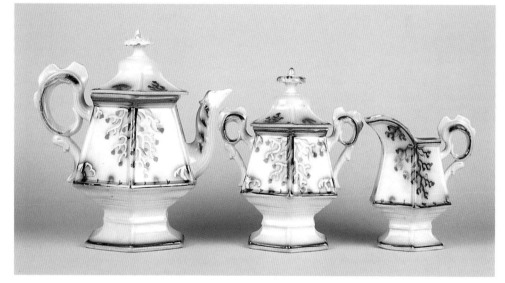

ST. LOUIS teapot by Johnson Bros. Ltd., 7 1/4" high. *Courtesy of Warren and Connie Macy.* $600-700

Johnson Bros. Ltd., Hanley, Tunstall, Staffordshire, 1883-1968, printed manufacturer's mark postdating 1891, and St. Louis pattern name. *Courtesy of Warren and Connie Macy.*

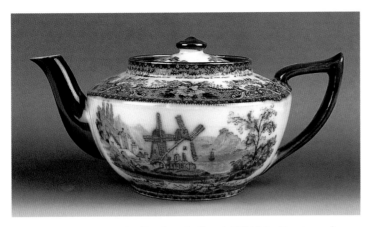

SWITZERLAND teapot by Doulton & Co., 4 1/4" high. *Courtesy of Warren and Connie Macy.* $400-450

Doulton & Co., Burslem, Staffordshire, c. 1882-1955, printed "Doulton's" manufacturer's mark in use from 1882-1886, and Switzerland pattern name. *Courtesy of Warren and Connie Macy.*

Below:
SYLVAN teapot & undertray by Bourne & Leigh. Undertray: 7 1/2" in length. Teapot: 6" high. *Courtesy of Jerry and Margaret Taylor.* $800-850

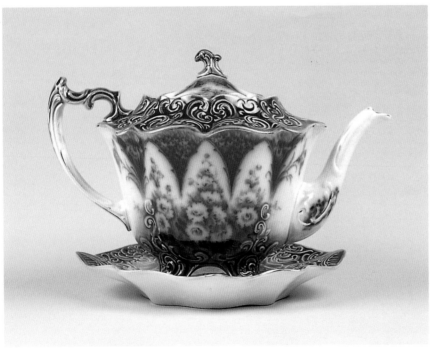

Bourne & Leigh, Burslem, Staffordshire, c. 1892-1941, printed "Albion Pottery / E.B. & J.E.L." mark in use c. 1912+, and Sylvan pattern name. *Courtesy of Jerry and Margaret Taylor.*

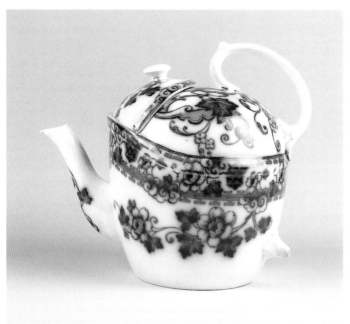

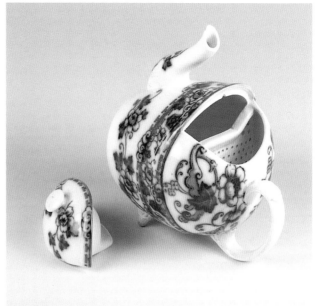

Unidentified pattern Simple Yet Perfect teapot attributed to Wedgwood & Co., 7 1/2". *Courtesy of Warren and Connie Macy.* $700-800

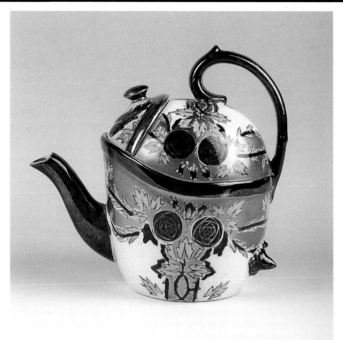

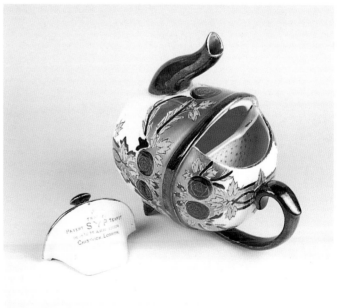

Shown in these three photos:
Unidentified pattern Simple Yet Perfect teapot attributed to Wedgwood & Co., 6" high. The registration number indicates the year of registry to be 1909. *Courtesy of Warren and Connie Macy.* $700-800

Below:
Both "SYP" teapot's together. *Courtesy of Warren and Connie Macy.*

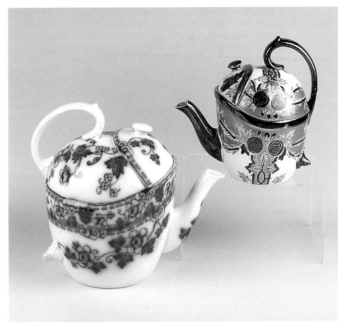

Wedgwood & Co. (Ltd.), Tunstall, Staffordshire, 1860-1965. A similar blue and white Simple Yet Perfect bore this Wedgwood & Co. wreath trade-mark. Also appearing is an impressed Wedgwood mark in use from 1840-1868 and a code the company used that indicates the year was 1862. Considering the previous registry number, these SYP's were in use for quite some time. *Courtesy of Warren and Connie Macy.*

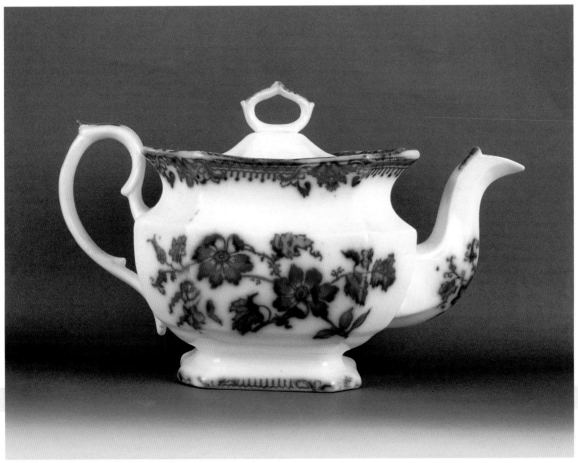

Unidentified pattern large teapot, no manufacturer's mark, 13 1/2" from handle to spout, 8" to finial. *Courtesy of James and Christine Stucko.* $1100-1210

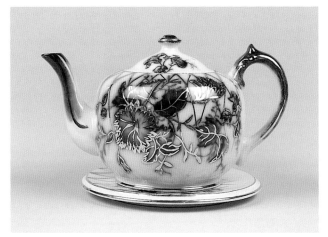

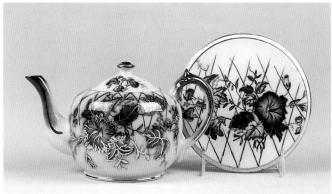

Unidentified floral pattern teapot and undertray by H. J. Wood. On the undertray mark is a "Wood & Sons Ltd." mark with a crown and banner. Teapot: 4 3/4" high. Trivet: 6 1/2" in diameter. *Courtesy of Jerry and Margaret Taylor.* $450-495

H.J. Wood (Ltd.), Burslem, Staffordshire, c. 1884- , printed Staffordshire knot mark with initials H J W in the knot and B below in use from c. 1884. *Courtesy of Jerry and Margaret Taylor.*

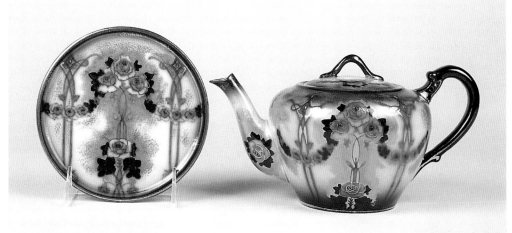

Unidentified floral pattern with gold teapot and trivet by Keeling & Co., Ltd. Teapot: 5 1/4" high. Trivet: 6" in diameter. *Courtesy of Jerry and Margaret Taylor.* $500-550

Keeling & Co., Ltd., Burslem, Staffordshire, c. 1886-1936, printed marks in use from c. 1912-1936. *Courtesy of Jerry and Margaret Taylor.*

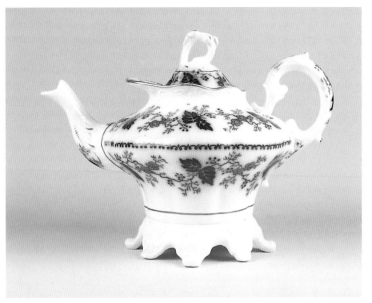

Unidentified pattern large teapot, no manufacturer's mark, 8" high. *Courtesy of Warren and Connie Macy.* $750-850

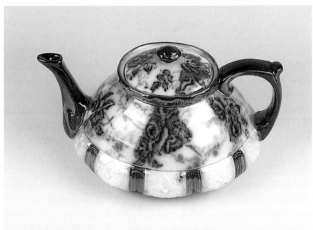

Unidentified pattern short, squat teapot, no manufacturer's mark, 5" high. *Courtesy of Warren and Connie Macy.* $700-800

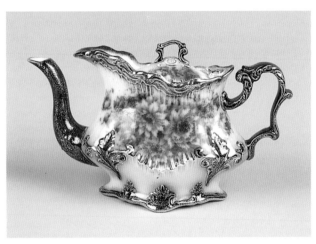

Unidentified pattern narrow teapot, no manufacturer's mark, 5" high. *Courtesy of Warren and Connie Macy.* $400-500

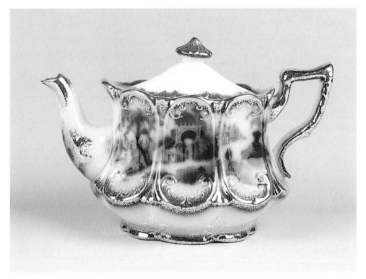

Unidentified pattern gold gilt teapot, no manufacturer's mark, 6" high. *Courtesy of Warren and Connie Macy.* $450-550

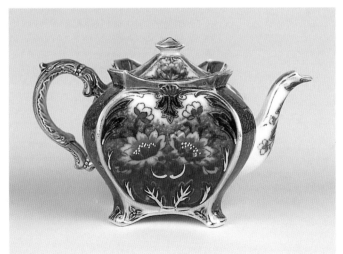

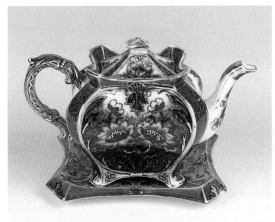

Unidentified pattern teapot on trivet, no manufacturer's mark, 6" high. *Courtesy of Warren and Connie Macy.* $500-600

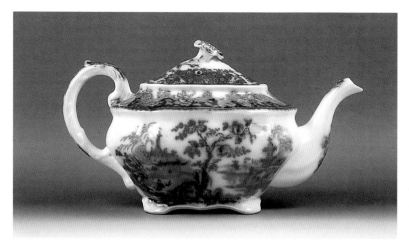

Unidentified scenic pattern teapot, no manufacturer's mark, 5 3/4" high to finial. *Courtesy of Jerry and Margaret Taylor.* $650-715

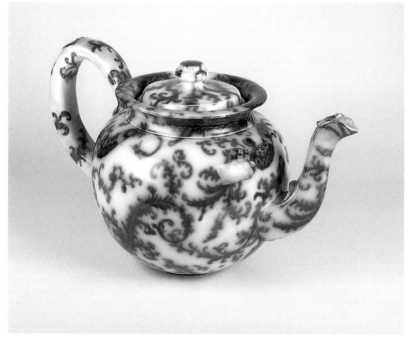

Unidentified pattern massive teapot, no manufacturer's mark, 10 1/2" high to finial. 18" handle to spout. *Courtesy of Warren and Connie Macy.* $750-1000

Unidentified pattern self pouring teapot by Doulton & Co., 8" high. *Courtesy of Jerry and Margaret Taylor.* $800-880

Unidentified pattern small self pouring teapot by Doulton & Co., 6 3/4" high. *Courtesy of Jerry and Margaret Taylor.* $775-850

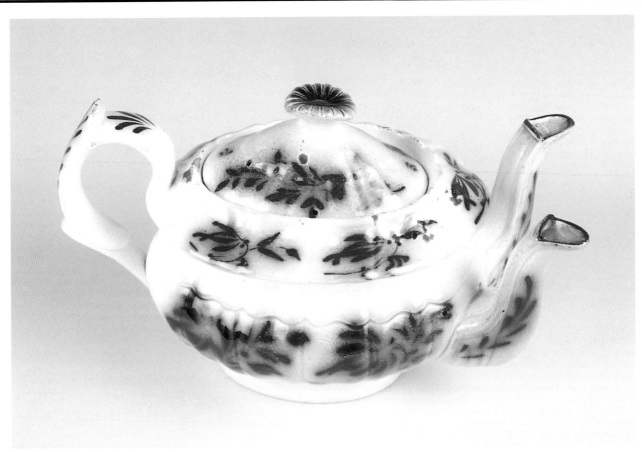

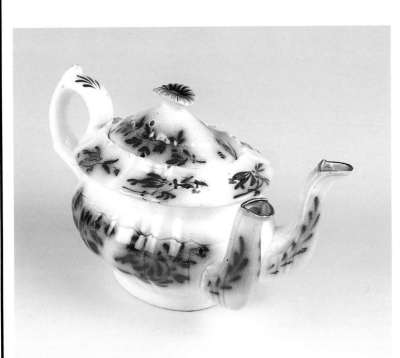

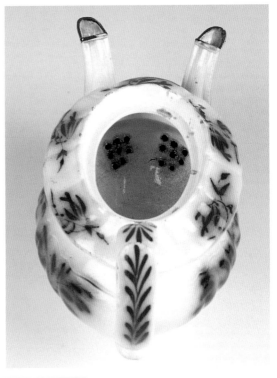

Unidentified pattern unusual two spouted teapot, no manufacturer's mark, 6 1/2" high. Both spouts are functional, as you can see from the two strainers. Now, this teapot would have taken coordination to use! *Courtesy of Warren and Connie Macy.* $1750-2000

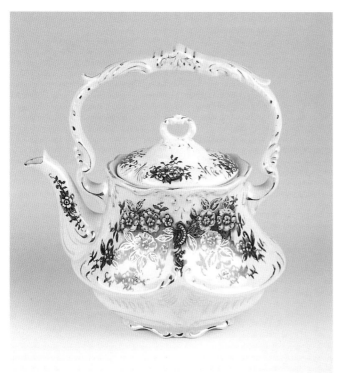

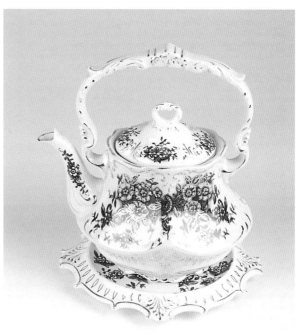

Unidentified pattern tea kettle with ceramic handle over the top, no manufacturer's mark, 10" high to top of handle. *Courtesy of Warren and Connie Macy.* $800-1000

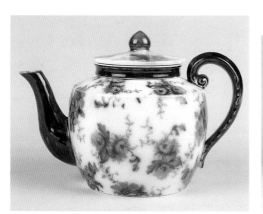

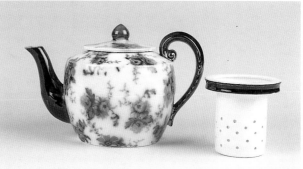

VERONA teapot by Ridgways, 4 1/2" high. *Courtesy of Warren and Connie Macy.* $450-550

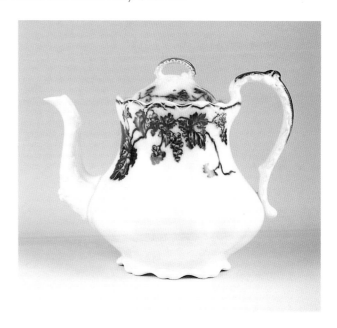

Ridgways, Shelton, Hanley, Staffordshire, c. 1878-1920, printed Quiver & Bow trademark registered c. 1880 and in use after 1891 with the addition of "England" to the mark, and the Verona pattern name. *Courtesy of Warren and Connie Macy.*

Right:
WARWICK teapot by Johnson Bros. Ltd., 7 1/2" high. *Courtesy of Warren and Connie Macy.* $600-700

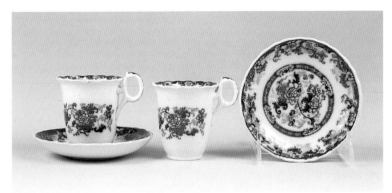

BENTICK chocolate cup & saucer by Cauldon Ltd. Cup: 3 1/8" high. Saucer: 5" in diameter. *Courtesy of Jerry and Margaret Taylor.* $150-165 each cup and saucer set

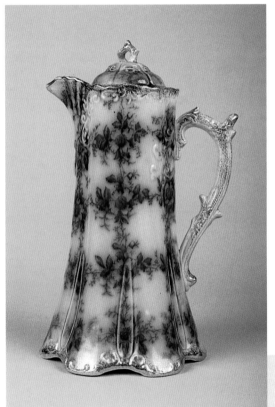

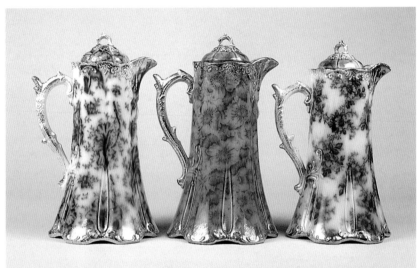

PANSY, WILD ROSE, and CALICO chocolate pots by Warwick China. *Courtesy of Jerry and Margaret Taylor.* Left to right: $1000-1100; $900-990; $900-990

CALICO chocolate pot by Warwick china. 9" high. *Courtesy of Jerry and Margaret Taylor.* $800-880

CRACKED ICE chocolate set by Warwick China. Cups: 3" high. Saucers: 5 1/8" in diameter. Chocolate pot: 9" high. *Courtesy of Jerry and Margaret Taylor.* $2500-2750 set

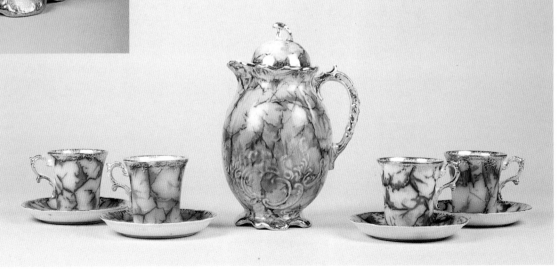

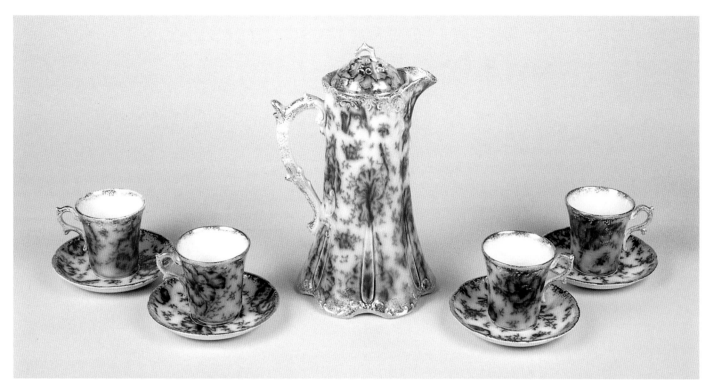

PANSY chocolate pot, chocolate cup and saucer by Warwick China. Chocolate pot: 8 7/8" high to lip. Cup: 3" high. Saucer: 5 1/8" in diameter. *Courtesy of Jerry and Margaret Taylor.* $2000-2200 set (complete with four cups and saucers)

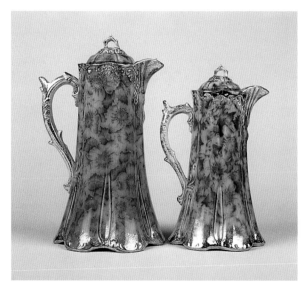

Left:
WILD ROSE chocolate pots by Warwick China. 8 7/8" high, 7 5/8" high. *Courtesy of Jerry and Margaret Taylor.* $900-990; $700-770

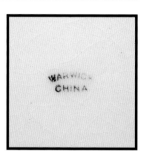

Warwick China (Co.), Wheeling, West Virginia, 1884-1951, printed manufacturer's mark in use from c. 1898-c. 1910. *Courtesy of Jerry and Margaret Taylor.*

WILD ROSE chocolate pot, cups and saucers by Warwick China. *Courtesy of Jerry and Margaret Taylor.* Small pot: 7 5/8" high. Cups: 3" high. Saucers: 5 1/8" in diameter. $2100-2310 set (including four cups and saucers)

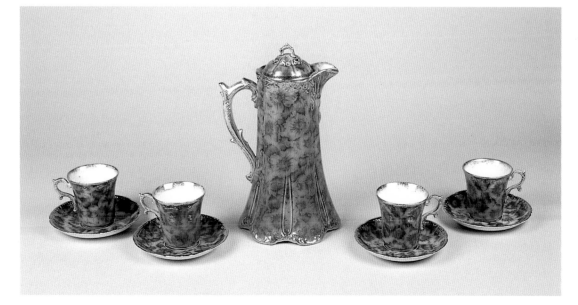

Syrup Pitchers

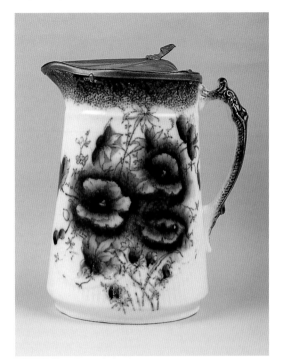

ARGYLE syrup pitcher by Myott, Sons & Co., 7"
high to lip. *Courtesy of Jerry and Margaret Taylor.*
$300-330

Myott, Sons & Co. (Ltd.), Stoke-on-Trent, Cobridge, Staffordshire, c. 1898-1977, printed mark in use from c. 1898-1902, and Argyle pattern name. *Courtesy of Jerry and Margaret Taylor.*

Wedgwood & Co. (Ltd.), Tunstall, Staffordshire, 1860-1965, printed name mark in use from 1890-1906, and Blossom pattern name. *Courtesy of Jerry and Margaret Taylor.*

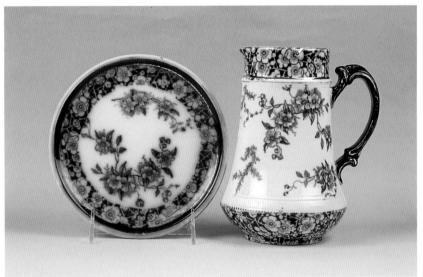

BLOSSOM syrup with undertray by Wedgwood & Co. Syrup: 7" high. Undertray:
6 3/4" in diameter. *Courtesy of Jerry and Margaret Taylor.* $375-410

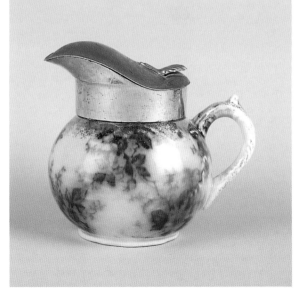

CALICO (a.k.a. DAISY CHAIN) syrup with pewter
lid by Warwick China. 3 3/4" high to lip. *Courtesy
of Jim and Shelley Lewis.* $350-385

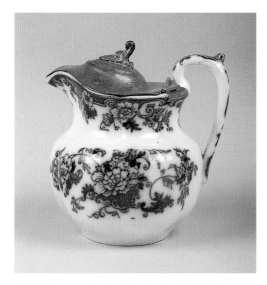

CANDIA syrup by Cauldon Ltd. 3 3/4" high to lip. *Courtesy of Jerry and Margaret Taylor.* $300-330

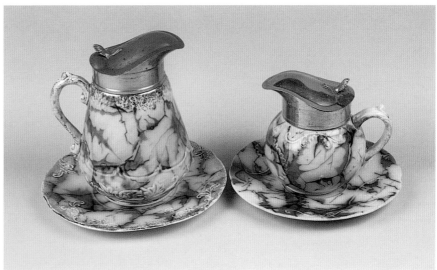

Two CRACKED ICE syrups by Warwick China. Left, a tall syrup with unusual body: 5 1/2" high. Right: 3 3/4" high. Undertrays: 6 1/2" & 6" in diameter. *Courtesy of Jerry and Margaret Taylor.* $1200-1320; $600-660

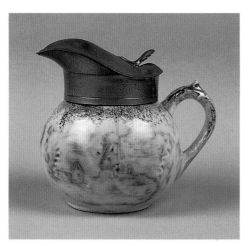

Warwick China (Co.), Wheeling, West Virginia, 1884-1951, printed manufacturer's mark in use from c. 1898-c. 1910, with Delft pattern name. *Courtesy of Jerry and Margaret Taylor.*

DELFT syrup by Warwick China. 3 3/4" high. *Courtesy of Jerry and Margaret Taylor.* $275-300

DRESDEN FLOWERS syrup, probably by Burgess & Leigh. 6 1/4" high. *Courtesy of Jerry and Margaret Taylor.* $275-300

This "Middleport Pott" printed mark is probably a mark of Burgess & Leigh (Ltd.), Burslem, Staffordshire, c. 1862-onward. This mark, if it truly belongs to Burgess & Leigh, was in use from c. 1889-1912. This mark also includes the Dresden Flowers pattern name. *Courtesy of Jerry and Margaret Taylor.*

Josiah Wedgwood (& Sons, Ltd.), Staffordshire, c. 1759-present, printed mark dating after 1891. *Courtesy of Jerry and Margaret Taylor.*

FALLOW DEER syrup by Josiah Wedgwood (& Sons, Ltd.). 5" high. *Courtesy of Jerry and Margaret Taylor.* $225-275

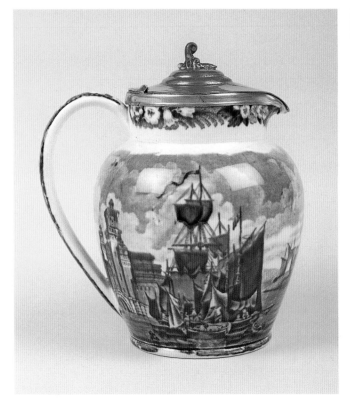

Josiah Wedgwood (& Sons, Ltd.), Staffordshire, c. 1759-present, printed mark dating after 1891.

FERRARA syrup by Josiah Wedgwood (& Sons, Ltd.). 4" high to spout. *Courtesy of Jerry and Margaret Taylor.* $275-300

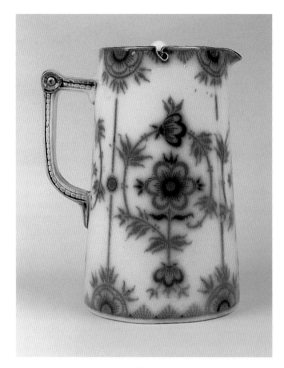
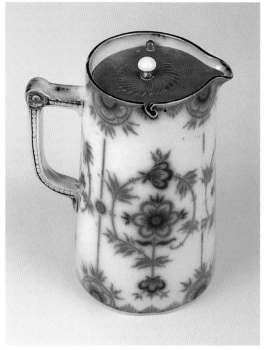

HAARLEM syrup by Burgess & Leigh. 6" high. *Courtesy of Jerry and Margaret Taylor.* $300-330

Burgess & Leigh, Burslem, Staffordshire, c. 1862-onward, printed "Burleigh Ware / B & L" mark in use in c. 1930s, and Haarlem pattern name. The registry number indicates a registration date of 1905. *Courtesy of Jerry and Margaret Taylor.*

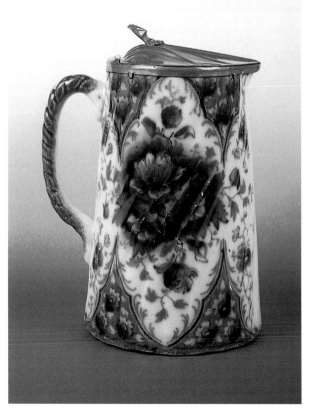

Myott, Son & Co. (Ltd.), Stoke-on-Trent, Cobridge, & Hanley, Staffordshire, c. 1898-1977, printed "M S & Co." mark in use c. 1900+, and Doris pattern name. *Courtesy of Jerry and Margaret Taylor.*

IDRIS syrup by Myott, Son & Co. 6 1/2" high. *Courtesy of Jerry and Margaret Taylor.* $325-355

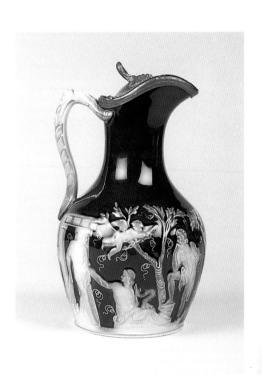

Above two photos:
"IN THE GARDEN" syrup with a classical design and cobalt ground. There is no manufacturer's mark. 8" high. *Courtesy of Jerry and Margaret Taylor.* $400-440

JAPAN FLOWERS syrup by Charles Meigh. This is an Early Victorian period piece. 10 1/2" high to lip. *Courtesy of Jerry and Margaret Taylor.* $1000-1100

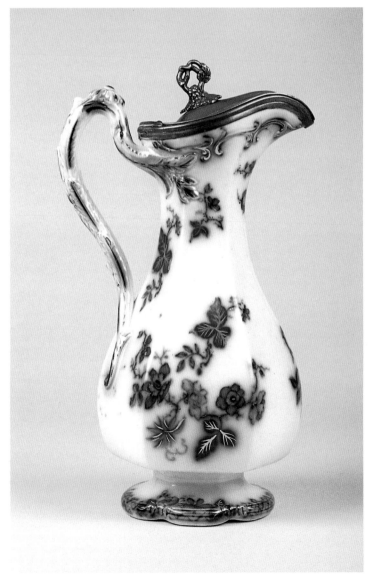

LILY polychrome covered pitcher with "tortoise shell" lid by Charles Meigh. This is an Early Victorian period piece. 4 1/2" high to spout. *Courtesy of Jerry and Margaret Taylor.* $750-825

Charles Meigh, Hanley, Staffordshire, c. 1832-1850, printed "C. M." mark in use from c. 1832-1850, and the Lily pattern name. *Courtesy of Jerry and Margaret Taylor.*

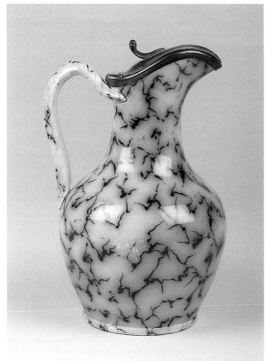

MARBLE syrup by Edward Walley. This is an Early Victorian period piece. 8" high. *Courtesy of Jerry and Margaret Taylor.* $700-770

Edward Walley, Cobridge, Staffordshire, c. 1845-1858, impressed "IRONSTONE / CHINA / E. WALLEY" manufacturer's mark in use from c. 1845-1858. *Courtesy of Jerry and Margaret Taylor.*

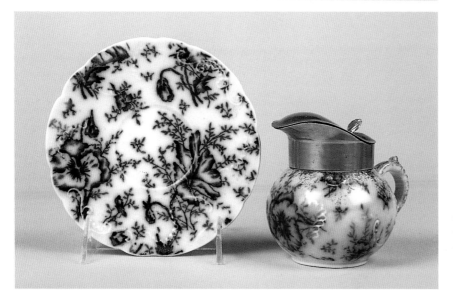

PANSY syrup with undertray by Warwick China. Syrup: 3 3/4" high. Undertray: 6" in diameter. undertray. *Courtesy of Jerry and Margaret Taylor.* $600-660

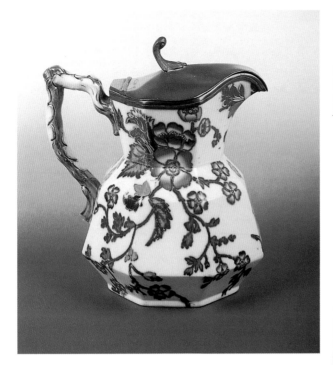

Left:
PRUNUS polychrome syrup (c. 1850), no manufacturer's mark. 7" high. *Courtesy of Jerry and Margaret Taylor.* $650-715

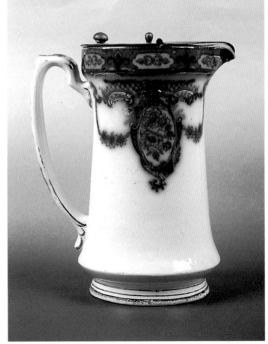

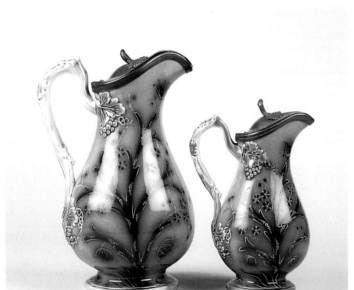

Above and left:
REEDS & FLOWERS syrup pitchers with ground color, no manufacturer's mark. Left to right: 9" high, 7 1/8" high. *Courtesy of Jerry and Margaret Taylor.* Left to right: $900-990; $700-770

Right and far right:
RUBY syrup pitcher with an unidentified "B. & S." printed laurel mark. 7" high. Note: this has a spring loaded lid held in place by pressure. *Courtesy of Jerry and Margaret Taylor.* $275-300

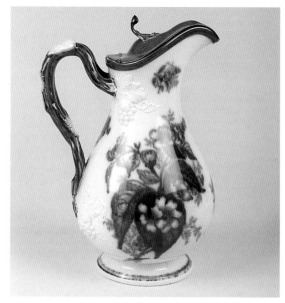

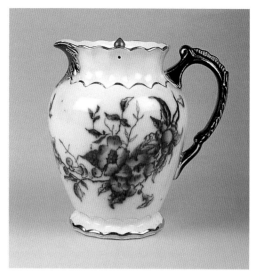

▶▶ Left and center: Unidentified floral pattern syrup by Wiltshaw & Robinson (Ltd.). 6" high to lip. *Courtesy of Jerry and Margaret Taylor.* $300-330

Unidentified floral pattern syrup, no manufacturer's mark. 9 5/8" high. *Courtesy of Jerry and Margaret Taylor.* $800-880

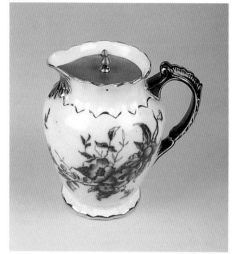

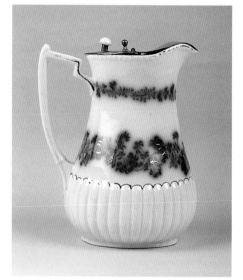

Left and below:
Unidentified floral band pattern syrup by Arthur Wood. The silver lid is held in place by tension. 6 3/4" high. *Courtesy of Jerry and Margaret Taylor.* $275-300

Wiltshaw & Robinson (Ltd.), Stoke-upon-Trent, Staffordshire, 1890-1957, printed mark in use from c. 1906 onward, and two registration numbers. The upper-most registry number dates to 1899. The lower number dates to 1894. *Courtesy of Jerry and Margaret Taylor.*

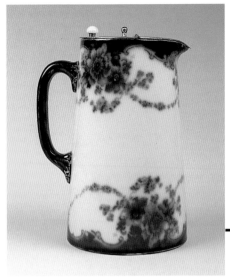

Bishop & Stonier (Ltd.), Hanley, Staffordshire, c. 1891-1939, printed "Bisto" mark in use from c. 1891-1936. *Courtesy of Jerry and Margaret Taylor.*

Unidentified pattern syrup by Bishop & Stonier. 6 3/4" high. *Courtesy of Jerry and Margaret Taylor.* $300-330

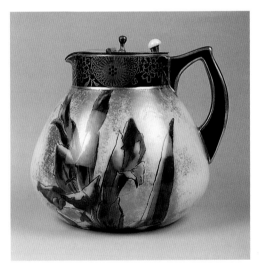

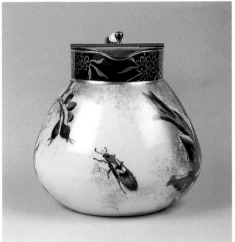

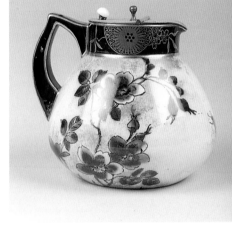

Center three photos:
Unidentified floral pattern, with Persian Spray at rim, syrup by Doulton & Co. This floral pattern includes an iris, a dogwood, and an insect in the motif. 5 1/2" high. *Courtesy of Jerry and Margaret Taylor.* $400-440

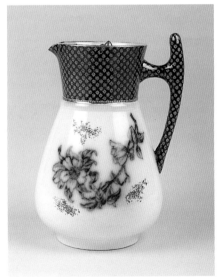

Unidentified floral pattern with an unidentified "E C" manufacturer's mark. 6 1/2" high to the lip. *Courtesy of Jerry and Margaret Taylor.* $275-300

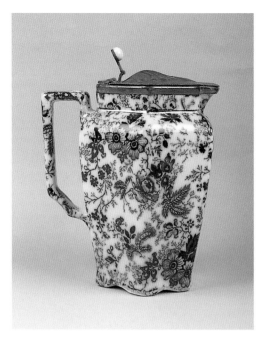

Unidentified floral sheet pattern syrup by H. J. Wood. 6" high. *Courtesy of Jerry and Margaret Taylor.* $325-355

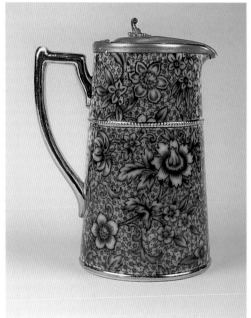

Unidentified sheet pattern syrup by Samuel Johnson, Ltd. 6 3/4" high. *Courtesy of Jerry and Margaret Taylor.* $275-300

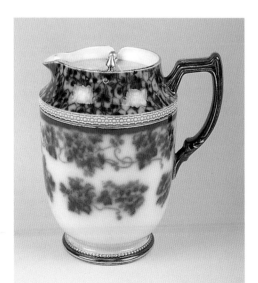

Left:
Unidentified pattern "Carlton Ware" syrup by Wiltshaw and Robinson. 5 3/4" high to lip. *Courtesy of Jerry and Margaret Taylor.* $325-355

Right:
Unidentified pattern Oriental style syrup, unmarked, with lid held in place by spring action. 6 1/2" high. Covered jug. *Courtesy of Jerry and Margaret Taylor.* $275-300

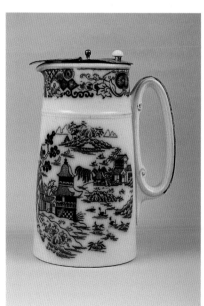

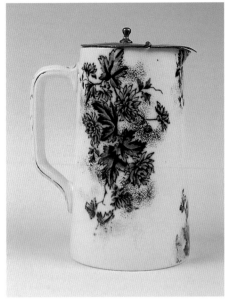

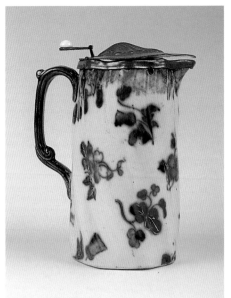

Unidentified floral pattern syrup, no manufacturer's mark. 5 3/4" high. *Courtesy of Jerry and Margaret Taylor.* $275-300

Unidentified floral pattern syrup, no manufacturer's mark. 6 1/4" high. *Courtesy of Jerry and Margaret Taylor.* $275-300

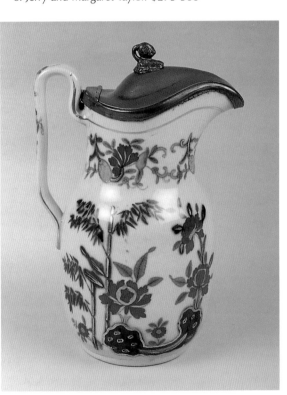

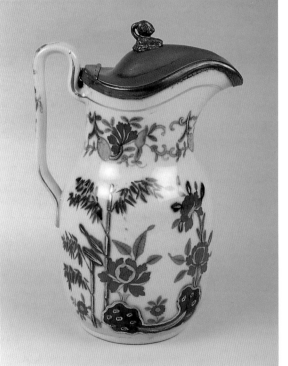

Right:
Unidentified polychrome pattern syrup (# 3008), maker unknown, twig handled, c. 1875. 8" high with pewter lid. *Courtesy of Jerry and Margaret Taylor.* $475-520

Unidentified polychrome pattern syrup by Davenport & Co. 7 1/2" high. *Courtesy of Jerry and Margaret Taylor.* $350-385

Davenport, Longport, Staffordshire, c. 1794-1887, printed "Davenport / Stone China" mark in use from c. 1815-1870s. *Courtesy of Jerry and Margaret Taylor.*

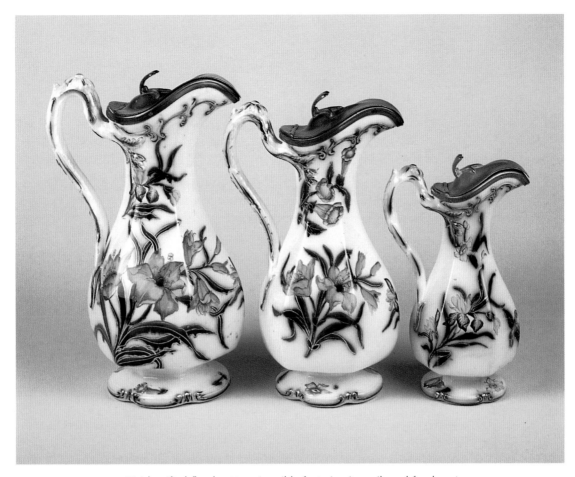

Unidentified floral pattern (possibly featuring jonquils and foxgloves) syrups, no manufacturer's marks. 11 1/4", 10 1/2", & 8 1/4" high to lip. *Courtesy of Jerry and Margaret Taylor.* Left to right: $900-990; $800-880; $700-770

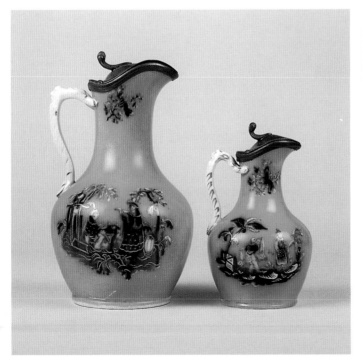

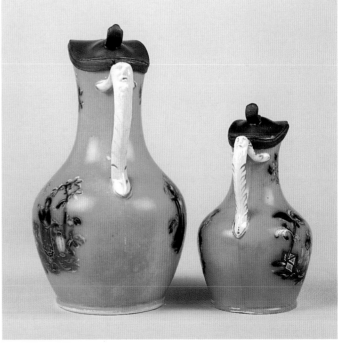

Two unidentified Oriental pattern syrups with red ground, no manufacturer's marks. 8 1/4" & 5 3/4" to lip. *Courtesy of Jerry and Margaret Taylor.* $800-880; $600-660

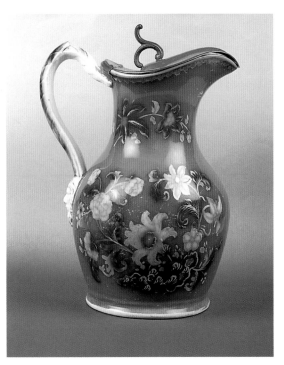

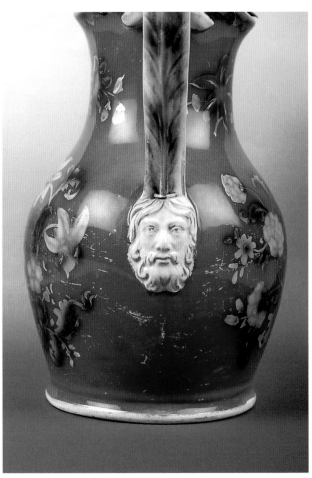

Above and right:
Unidentified pattern syrup with ground coloring, no manufacturer's mark. 7 3/4" high. Note the face at the base of the handle. *Courtesy of Jerry and Margaret Taylor.* $800-880

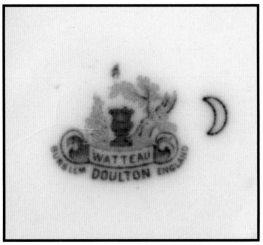

Doulton & Co., Burslem, Staffordshire, c. 1882-1955, printed manufacturer's mark in use from 1895-1930s, and Watteau pattern name. *Courtesy of Jerry and Margaret Taylor.*

WATTEAU syrup pitcher by Doulton & Co., 5 3/4" high. *Courtesy of Jerry and Margaret Taylor.* $350-385

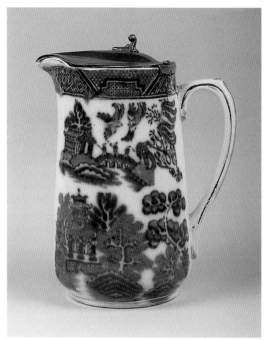

WILD ROSE syrup and undertray by Warwick China. Syrup: 3 3/4" high. Undertray: 6" in diameter. *Courtesy of Jerry and Margaret Taylor.* $525-575

WILLOW syrup pitcher, no manufacturer's marks. 5 3/4" high. *Courtesy of Jerry and Margaret Taylor.* $275-300

Children's Wares

CLYDE child's teapot by New Wharf Pottery Co. 3 1/2" high. *Courtesy of Warren and Connie Macy.* $350-450

New Wharf Pottery Co., Burslem, Staffordshire, c. 1878-1894, printed manufacturer's mark in use from 1890-1894, and Clyde pattern name. *Courtesy of Warren and Connie Macy.*

COBURG chamber pot from a child's set, 4" in diameter. 3" high. *Courtesy of James and Christine Stucko.* $450-495

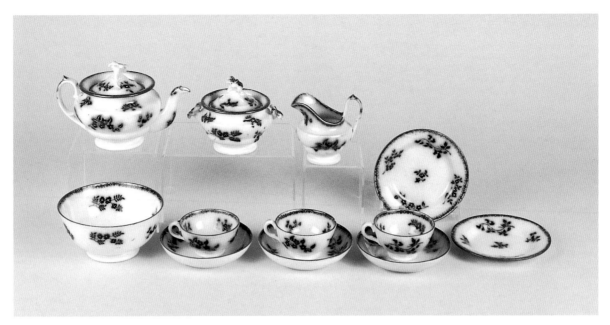

FORGET-ME-NOT child's set with red polychrome trim. Two cheese dishes: 4 1/2" in diameter. Waste bowl: 4 1/2" in diameter x 2 1/2" high. Cups: 2 3/4" in diameter x 1 1/2" high. Saucers: 4 1/8" in diameter. Creamer: 3" to spout. Sugar: 3 1/2" high. Teapot: 6 3/4" handle to spout x 4" high to finial. *Courtesy of James and Christine Stucko.* $3000-3300 set

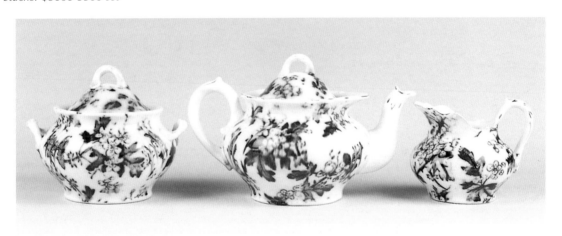

HAWTHORNE child's tea set by Mercer Pottery Company. *Courtesy of Warren and Connie Macy.* $850-900

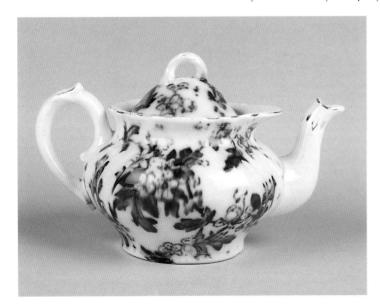

Mercer Pottery Company, Trenton, New Jersey, 1868-1930s(37), printed manufacturer's mark in use in the 1890s. *Courtesy of Warren and Connie Macy.*

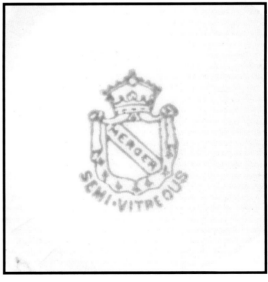

HAWTHORNE child's teapot by Mercer Pottery Company. 4 1/4" high. *Courtesy of Warren and Connie Macy.* $450-550

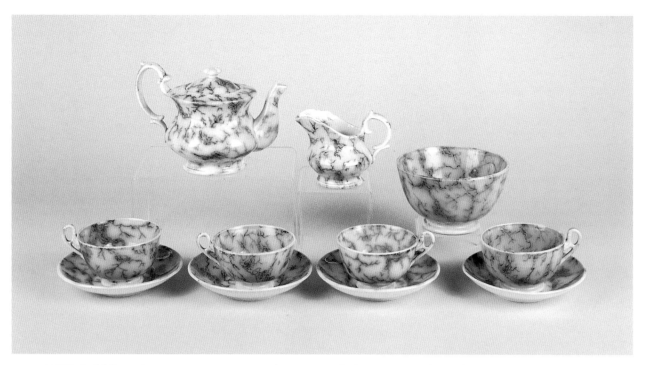

MARBLE child's set by Davenport. Cups: 3" in diameter x 2" high. Saucers: 4 1/2" in diameter. Waste bowl: 4 1/2" in diameter x 2 3/4" high. Creamer: 2 3/4" high to spout. Teapot: 6 1/4" handle to spout x 4" high to finial. *Courtesy of James and Christine Stucko.* $1200-1320

MARBLE child's teapot by Davenport. *Courtesy of Jerry and Margaret Taylor.* $400-440

Davenport, Longport, Staffordshire, c. 1794-1887, printed upper case "DAVENPORT" manufacturer's mark in use from c. 1835-1887. *Courtesy of Jerry and Margaret Taylor.*

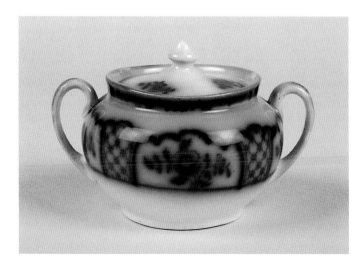

MELBOURNE jam bowl by W. H. Grindley & Co. This is a rare piece. Be aware that not all small pieces are children's pieces. Although small, this one is not a child's piece. 3" x 5". *Courtesy of Arnold A. and Dorothy E. Kowalsky.* $300-400

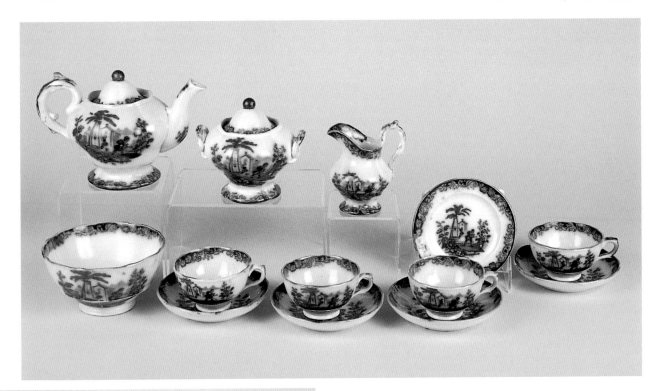

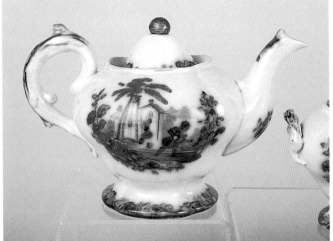

Above and left:
SERVANTS child's set, maker unknown. Cheese plate: 4" in diameter. Cups: 3" in diameter. Saucers: 4 1/4" in diameter. Waste bowl: 2 1/2" high x 4 1/2" in diameter. Creamer: 3 1/4" to spout. Sugar: 4" high to finial. Teapot: 7" from spout to handle x 4 1/2" high to the top of the finial. Polychrome décoration with metal balls used as repairs for the finials on the teapot and sugar. *Courtesy of James and Christine Stucko.* $2500-2750

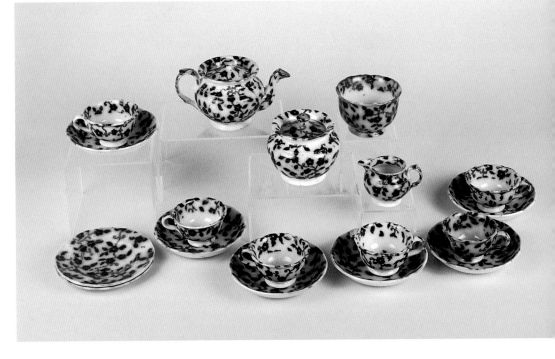

SLOE BLOSSOM child's set by Ridgways. Cheese plates: 4 1/2" in diameter. Cups: 2 1/2" in diameter x 1 1/2" high. Saucers: 4 1/2" in diameter. Waste bowl: 2 1/4" high x 3 1/4" in diameter. Sugar bowl: 3 1/4" high to finial. Teapot: 3 1/2" to finial x 5 3/4" from spout to handle. *Courtesy of James and Christine Stucko.* $3700-4000 set

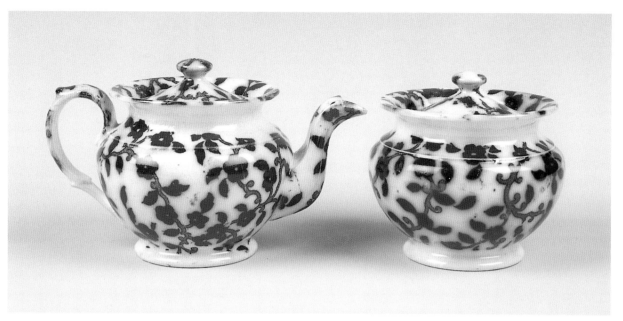

SLOE BLOSSOM child's teapot and sugar bowl, no manufacturer's mark. Teapot: 3 1/4" high. Sugar: 3 1/8" high. *Courtesy of Jerry and Margaret Taylor.* $1100-1210 teapot and sugar

Patterns Through Pieces—Butter Pats & Egg Cups

Butter pats by W. H. Grindley & Co. The patterns are (left to right): LYNDHURST, THE HARTINGTON, MELBOURNE. *Courtesy of Jim and Shelley Lewis.* Left to right: $50-55; $50-55; $70-75

Butter pats by W. H. Grindley & Co. The patterns are (left to right): GIRONDE, CELTIC, COUNTESS. *Courtesy of Jim and Shelley Lewis.* Left to right: $45-50; $50-55; $45-50

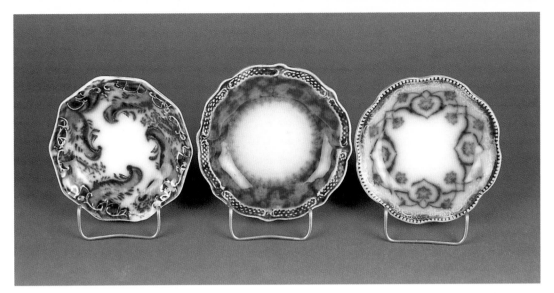

Butter pats by W. H. Grindley & Co. The patterns are (left to right): ARGYLE, GRACE, HADDON. *Courtesy of Jim and Shelley Lewis. Left to right: $70-75; $70-75; $50-55*

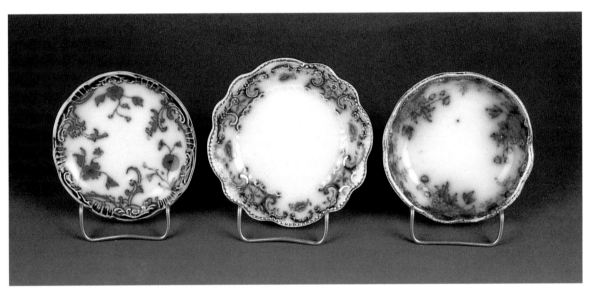

Butter pats by W. H. Grindley & Co. The patterns are (left to right): MARIE, PORTMAN, "MARGUERITE". *Courtesy of Jim and Shelley Lewis. $50-55 each*

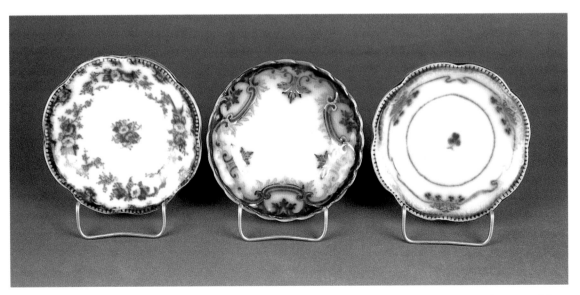

Butter pats by W. H. Grindley & Co. The patterns are (left to right): FLORIDA, CLIFTON, LORNE. *Courtesy of Jim and Shelley Lewis. Left to right: $65-70; $55-60; $55-60*

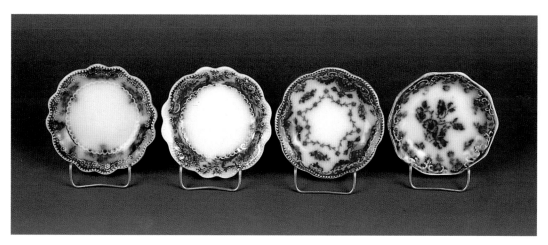

Butter pats by W. H. Grindley & Co. The patterns are (left to right): OSBORNE, ALASKA, WAVERLY, JANETTE. *Courtesy of Jim and Shelley Lewis.* Left to right: $50-55; $55-60; $60-65; $50-55

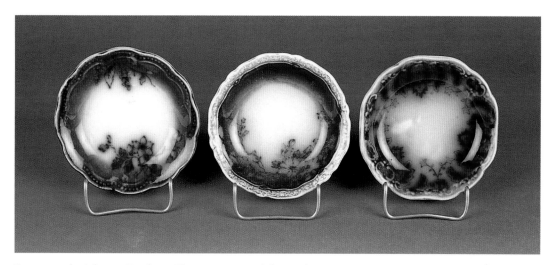

Butter pats by Johnson Brothers. The patterns are (left to right): ST. LOUIS, CLAYTON, FLORIDA. *Courtesy of Jim and Shelley Lewis.* Left to right: $50-55; $50-55; $55-60

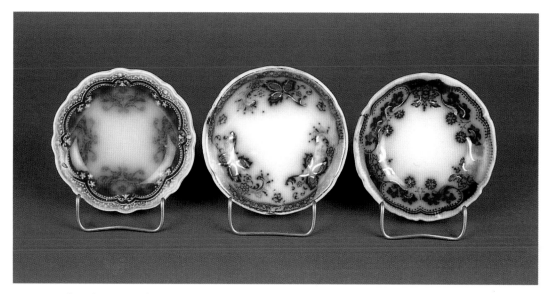

Butter pats by Johnson Brothers. The patterns are (left to right): OREGON, PRINCETON, STANLEY. *Courtesy of Jim and Shelley Lewis.* $50-55 each

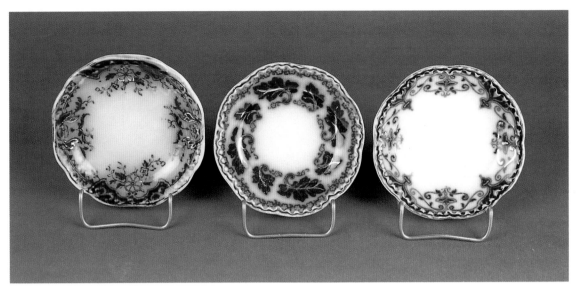

Butter pats by Johnson Brothers. The patterns are (left to right): BROOKLYN, NORMANDY, JEWEL. *Courtesy of Jim and Shelley Lewis.* Left to right: $50-55; $75-80; $50-55

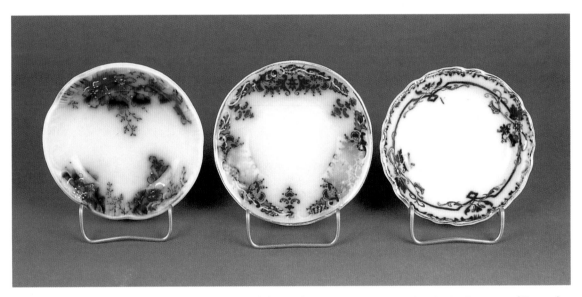

Butter pats by Johnson Brothers. The patterns are (left to right): PEACH, ALBANY, OXFORD. *Courtesy of Jim and Shelley Lewis.* Left to right: $50-55; $50-55; $45-50

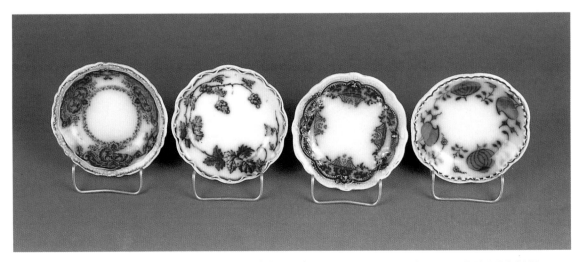

Butter pats by Johnson Brothers. The patterns are (left to right): PERSIAN, WARWICK, BLUE DANUBE, HOLLAND. *Courtesy of Jim and Shelley Lewis.* $50-55 each

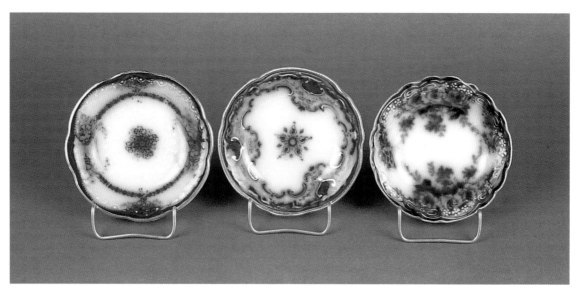

Butter pats by J. & G. Meakin. The patterns are (left to right): KELVIN, CAMBRIDGE, DEVON. *Courtesy of Jim and Shelley Lewis.* Left to right: $55-60; $75-80; $75-80

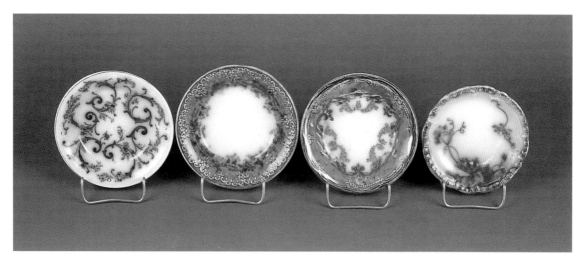

Butter pats by Ridgways. The patterns are (left to right): GAINSBOROUGH, DUNDEE, VERONA, LONSDALE. *Courtesy of Jim and Shelley Lewis.* $50-55 each

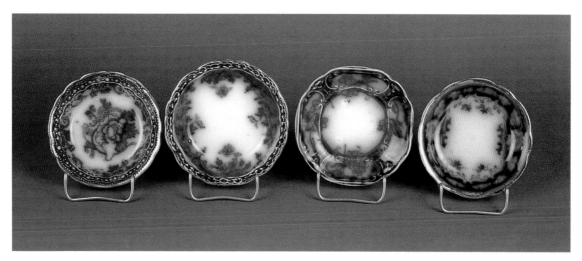

Butter pats, patterns and potters (left to right): VERONA by Wood & Son; ROMA by Wedgwood; CECIL by Till; CRUMLIN by Myott. *Courtesy of Jim and Shelley Lewis.* $50-55 each

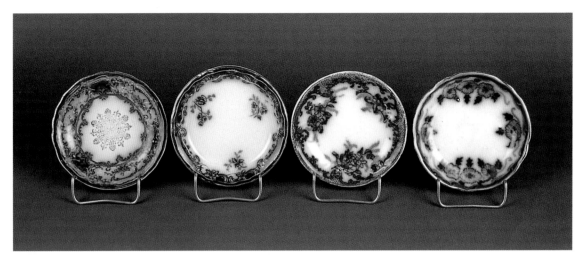

Butter pats, patterns and potters (left to right): DAINTY by Maddock; GRENADA by Alcock; VERSAILLES by Furnival; BURLEIGH by Bourne & Leigh. *Courtesy of Jim and Shelley Lewis.* Left to right: $50-55; $45-50; $45-50; $45-50

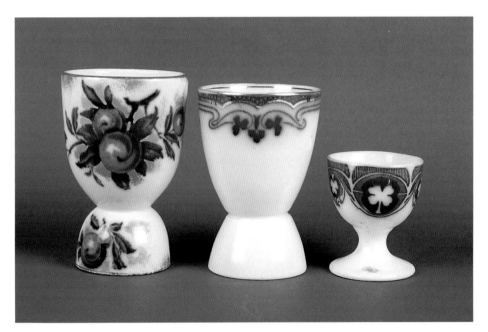

Egg cups, patterns and potters (left to right): unidentified pattern & potter, 4" high; IDRIS by W. H. Grindley & Co., 3 1/2" high; SAVOY by Johnson Bros. Ltd., 2 1/4" high. *Courtesy of Jim and Shelley Lewis.* Left to right: $150-165; $150-165; $125-135

Egg cups, patterns and potters (left to right): LINDA by Maddock, 4 1/4" high; OPHIR by Bourne & Leigh, 4" high; DAINTY by Maddock, 4 1/8" high. *Courtesy of Jim and Shelley Lewis.* Left to right: $150-165; $150-165; $200-220

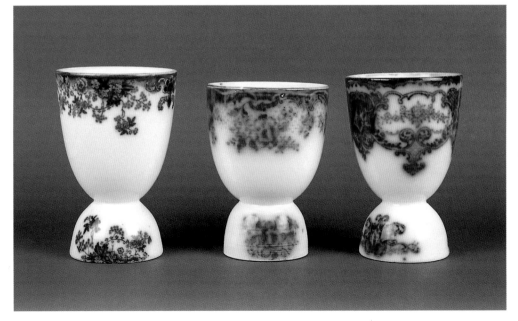

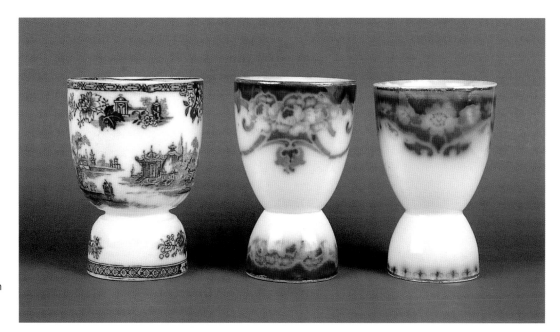

Egg cups, patterns and potters (left to right): MADRAS by Doulton & Co., 4 3/4" high; MONARCH by Myott, 3 7/8" high; CRUMLIN by Myott, 3 7/8" high. *Courtesy of Jim and Shelley Lewis.* $150-165 each

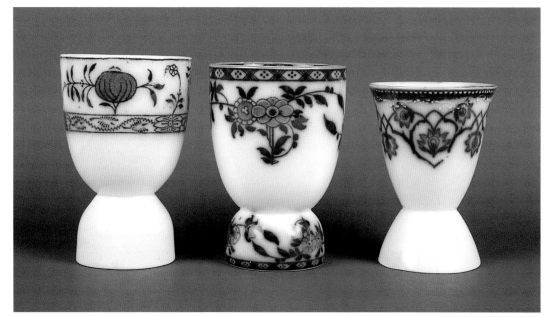

Egg cups, patterns and potters (left to right): HOLLAND by Johnson Bros. Ltd., 4"; DELPH by Globe Pottery, 4"; HADDON by W. H. Grindley & Co., 3 1/2" high. *Courtesy of Jim and Shelley Lewis.* Left to right: $150-165; $125-135; $150-165

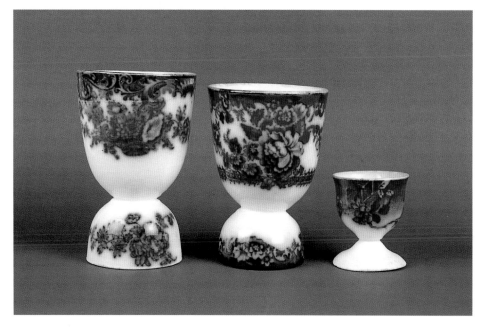

Egg cups, patterns and potters (left to right): ARCADIA by Wilkenson, 4"; GENEVESE by Edge, Malkin, 3 3/4" high; ST. LOUIS by Johnson Bros. Ltd., 2" high. *Courtesy of Jim and Shelley Lewis.* Left to right: $175-190; $150-165; $125-135

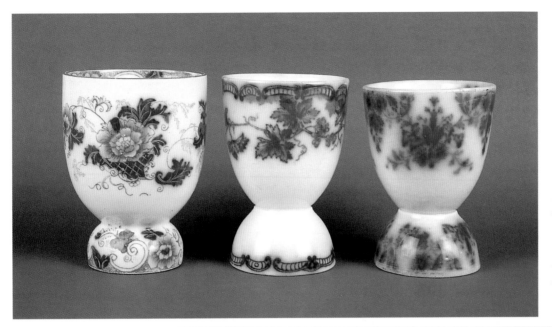

Egg cups, patterns and potters (left to right): BENTICK by Cauldon Ltd., 3 1/2" high; LONSDALE by Ridgways, 3 1/2" high; OSBORNE by Ridgways, 3 1/2" high. *Courtesy of Jim and Shelley Lewis.* $150-165 each

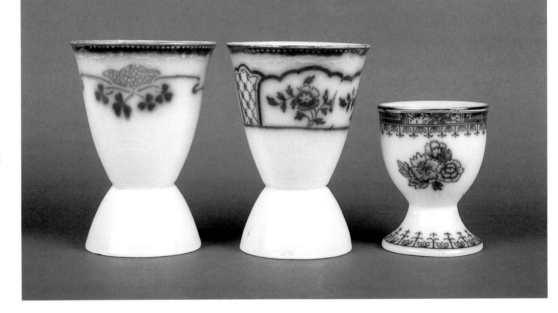

Egg cups, patterns and potters (left to right): LORNE by W. H. Grindley & Co., 3 1/2" high; MELBOURNE by W. H. Grindley & Co., 3 1/2" high; unidentified pattern and potter, 2 1/2" high. *Courtesy of Jim and Shelley Lewis.* Left to right: $200-220; $200-220; $100-110

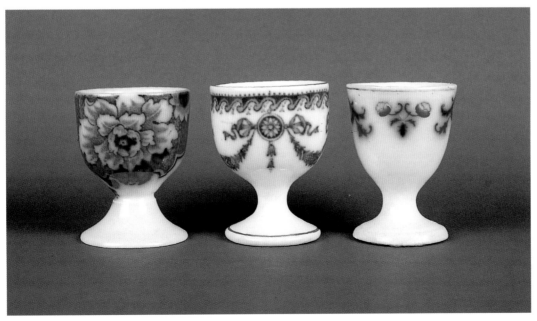

Egg cups, patterns and potters (left to right): CAMBRIDGE by New Wharf Pottery, 2 1/4" high; unidentified pattern and potter, 2 1/4" high; COUNTESS by W. H. Grindley & Co., 2 3/8" high. *Courtesy of Jim and Shelley Lewis.* $100-110 each

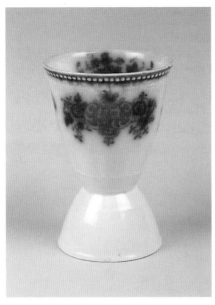

CLARENCE egg cup by W. H. Grindley & Co. 3 1/2" x 2 1/2" in diameter. *Courtesy of Jerry and Margaret Taylor.* $150-165

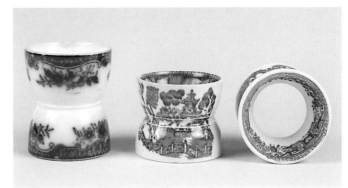

Double egg cups should not be confused with napkin holders and are very rare. Unidentified pattern and potter double egg cup. WILLOW double egg cups, c. 1850+. *Courtesy of Arnold A. and Dorothy E. Kowalsky.* Unidentified pattern: $250-300. Willow: $150 each.

Varied Wares, Additional Patterns

Included in this section are patterns which have not appeared in my previous books. Unlike my other texts, the patterns are arranged here only in alphabetical order. No attempt has been made to separate these patterns into the Early, Middle, and Late Victorian periods as the vast majority are from the Late Victorian. Wares dating from earlier periods are noted in the captions.

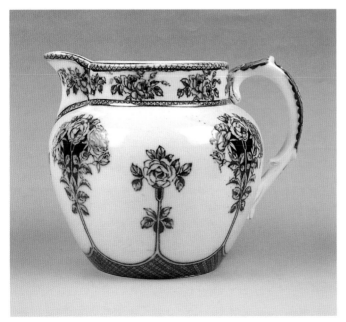

ARGYLE pitcher by J & E. Mayer. 6 1/2" high. *Courtesy of Jerry and Margaret Taylor.* $350-385

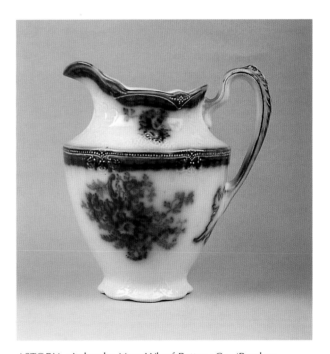

ASTORIA pitcher by New Wharf Pottery Co. (Burslem, Staffordshire, c. 1878-1894), 6 1/4" high to lip. *Courtesy of Jerry and Margaret Taylor.* $275-300

J. & E. Mayer Potteries Co., Ltd., Beaver Falls, Pennsylvania, 1881-1964, printed manufacturer's mark in use from c. 1881-c. 1888, and Argyle pattern name. *Courtesy of Jerry and Margaret Taylor.*

Left and far left:
BABES IN THE WOODS parasol
handle (refer to the teapots
section for a better look at this
pattern), no manufacturer's mark.
2 3/4" x 1 1/2". *Courtesy of Arnold
A. and Dorothy E. Kowalsky.* NP

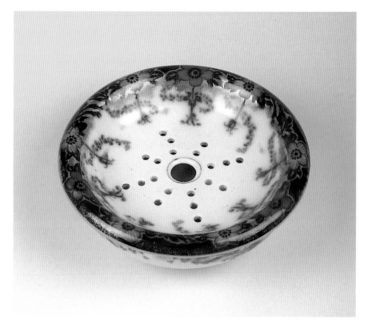

BRIAR sponge bowl by Burgess & Leigh. 7" in diameter. *Courtesy of
Jerry and Margaret Taylor.* $275-300

Burgess & Leigh (Ltd.), Burslem, Stafford-
shire, c. 1862-onward, printed
"Middleport Pottery / B & L" mark in use
from 1889-1912, and Briar pattern name.
The registry number indicates a registra-
tion date of 1904. *Courtesy of Jerry and
Margaret Taylor.*

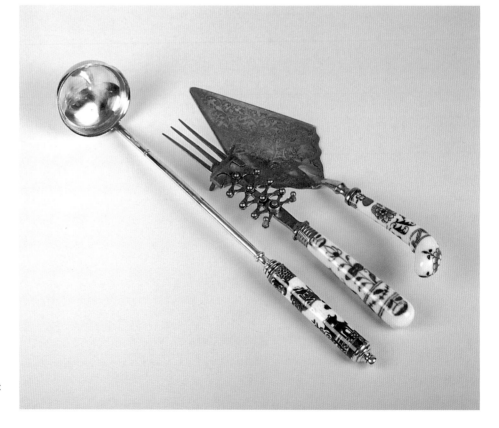

Left to right: Unidentified pattern silver
punch ladle, no manufacturer's mark. 12"
in length. BLUE ONION serving fork, no
manufacturer's mark, with spring action
release, 10" in length. BLUE ONION cake
server, no manufacturer's mark. 11".
*Courtesy of Arnold A. and Dorothy E.
Kowalsky.* Punch ladle: $300-400. Blue
Onion fork: $250-350. Blue Onion server:
$150-250.

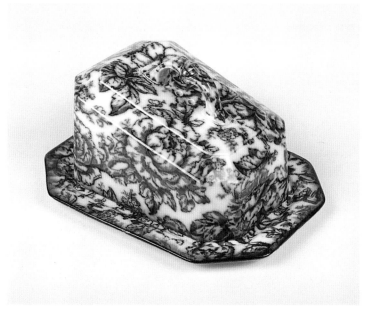

CAVENDISH covered cheese dish by Keeling & Co. 8 3/4" base length, 7" base width, 4 1/2" high. *Courtesy of Jerry and Margaret Taylor.* $400-440

Keeling & Co., Burslem, Staffordshire, c. 1886-1936, printed "Lysol Ware" mark in use from c. 1912-1936, and Cavendish pattern name. *Courtesy of Jerry and Margaret Taylor.*

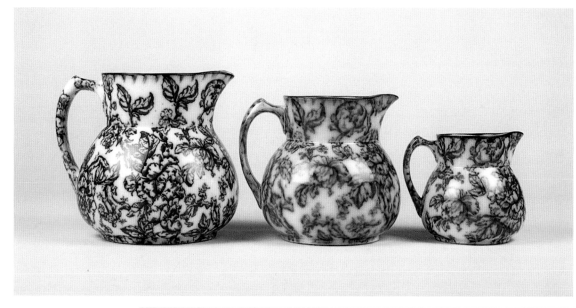

CAVENDISH graduated pitchers by Keeling & Co. 6 1/4", 5 1/4", & 4 1/8" high to lip. *Courtesy of Jerry and Margaret Taylor.* Left to right: $600-660; $525-575; $450-495

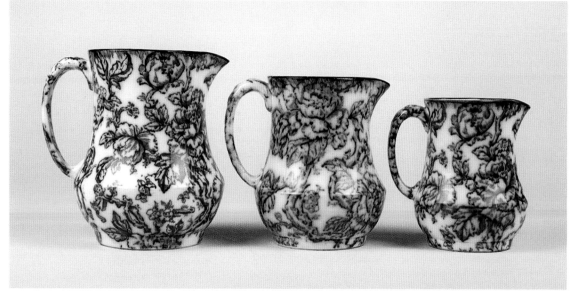

CAVENDISH pitchers by Keeling & Co. 6", 5 1/4", & 4 5/8" high to lip. *Courtesy of Jerry and Margaret Taylor.* Left to right: $600-660; $525-575; $450-495

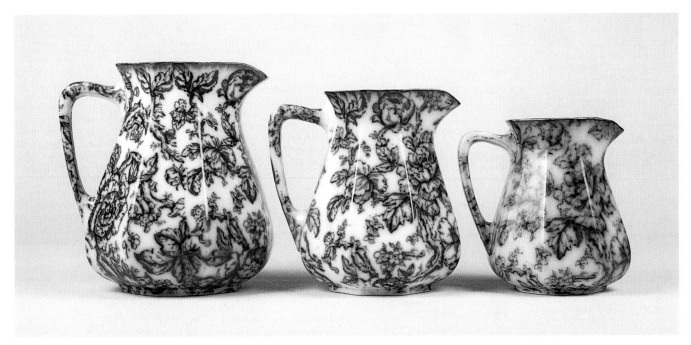

CAVENDISH paneled pitchers by Keeling & Co. 6 1/4", 6", & 5 1/8" high to lip. *Courtesy of Jerry and Margaret Taylor.* Left to right: $600-660; $525-575; $450-495

CAVENDISH vases by Keeling & Co. 9 1/8" high each. *Courtesy of Jerry and Margaret Taylor.* $800-880 pair

CLAREMONT berry drainer with underplate, "Burleigh Ware" by Burgess & Leigh. Drainer: 8" in diameter. Undertray: 8 1/2" in diameter. *Courtesy of Jerry and Margaret Taylor.* $350-385

CLARENCE platter by W. H. Grindley & Co. 18". *Courtesy of Jerry and Margaret Taylor.* $325-355

CLYTIE platter by Wedgwood & Co., c. 1906. 17 1/2". *Courtesy of Jerry and Margaret Taylor.* $800-880

Wedgwood & Co. (Ltd.), Tunstall, Staffordshire, 1860-1965, printed "Royal / Semi-Porcelain / Wedgwood & Co. Ld." mark in use c. 1906+, and Clytie pattern name. *Courtesy of Jerry and Margaret Taylor.*

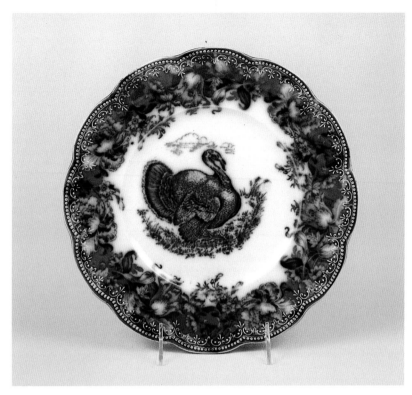

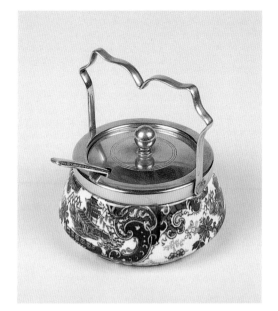

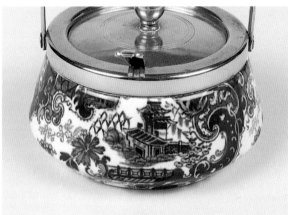

CLYTIE plate by Wedgwood, c. 1906. 10" in diameter. *Courtesy of Jerry and Margaret Taylor.* $150-165

COREY HILL condiment dish (lidded), no manufacturer's mark. Although unmarked, this pattern is known to have been produced by Ridgway, Sparks & Ridgway (Shelton, Hanley, Staffordshire, c. 1872-1878). 3" high to finial x 4 1/2" in diameter. *Courtesy of Jerry and Margaret Taylor.* $275-300

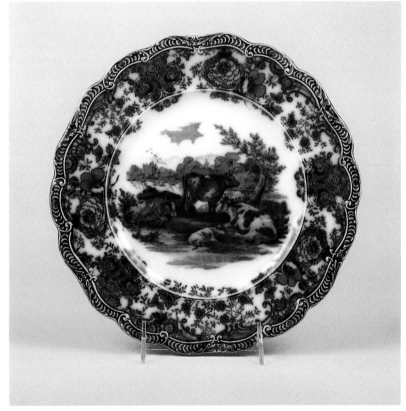

COWS plate by Ridgways. 10" in diameter. *Courtesy of Jerry and Margaret Taylor.* $150-165

Ridgways, Shelton, Hanley, Staffordshire, c. 1878-1920, printed mark in use from post-1891 - c. 1920. *Courtesy of Jerry and Margaret Taylor.*

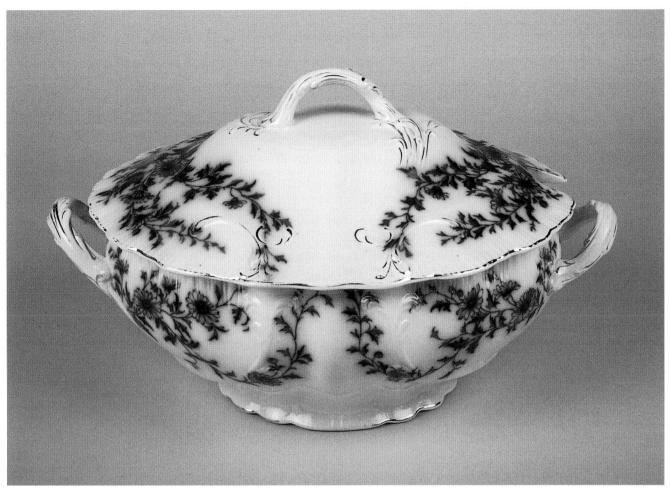

DAISY soup tureen by Burgess & Leigh. 14″ in length x 8″ high.
Courtesy of Jerry and Margaret Taylor. $425-465

Right:
Burgess & Leigh (Ltd.), Burslem,
Staffordshire, c. 1862-onward,
printed mark in use from c.
1906-1912, and Daisy pattern
name. *Courtesy of Jerry and
Margaret Taylor.*

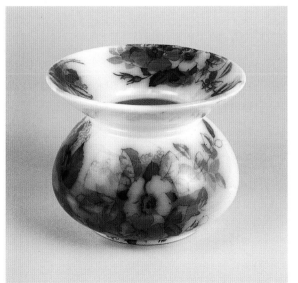

DOG-ROSE spittoon by Ridgways, c. 1905. 5 1/2″ high.
Courtesy of Warren and Connie Macy. $500-600

Ridgways, Shelton, Hanley, Stafford-
shire, c. 1878-1920, printed
manufacturer's mark, c. 1905+,
and Dog-Rose pattern name.
*Courtesy of Warren and Connie
Macy.*

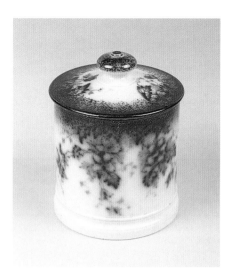

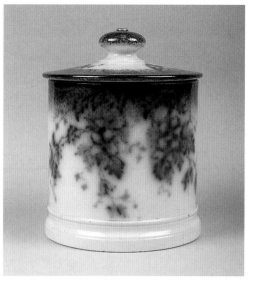

DORIC tea caddy by William Adams & Co. 5 1/4" high to finial.
Courtesy of Jerry and Margaret Taylor. $325-355

William Adams & Co., Tunstall,
Staffordshire, c. 1829 onward, printed
"W. A. & Co." mark in use from
c. 1893-1917, and Doric pattern name.
Courtesy of Jerry and Margaret Taylor.

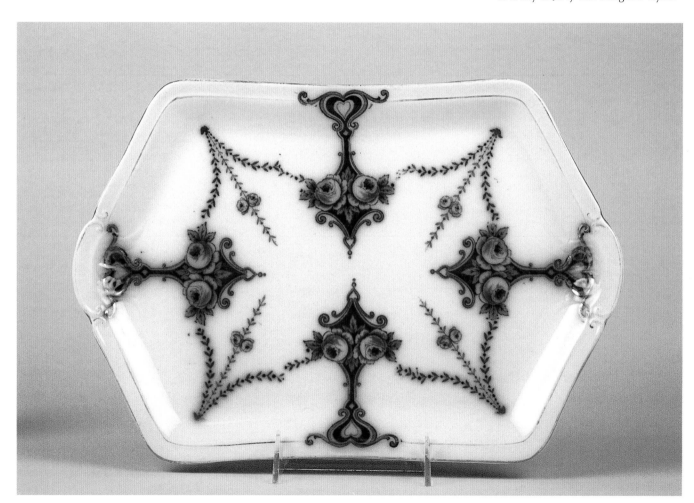

DRAYTON undertray from a dresser set by Ford & Sons Ltd., c. 1908. 13 1/8"
in length x 9 1/4" wide. *Courtesy of Jerry and Margaret Taylor.*

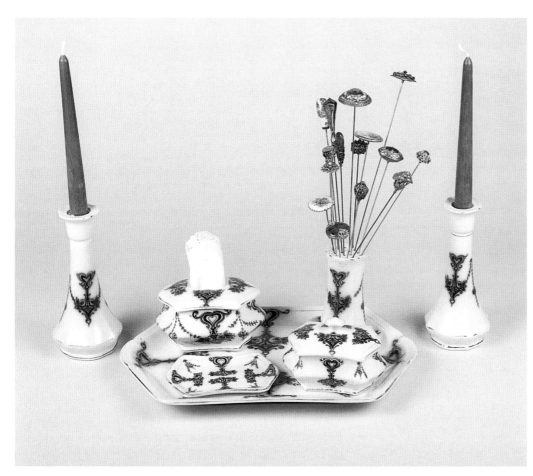

DRAYTON dresser set by Ford & Sons Ltd., c. 1908. *Courtesy of Jerry and Margaret Taylor.* $700 set

Ford & Sons (Ltd.), Burslem, Staffordshire, c. 1893-1938, printed "F & Sons Ltd." mark in use in c. 1908+, with Drayton pattern name. *Courtesy of Jerry and Margaret Taylor.*

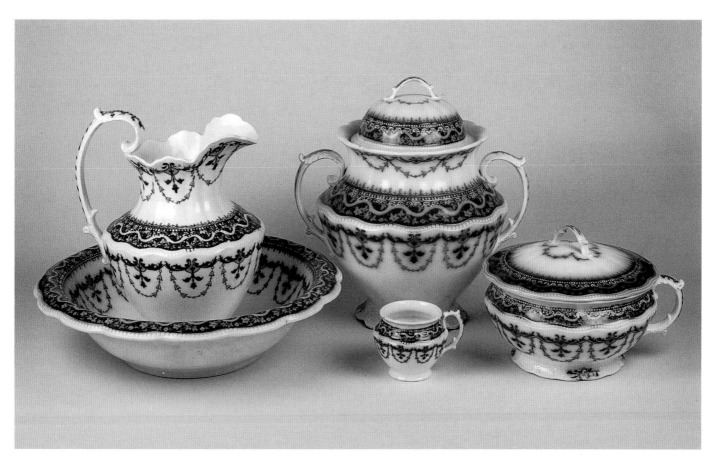

FESTOON partial toilet set by W. H. Grindley & Co. Chamber pot, shaving mug, ewer & basin, master slop jar. Pitcher: 11 1/4" high. Master slop jar: 14 1/2" high. *Courtesy of Jerry and Margaret Taylor.* $2400-2640 set

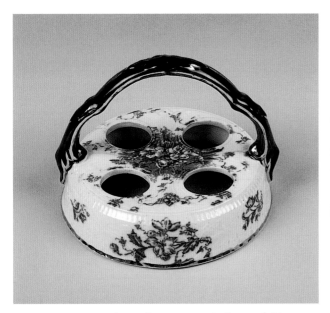

FLORA egg carrier by Keeling & Co. 5" high x 6 1/2" in
diameter. *Courtesy of Jerry and Margaret Taylor.* $525-575

Keeling & Co., Burslem, Staffordshire, c. 1886-1936, printed "K. & Co. B"
trade-mark in use from c. 1886-1936, and Flora pattern name. *Courtesy of
Jerry and Margaret Taylor.*

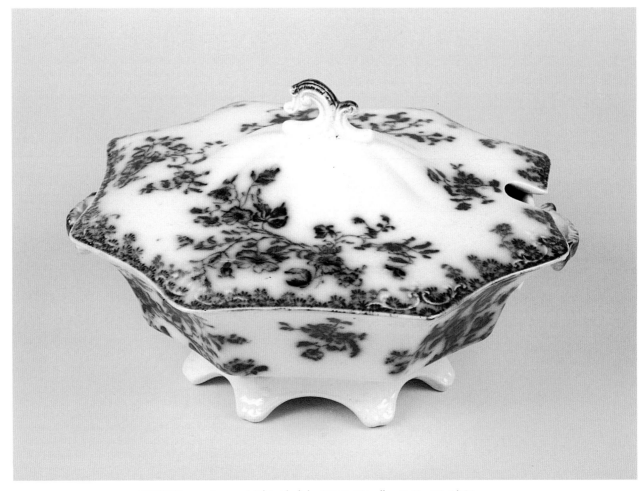

JANETTE soup tureen (eight sided) by W. H. Grindley & Co. 11 1/4" in
length x 6 1/2" high. *Courtesy of Jerry and Margaret Taylor.* $475-520

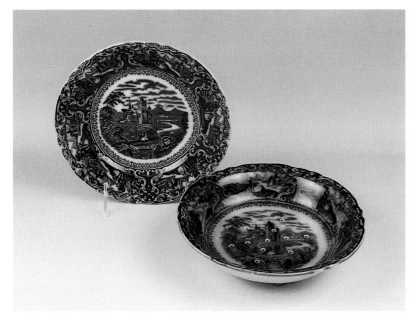

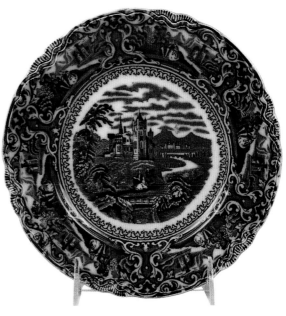

Above and right:
MATTEAN berry (or water cress) drainer & undertray, no manufacturer's mark (although this pattern is known to have been produced by Sampson Hancock [& Sons], Tunstall, Stoke-on-Trent, Hanley, Staffordshire, c. 1858-1937). Drainer & undertray: 7 7/8" in diameter each. *Courtesy of Jerry and Margaret Taylor.* $300-330

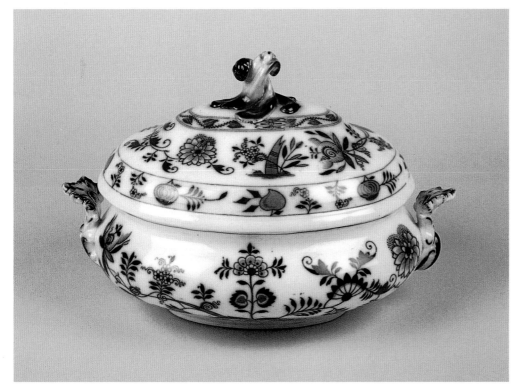

Brown-Westhead, Moore & Co., Shelton, Hanley, Staffordshire, c. 1862-1904, printed mark in use from c. 1895-1904, and Meissen pattern name. *Courtesy of Jerry and Margaret Taylor.*

MEISSEN covered tureen (the lid is unusual as it has no access for the ladle) by Brown-Westhead, Moore & Co. 13 1/2" in length x 9 1/4" high. *Courtesy of Jerry and Margaret Taylor.* $350-385

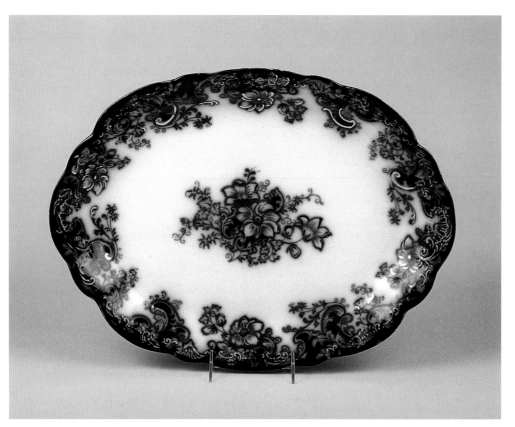

Alfred Meakin (Ltd.), Tunstall, Staffordshire, 1875-1913, printed manufacturer's mark in use in c. 1897+, and Ormonde pattern name. *Courtesy of Jerry and Margaret Taylor.*

ORMONDE platter by Alfred Meakin, c. 1897. 18" in length x 13 1/4" wide. *Courtesy of Jerry and Margaret Taylor.* $375-410

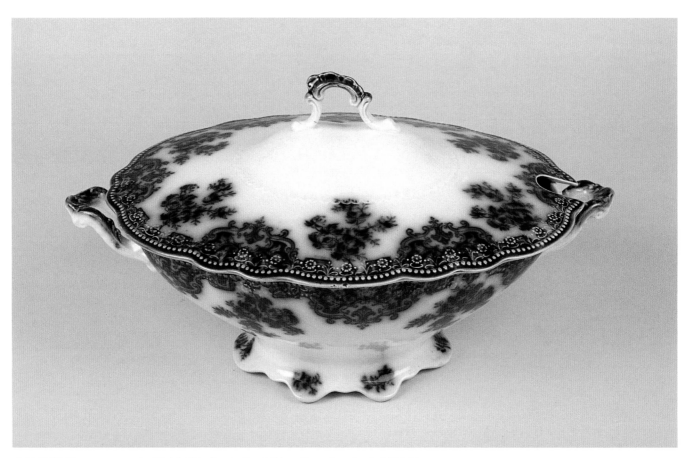

OSBOURNE soup tureen by W. H. Grindley & Co. 14" handle to handle, 8 3/8" high. *Courtesy of Jerry and Margaret Taylor.* $575-630

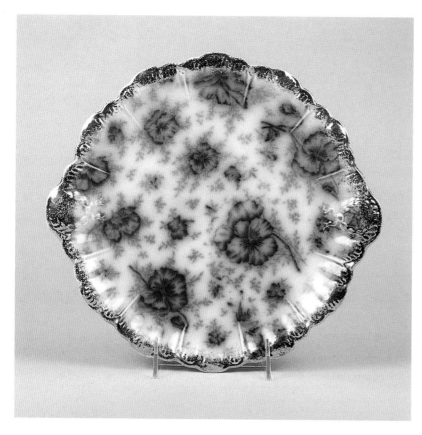

PANSY plate by Warwick China. 11" in diameter. *Courtesy of Jerry and Margaret Taylor.* $150-165

Unidentified pattern shot glass, maker unknown, and PANSY card deck holder by Warwick China. Shot glass: 2" high x 2" in diameter. Card holder: 2 3/4" high x 4" in length x 1" wide. *Courtesy of Tom and Kathy Clarke.* Shot glass: $100+. Card holder: $400+

Below:
PEONY horizontal razor box by Alfred Meakin, c. 1907. It is unusual to find a razor box among such late dating wares. Normally these objects were associated with the 1840-1860 Early Victorian period. 8 1/2" in length. *Courtesy of Arnold A. and Dorothy E. Kowalsky.* $350-450.

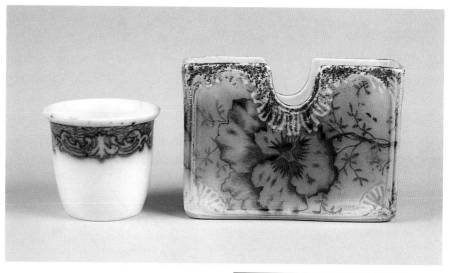

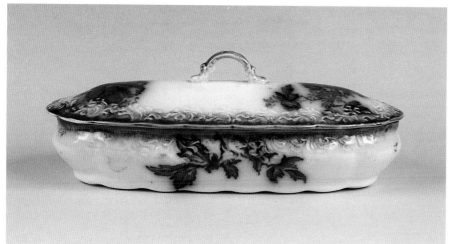

Alfred Meakin, (Ltd.), Tunstall, Staffordshire, 1875-1913, printed manufacturer's mark in use in c. 1907+, and Peony pattern name. *Courtesy of Arnold A. and Dorothy E. Kowalsky.*

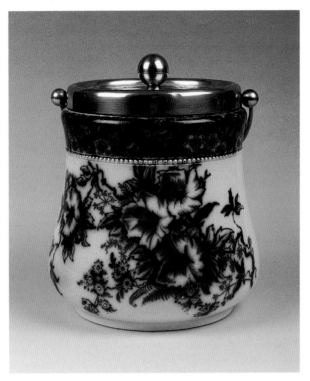

PETUNIA biscuit jar by Wiltshaw & Robinson with a silver lid & bail. 6 3/4" high to top of finial. *Courtesy of Jerry and Margaret Taylor.* $425-465

Wiltshaw & Robinson, Stoke-upon-Trent, Staffordshire, 1890-1957, printed mark in use from 1906 onward, and Petunia pattern name. The registration number indicates a registry date of 1895. *Courtesy of Jerry and Margaret Taylor.*

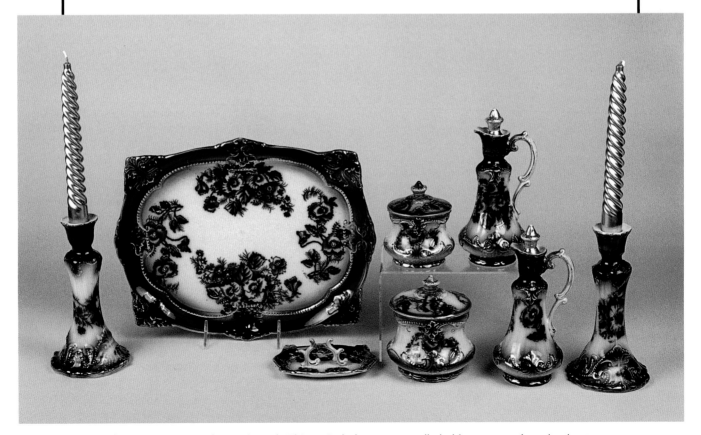

POPPY dresser set, no manufacturer's mark. This set includes a tray, candle holders, two perfume bottles, two lidded boxes, and a pin tray. Tray: 13" in length x 10" wide. *Courtesy of Jerry and Margaret Taylor.* $850-935

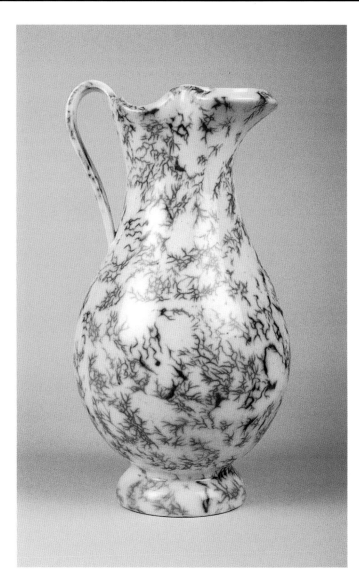

W.T. Copeland (& Sons Ltd.), Stoke-on-Trent, Staffordshire, 1847-1970+, printed "Copeland" and impressed name and crown marks in use from c. 1847-1969. *Courtesy of Jerry and Margaret Taylor.*

SEAWEED pitcher by W.T. Copeland, c. 1847. 12 1/2" high. *Courtesy of Jerry and Margaret Taylor.* $350-385

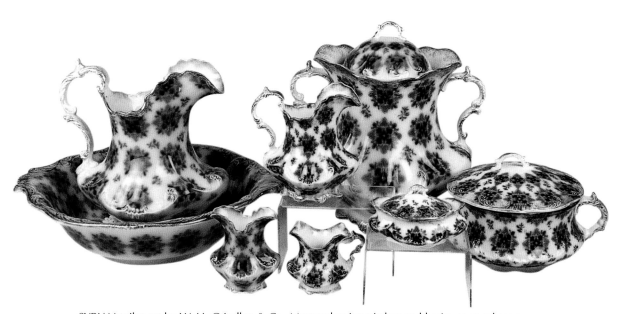

SYRIAN toilet set by W. H. Grindley & Co. Master slop jar, pitcher and basin, covered soap dish, toothbrush holder, and two pitchers. Slop jar: 14" high. Pitcher: 9 1/2" high to lip. *Courtesy of Jerry and Margaret Taylor.* $4000-4400 set

TURKEY platter by Ridgways. 22". *Courtesy of Jerry and Margaret Taylor.* $1400-1540

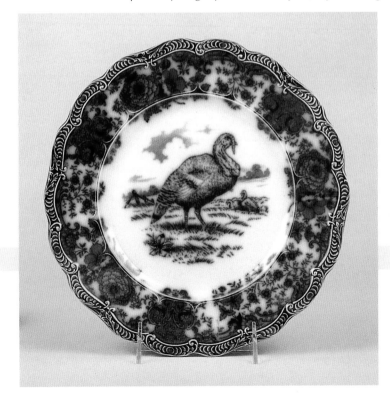

TURKEY plate by Ridgways. 10" in diameter. *Courtesy of Jerry and Margaret Taylor.* $150-165

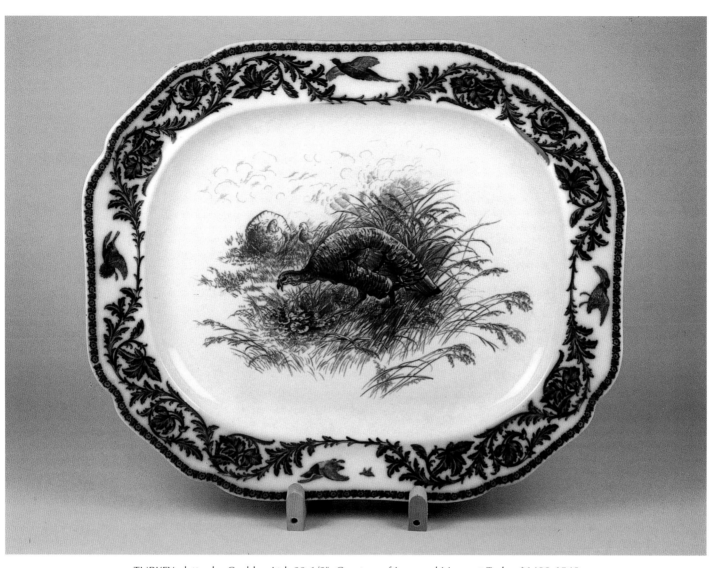

TURKEY platter by Cauldon Ltd. 23 1/2". *Courtesy of Jerry and Margaret Taylor.* $1400-1540

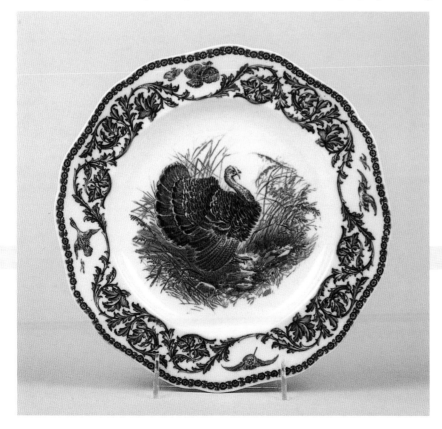

TURKEY plate by Cauldon Ltd. 10" in diameter. *Courtesy of Jerry and Margaret Taylor.* $125-135

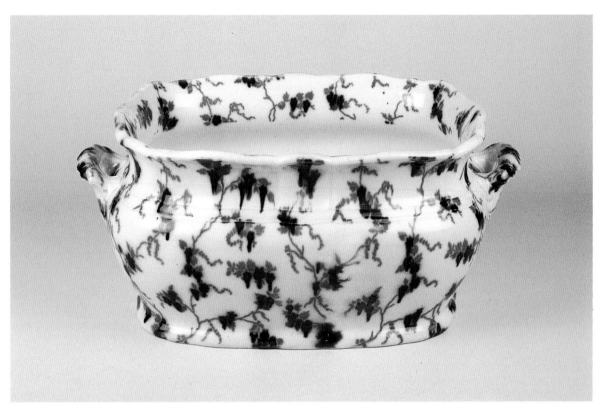

Unidentified grape or berry pattern foot bath, no manufacturer's mark. 8 1/2" high x 19" handle to handle. *Courtesy of Jerry and Margaret Taylor.* $2400-2640

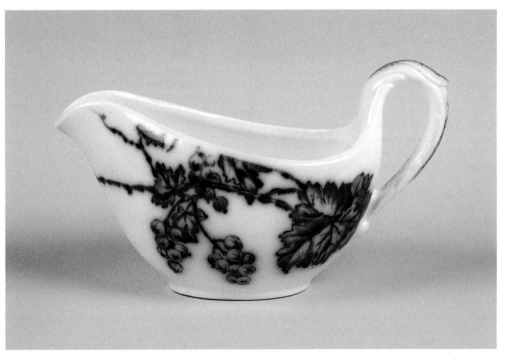

Johnson Bros. Ltd., Hanley, Tunstall, Staffordshire, c. 1883-1968, printed manufacturer's mark in use in c. 1913+, and Warwick pattern name. *Courtesy of Arnold A. and Dorothy E. Kowalsky.*

WARWICK sauce boat by Johnson Bros. Ltd., c. 1913. This small size sauce is extremely rare and was used for cold sauces, i.e. mint sauce. 4" x 2 1/2" (5 1/2" to handle). *Courtesy of Arnold A. and Dorothy E. Kowalsky.* $300-400

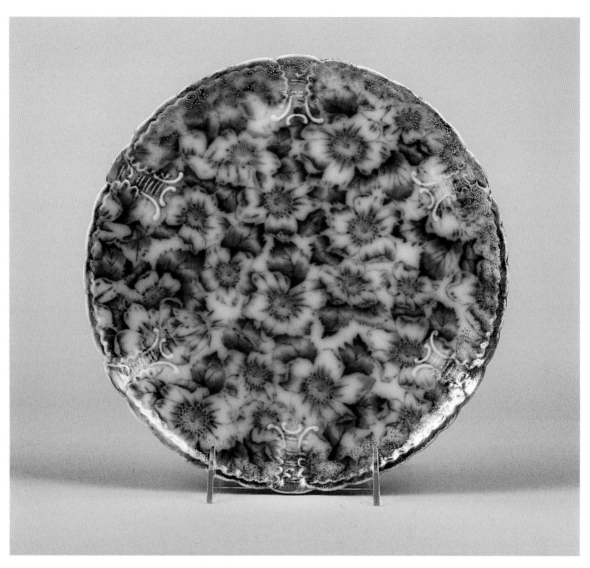

WILD ROSE cake plate by Warwick China. 9 1/2″ in diameter.
Courtesy of Jerry and Margaret Taylor. $150-165

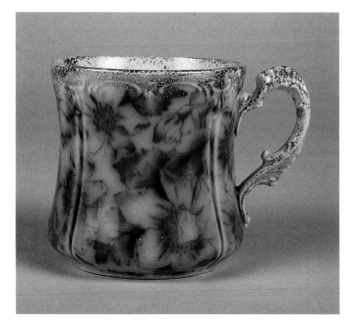

WILD ROSE mug by Warwick China.
Courtesy of Warren and Connie Macy.
$250-300

Bibliography

Busby, Judith. "Sources of Design — Introduction." In *True Blue*, edited by Roberts, Gaye Blake. East Hagbourne, Oxfordshire: Friends of Blue, 1998.

Copeland, Robert. "A Brief History of Transfer-Printing on Blue and White Ceramics." In Kowalsky, Arnold A. and Dorothy E. *Encyclopedia of Marks On American, English and European Earthenware, Ironstone, and Stoneware 1780-1980*. Atglen, Pennsylvania: Schiffer Publishing Ltd., 1999.

Copeland, Robert. "The Marketing of Blue and White Wares." In *True Blue*, edited by Roberts, Gaye Blake. East Hagbourne, Oxfordshire: Friends of Blue, 1998.

Ewins, Neil. *Supplying the Present Wants of Our Yankee Cousins ... : Staffordshire Ceramics and the American Market 1775-1880*. Journal of Ceramic History 15, 1997.

Holdaway, Minnie. "Sources of Design — Botanical Patterns." In *True Blue*, edited by Roberts, Gaye Blake. East Hagbourne, Oxfordshire: Friends of Blue, 1998.

Holdaway, Minnie. "The Early Wares 1780-1805." In *True Blue*, edited by Roberts, Gaye Blake. East Hagbourne, Oxfordshire: Friends of Blue, 1998.

Klein, Terry H. "Nineteenth-Century Ceramics and Models of Consumer Behavior." *Historical Archaeology* 25(2), 1991, pp. 77-88.

Kowalsky, Arnold A. and Dorothy E. *Encyclopedia of Marks On American, English and European Earthenware, Ironstone, and Stoneware 1780-1980*. Atglen, Pennsylvania: Schiffer Publishing Ltd., 1999.

McCormick, Malachi. *A Decent Cup of Tea*. New York: Clarkson Potter, 1991.

Moore, N. Hudson. *The Old China Book*. New York: Tudor Publishing Company, 1903

Otto, Doreen. "The Useful Wares." In *True Blue*, edited by Roberts, Gaye Blake. East Hagbourne, Oxfordshire: Friends of Blue, 1998.

Pulver, Rosalind. "Changing Styles 1840-1870." In *True Blue*, edited by Roberts, Gaye Blake. East Hagbourne, Oxfordshire: Friends of Blue, 1998.

Snyder, Jeffrey B. *Fascinating Flow Blue*. Atglen, Pennsylvania: Schiffer Publishing Ltd., 1997.

_____. *Flow Blue. A Collector's Guide to Pattens, History, and Values*. Atglen, Pennsylvania: Schiffer Publishing Ltd., 1992.

_____. *Historic Flow Blue*. Atglen, Pennsylvania: Schiffer Publishing Ltd., 1994.

_____. *A Pocket Guide to Flow Blue*. Atglen, Pennsylvania: Schiffer Publishing Ltd., 1995.

Wheeling Potteries Company, *Catalogue No. 31*, Wheeling, West Virginia, 1906.

Williams, Petra. *Flow Blue China. An Aid to Identification*. Jeffersontown, Kentucky: Fountain House East, 1971.

Indexes

The first Index references patterns and items of interest in this book alone.

The Index of Patterns which follows, on pages 188-192, lists all of the patterns found in my five books on this subject: *Flow Blue* (1992, revised 1996 & 1999), *Historic Flow Blue* (1994), *A Pocket Guide to Flow Blue* (1995, revised 1999), *Fascinating Flow Blue* (1997), and *Flow Blue: A Closer Look* (2000). This should provide a useful cross-reference when you are searching for one special pattern and its value. Be aware that when you see the same pattern name referenced in several different books, it is not always the *same* pattern from one book to the next. Different pottery firms used the same name to identify very different patterns in many instances.

Adams & Co., William, 174
Admiral Dewey jardiniere and jardiniere stand, 10, 102
Alcock & Company (Ltd.), Henry, 4, 7, 102-110, 119
Biscuit jars, 65, 180
Bishop & Stonier (Ltd.), 150
Bone dishes, 66, 107
Bouillon cups and saucers, 66
Bourne & Leigh, 132, 164
Bowls, 52-55, 57-58
Bowls, berry, 4, 49
Bowls, cereal, 52, 103
Bowls, covered/open vegetable, 23-24, 40-42, 63-64, 105-107
Bowls, master berry, 54
Bowls, soup, 18, 52, 103
Brown-Westhead, Moore & Co., 177
Burgess & Leigh, 114, 123, 143, 145, 168, 173
Butter dishes, covered, 25, 42, 65, 107
Butter pats, 66, 107, 159-164
Cake plates, 4, 185
Candle holders, 96
Card deck holders, 179
Cashmere pattern wares, 17-36
Cauldon Ltd., 119, 140, 143, 183
Centennial Exhibition of 1876, 10
Ceramic history, 8-16
Chapoo pattern wares, 37-47
Chargers, 58-59
Chargers, portrait, 87-88, 92
Cheese dishes, covered, 169
Children's wares, 36, 47, 96, 155-159
Chocolate sets, 6, 31, 79-80, 140-141
Chop plates, 103
Clementson, Joseph, 13
Coffee sets, 31, 43, 78
Condiment dishes, 172
Copeland, Robert, 8
Copeland, W.T., 181
Copyright Act of 1842, 7
Cracker jars, 65
Davenport & Co., 152, 157
Definition, Flow Blue, 5
Definition, whiteware, 5
Dessert services, 26-28, 71-72, 108
Doulton & Co. (Ltd.), 7, 15, 117, 127-129, 132, 137, 150, 154, 165
Drainers, berry, 170, 177
Dresser sets, 174-175, 180
Early Victorian period, 6
Early Victorian wares, 17-47
Edge, Malkin & Co., 121
Egg carriers, 176
Egg cups, 108
Farmer's cups, 44
Ferners, 99
Flow Blue, definition, 5
Flow Blue, origins, 9
Flow powder, 5, 9

Footbaths, 35-36, 47, 184
Ford & Sons Ltd., 174-175
Game sets, 84-87
Garden seats, 99
Gravy boats, 23, 40, 63, 105
Great Exhibition of 1851, London, 13, 14
Grindley & Co., W.H., 11, 111-114, 118-120, 131, 157, 159-161, 164, 166-167, 171, 175-176, 178, 181
Honey dishes, 38
Hughes, Thomas, 116
Ironstone, 5-6
Jardinieres and jardiniere stands, 10, 100-102
Johnson Bros. Ltd., 112, 116, 118, 121-127, 131, 139, 161-162, 164, 165, 184
Johnson, Ltd., Samuel, 151
Keeling & Co., Ltd., 112, 135, 169-170, 176
La Belle pattern wares, 48-102
Late Victorian period, 6
Late Victorian wares, 48-110
Livesley, Powell & Co., 119
Loving cups, 31
Manufacturers' marks, 7
Mason, Charles James, 5-6, 9
Mayer, J. & E., 167
Meakin, Alfred, 126, 178-179
Meakin, J. & G., 115, 163
Meigh, Charles, 146-147
Mercer Pottery Company, 118, 126, 156
Middle Victorian period, 6
Minton, Herbert, 5
Moore, N. Hudson, 8
Mugs, 185
Myott, Sons & Co. (Ltd.), 142, 145
New Wharf Pottery Co., 155, 166-167
Opaque china, 6
Parasol handles, 168
Pattern designs and themes, 6-7
Patterns:
Alaska, 161
Albany, 111, 162
Aldine, 111
Apples, 112
Arcadia, 165
Argyle, 112, 142, 160, 167
Astoria, 112, 167
Babes in the Woods, 168
Beaufort, 113
Bentick, 140, 166
Blossom, 142
Blue Danube, 162
Blue Onion, 168
Brazil, 113
Briar, 114, 168
Brooklyn, 162
Burleigh, 164
Calico, 140, 142
Cambridge, 163, 166
Candia, 143
Cashmere, 4, 17-36

Cavendish, 169-170
Cecil, 163
Celtic, 114, 159
Chapoo, 5, 12, 37-47
Claremont, 170
Clarence, 114, 167, 171
Clayton, 161
Clifton, 160
Clyde, 155
Clytie, 171-172
Coburg, 155
Colonial, 115
Corey Hill, 172
Countess, 159, 166
Cows, 172
Cracked Ice, 115, 140, 143
Crumlin, 163, 165
Dainty, 164
Daisy, 173
Daisy Chain, 142
Delft, 116, 143
Delph, 165
Devon, 163
Dog-Rose, 173
Doreen, 11
Doric, 174
Dovedale, 116
Drayton, 174-175
Dresden Flowers, 143
Dundee, 163
Fallow Deer, 144
Ferrara, 144
Festoon, 175
Flora, 176
Floral, 116
Florida, 116, 160, 161
Forget-Me-Not, 156
Gainsborough, 163
Galleon, 117
Geneva, 117
Genevese, 165
Gironde, 159
Grace, 160
Grenada, 164
Haddon, 160, 165
Haarlem, 145
Hartington, The, 159
Hawthorne, 156
Holland, 118, 162, 165
Idris, 145, 164
"In the Garden," 146
Janette, 118, 161, 176
Japan Flowers, 146
Jewel, 162
Kelvin, 163
La Belle, 6, 10, 16, 48-102
Lily, 147
Linda, 164
Lonsdale, 163, 166
Lorne, 160, 166
Luzerne, 118
Lyndhurst, 159
Macina, 119
Madras, 165
Manhattan, 119
Marble, 119, 147, 157
Marechal Neil, 119-120

Margarite, 120
Marguerite, 160
Marie, 160
Mattean, 177
Melbourne, 120, 157, 159, 166
Mentone, 121
Meissen, 177
Missouri, 121
Monarch, 165
Mongolia, 122
Montana, 122
Moss Rose, 122
Neopolitan, 123
Non Pariel, 123
Normandy, 123-126, 162
Ophir, 164
Oregon, 161
Ormonde, 126, 178
Osborne, 161
Osbourne, 178
Oxford, 162
Paisley, 162
Pansy, 140-141, 147, 179
Peach, 127, 162
Peony, 179
Persian, 162
Persian Spray, 127-129
Petunia, 180
Poppy, 130, 180
Portman, 131, 160
Princeton, 161
Progress, 131
Prunus, 148
Reeds & Flowers, 148
Roma, 163
Ruby, 148
Savoy, 164
Seaweed, 131, 181
Servants, 158
Sloe Blossom, 158-159
St. Louis, 131, 161, 165
Stanley, 161
Switzerland, 132
Sylvan, 132
Syrian, 181
Touraine, 4, 102-110
Turkey, 182-183
Verona, 139, 163
Versailles, 164
Warwick, 139, 162, 184
Watteau, 15, 154
Waverly, 161
Wild Rose, 140-141, 155, 185
Willow, 155, 167
Periods of Flow Blue production, 6
Pitchers, 5, 14, 25, 43, 69-71, 108, 167, 169-170, 181
Pitchers, ice, 69-70
Pitchers, portrait, 92, 94-95
Pitchers, syrup, 15, 68-69, 142-155
Plaques, portrait, 16
Plates, 17-18, 37, 49-51, 103, 172, 179, 182-183
Plates, hot water, 18
Plates, portrait, 90-92

Plates, toddy, 4, 38
Platters, 19-20, 38-39, 59-60, 104, 171, 178, 182-183
Platters, well and tree, 21
Posset cups, 45
Punch sets, 32, 80-81
Ramekins, 67
Razor boxes, 179
Registration marks, 7
Relish dishes, 25, 43, 66
Ridgway & Morley, 4, 17, 122
Ridgway, William, 21
Ridgways, 139, 158, 163, 166, 172-173, 182
Salt dips, 67
Sampson Hancock & Sons, 116, 177
Sauce dishes, 38, 103, 184
Semi-porcelain, 6
Shot glasses, 179
Spittoons, 96-97, 173
Sponge bowls, 168
Stanley Pottery Company, Ltd., 4, 102-110
Stone china, 6
Tea caddies, 174
Tea kettle, 139
Tea sets, 29-30, 43-46, 73-77, 108-110, 111-139
Toilet sets, 11, 33-35, 46, 81-83, 175, 181
Touraine pattern wares, 102-110
Transfer printing, 6
Trays, 56-57, 60-61
Trays, portrait, 88-90
Trivets, 67
Tureens, 177
Tureens, sauce, 21, 22, 40, 63, 105
Tureens, soup, 12, 22, 39, 62, 104, 173, 176, 178
Umbrella stands, 98-99
Utzschneider/Sarreguemines, 5
Vases, 97-98, 170
Walley, Edward, 147
Warwick China, 115-116, 140-143, 147, 155, 179, 185
Waste bowls, 31, 45-46, 109-110
Waste jars, portrait, 93
Wedgwood & Co., 133-134, 142, 171-172
Wedgwood, Josiah (& Sons, Ltd.), 144
Wheeling Potteries Company, 48-49
Wheeling Pottery Company, 6, 10, 16, 48-49, 91
Whiteware, definition, 5
Wiltshaw & Robinson (Ltd.), 149, 151, 180
Wood & Son, 163
Wood, Arthur, 130, 149
Wood, H.J., 135, 151
Wood, John Wedg, 5, 12, 37

Pattern Names	Flow Blue	Historic Flow Blue	Pocket Guide to Flow Blue	Fascinat-ing Flow Blue	Flow Blue: A Closer Look
Abbey	16, 26, 75-76				
Acadia		74			
Acme			36		
Adderley		132			
Adelaide		132			
Alaska	76	56			161
Albany	76-77				111, 162
Aldine					111
Alma		29	52		
Althea				10	
Amherst Japan		133	107		
Amoy	30	5, 10, 15, 16, 18, 75-76	9, 34, 60	25, 34, 36, 38, 48, 59, 73, 81-82	
Anemone		62			
Apples					112
Arabesque	16, 30	30, 59	19, 61	37, 59, 82-83	
Arcadia	78-79			33	165
Argyle	79	133	44, 109		112, 142, 160, 167
Arvista	79				
"Asiatic Birds"				73	
Asiatic Pheasant	80				
"Astor & Grape Shot"				83	
Astoria					112, 167
Atalanta	80				
Athens	31			84	
Athol	80-81				
Atlas		133			
Aubrey	22, 25, 81-82				
Avon		133			
Ayr	82	26			
Babes in the Woods					168
Balmoral	83				
Bamboo		7, 35, 52, 76-77	62	84	
Basket			42	35, 42	
Basket Pattern No. 204				74	
Beaufort	83				113
Beauties of China	9, 31		63	5, 12	
Bell	84				
Bentick	84				140, 166
Benton	155				
Berry		77			
Bimrah		78	63		
Blackberry		78-79		50, 60, 85	
"Bleeding Heart"				33, 69	
Blenhiem	26, 84-85				
Blossom			110		142
Blue Bell		13, 17, 32, 79-80, 122-123	12, 95	30, 35, 85-86	

Pattern Names	Flow Blue	Historic Flow Blue	Pocket Guide to Flow Blue	Fascinat-ing Flow Blue	Flow Blue: A Closer Look
Blue Bell & Grapes w/ Cherry Border				86	
Blue Danube	85	26			162
Blue Onion					168
Blue Rose		7			
Brazil		134	111		113
Briar					114, 168
Brooklyn					162
Brunswick	85				
Brush stroke				4, 24-25, 35-36, 56, 60, 71, 74, 76	
Burleigh		40, 134			164
Byronia			41	87	
Cabul		36, 80	64	87-88	
Calico					140, 142
California		64			
Cambridge	85-86				163, 166
Candia	86			89	143
Canton	32	54			
Canton Vine				90	
Carlsbad	86				
Carlton		80		33, 93	
Cashmere	33, 34	16	45, 64	17, 40, 45, 62, 66, 90-93	4, 17-36
Cavendish					169-170
Cecil		134			163
Celtic					114, 159
Ceylon	61				
Chapoo	24, 34, 35	6	7, 9, 39, 65	15, 65, 93-95	5, 12, 37-47
Chen Si	36		13, 66	35, 75	
Chelsea		135			
Chinese		81	20, 47	20, 23, 27, 95-96	
Chinese Bells		33			
Chinese Dragons		5			
Chinese Landscape		36, 44, 124-125	96	140	
Chinese Musicians				13	
Chinese Pagoda		32	53		
Chinese Sports				75	
Ching		82			
Chrysanthemum				35	
Chusan		5, 9, 25, 27-28, 49, 82-83, 135-136	30, 36, 45, 51, 67-68, 113	28, 30, 34, 47, 54, 97-100	
Circassia	36				
Ciris				28	
Claremont					170
Clarence	87				114, 167, 171
Claremont Groups				136	
Clayton	87-89				161
Clifton	90				160

Pattern Names	Flow Blue	Historic Flow Blue	Pocket Guide to Flow Blue	Fascinating Flow Blue	Flow Blue: A Closer Look
Clyde					155
Clytie					171-172
Coburg	61-62		58	52-53, 55, 65, 100-102	155
Colonial	90				115
Columbia	21, 37				
Convulvulus			103		
Conway	91-92				
Corey Hill					172
Corinthian Flute	92				
Countess					159, 166
Cows					172
Cracked Ice					115, 140, 143
Croxton	93				
Crumlin		137			163, 165
Cypress	93	12	69		
Dahlia		83	70		
Dainty	94				164
Daisy					173
Daisy Chain					142
Damask Rose		125	97		
Davenport	94				
Dejapore		84			
Delamere	94				
Delft					116, 143
Delph	95-96			141	165
Derby		27			
Deva		138			
Devon		46			163
Dog-Rose					173
Doreen					11
Doric					174
Doris	96	22			
Dorothy	10, 97-98				
Dovedale					116
Drayton					174-175
Dresden	98				
Dresden Flowers					143
Duchess	99		114	13	
Dudley		138	115		
Dundee					163
Ebor	99				
Edgar	99				
Eglinton Tournament		139			
Euphrates				104	
Excelsior	37	54		104	
Fairy Villas		139			
Fallow Deer					144
Ferrara					144
Festoon					175
Fish	100				
"Fisherman"		84			
Flensburg	62-65				
Fleur-De-Lis	100				
Flora					176
Floral					116
Florida	101	26-27, 56-57	35-36, 43, 116-118		116, 160, 161
Floris		139			

Pattern Names	Flow Blue	Historic Flow Blue	Pocket Guide to Flow Blue	Fascinating Flow Blue	Flow Blue: A Closer Look
Forget-Me-Not		17		76	156
Formosa		13, 27, 84-85, 125-126	13, 70, 98	28, 105-106	
France	65				
Gainsborough					163
Galleon		140-141			117
Garland		141	119		
"Gaudy Berry"				49	
Gaudy				50, 70	
"Gaudy Strawberry"				19, 49	
Geisha	101		120		
Gem		126			
Geneva					117
Genevese					165
Georgia	102				
Geraneum		39			
Gironde			141		159
Gladys	103				
Glorie-De-Dijon		142	121		
Gotha		85			
Gothic	37		59		
Gouchos		143			
Grace	103				160
"Grasshopper & Flowers"			106		
Grecian Scroll		13			
Grenada					164
Gresham		45			
Haddon					160, 165
Hamilton		144			
Haarlem					145
Hartington, The					159
Hawthorne					156
"Heart with Arrow"		86			
"Heath's Flower"				60, 65,	
Hindustan	21, 38	11-12, 58		35	
Holland	104-105				118, 162, 165
Homestead	105			16	
Hong		86-87	71	33, 41, 62	
Hong Kong	17, 18, 20, 22, 38-41	6, 11	8, 72	6, 31, 33-34, 36-37, 107-108	
Hyson	87-88				
Idris	106				145, 164
"In The Garden"					146
India		73, 88	10	66, 87	
Indian	21, 41		27	57	
Indian Jar	42-45			109	
Indian Stone		89			
Indianah		89	73	109	
Iris		144	122		
Ivy		90		110	
Janette		27			118, 161, 176
Japan		127		4, 36, 137	
Japan Flowers				5	146
Japanese				19	

Pattern Names	Flow Blue	Historic Flow Blue	Pocket Guide to Flow Blue	Fascinat-ing Flow Blue	Flow Blue: A Closer Look
Japanese No.				138	
Jeddo		89			
Jenny Lind	66				
Jewel					162
Juvenile				77	
Kaolin		90			
Keele		144	123		
Kelvin		61			163
Kendal		144-145			
Kin-Shan		8, 48, 91	74	111	
Kirkee	7, 66-68			138	
Knox	107				
Kremlin		91			
Kyber	20, 69, 107	34, 41-42, 145	54		
La Belle	108	71, 146	11, 124	7-8, 11, 142-151	6, 10, 16, 48-102
Ladas	108				
Lahore	45, 109	47, 92		36, 58, 77, 111	
Lancaster	109-110				
Lazuli		92-93			
Lawrence	110				
"Leaf & Swag"		93			
Leicester	110				
Leon	110-111				
Lily		93	74		147
Lincoln		147			
Linda	111				164
Lintin	46	94			
Lobelia	17, 46				
Lonsdale	111	94			163, 166
Lorne	112				160, 166
Lorraine	112				
Lotus		147			
Lozern		27, 95			
Lucerne	112-113				
Luneville	113				
Luneville Blue		72			
Lusitania	113				
Luzerne	13, 114				118
Lyndhurst			125		159
Macina					119
Madras	115-117	9-10, 30, 51, 53, 95-96, 148-153	33, 43, 125-126		165
Malta	117		126		
Mandarin	47, 117				
Manhattan	117-118		127		119
Manilla	4, 47-48	27, 64, 96-100	46, 75	36, 50, 54, 68, 112-113	
Marble	149	13, 100-101		18, 35, 78, 113, 114	119, 147, 157
Marechal Neil	19, 118	153			119-120
Margarite					120
Marguerite		153			160
Marie	118-119		128		160
Martha	119				
Martha Washington	119-120				

Pattern Names	Flow Blue	Historic Flow Blue	Pocket Guide to Flow Blue	Fascinat-ing Flow Blue	Flow Blue: A Closer Look
Mattean					177
Melbourne	120	9-10, 27	31-32, 34, 37, 43, 51, 106, 128, 133		120, 157, 159, 166
Melrose		153			
Mentone	120-122				121
Meissen					177
Messina		102			
Mikado		154			
Minton	122				
Missouri					121
Monarch					165
Mongolia	123	127		152	122
Montana					122
"Morning Glory"		128		49, 114-115	
Moss Rose		102			122
Nankin	48	101		61	
Nankin Jar	25, 71				
Napier	123-124	18, 101			
Napoli		154			
"Nautilus Shell"		129		33	
Navy Marble		22, 32			
Neopolitan					123
Ning Po		17, 102-103	76	115	
Non Pariel	124	47	37, 133		123
Normandy		154-155		26, 152-154	123-126, 162
Oban	23, 124-125				
Olympic	125-126				
Ophir					164
Oregon	48	103	77	34, 46-47, 63, 68, 115-117	161
Oriental	126	104-107, 155	42, 78-80	9, 21, 118-119	
Ormonde					126, 178
Osaka		62			
Osborne	126-127				161
Osbourne					178
Oxford	127	27	134		162
Pagoda	48		81	15, 51	
Paisley	127-128				126
Pansy					140-141, 147, 179
Peach		155			127, 162
Pekin	6, 49, 128	19, 156			
Peking	49	107-109		120-121	
Pelew	6, 50		82	29, 36,	
Penang				120	
Peony					179
Persian					162
Persian Moss	128-129				
Persian Spray	129-130			155	127-129
Persiana		24, 129	94	139	
Perth	6, 130				
Petunia					180
Pheasant	51				
"Pinwheel"		109		20	
Plymouth		45			

Pattern Names	Flow Blue	Historic Flow Blue	Pocket Guide to Flow Blue	Fascinating Flow Blue	Flow Blue: A Closer Look
"Pomegranate"		156			
Poppy	131		54		130, 180
Portman		156-157			131, 160
Princeton	132				161
Progress					131
Prunus					148
Reeds & Flowers				15	148
Regal	132-133	158			
Regina	133				
Renown		158			
Rhine		112			
Rhoda Gardens		112			
Rhone	51	112-113		68, 122	
Rialto	133				
Richmond	133-134	27			
Rock	51				
Roma					163
Rose	134	158			
Rose & Jasmine		113			
Roseville		27, 158			
Roxbury		159			
Royal Blue		67-68	135		
Royston		159			
Ruby					148
Ruins		159			
Savoy	134-135				164
Scinde	52-55	18, 29, 43, 114-116	28-29, 83-88	6, 14, 32-33, 37, 42-43, 52, 72, 79, 122-127	
"Scott's Bar"				79, 127	
Scroll				127	
Seaweed					131, 181
Senator	135				
Servants					158
Shanghae	71	27	99	26, 53, 67	
Shanghai	72			6	
Shapoo	55		89		
Shell		4, 38, 129-130	100-102	32, 140	
Siam		159	33		
Simla		130	103		
Singa	56	31	48	140	
Sloe Blossom		31	48	35	158-159
"Snowflake"				80	
Snowflower		160-161	136		
Sobraon	56	116	90	51, 128	
Sphinx		38			
"Spinach"		162			
St. Louis					131, 161, 165
Stanley	138				161
"Stratford"		162			
"Strawberry"		29	104	49, 129	
Swiss	72				
Switzerland					132
Sydenham	72				
Sylvan					132
Syrian					181
Talli		162			
Tedworth		163			

Pattern Names	Flow Blue	Historic Flow Blue	Pocket Guide to Flow Blue	Fascinating Flow Blue	Flow Blue: A Closer Look
Temple	56	116		46, 48, 59	
Tivoli	57	11		61	
Togo		163			
Tonquin	57-58	27, 119	8, 20, 44, 91-92	37, 67, 129-131	
Touraine	138-140	6	137	38, 155-156	4, 102-110
"Tree of Life"		119			
Trent			138		
Trilby	77, 140				
Troy	58	61		69	
"Tulip"		118			
"Tulip & Fern"		117		104, 132	
"Tulip & Sprig"		117		57, 61-62, 132	
Turkey					182-183
Tuscon				33	
Venice	142				
Vermont	143-145				
Verona	146				139, 163
Versailles					164
Victoria	146	20			
Vienna		165			
Vine Border		120			
Waldorf	146-147			157	
Warwick				68, 133	139, 162, 184
Washington Vase	60				
Water Nymph	73				
Watteau	147		32, 139-141		15, 154
Waverly					161
Whampoa			93	37, 134-135	
Wheel	153				
Wild Rose					140-141, 155, 185
Willow		131, 166-168	57, 142-143		155, 167
Windsor Scrolls				35, 40	
Yellow River				135	